Mastering
Glazing Techniques
in Watercolor

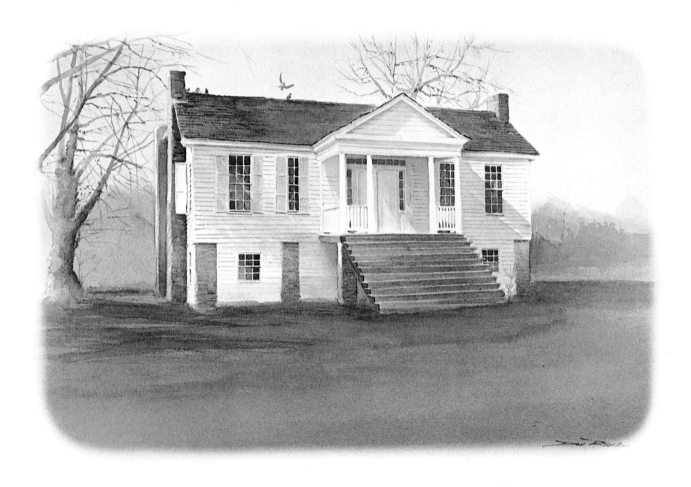

MASTERING

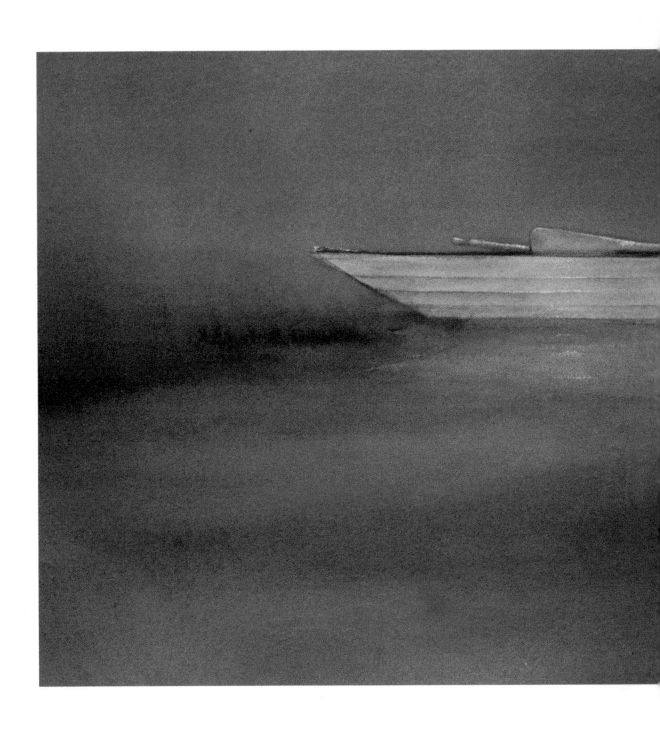

GLAZING TECHNIQUES
IN WATERCOLOR

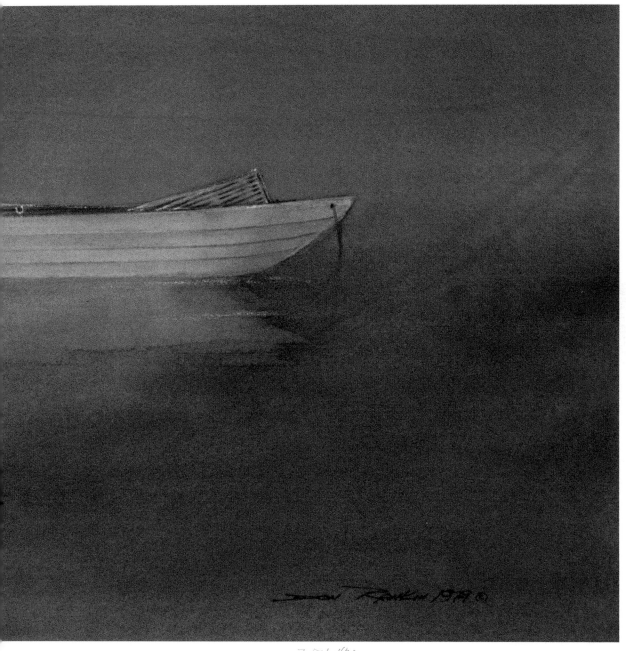

Don Rankin

WATSON-GUPTILL PUBLICATIONS / NEW YORK

This book is dedicated to my wife, Geneal, for over twenty years of enthusiasm and steadfast support in her quiet and gentle spirit both as a helper and a mother of two fine children, Carol and David.

Frontispiece art:
EARLY SPRING
20″ × 13′ (50.80 × 33.02 cm)
Collection of First National Bank of Tuskaloosa

Title page art:
GHOST
24″ × 10″ (60.96 × 25.40 cm)
Collection of Robert Linthout

First published 1986 in New York by Watson-Guptill Publications, a division of Billboard Publications, Inc., 1515 Broadway, New York, N.Y. 10036

Library of Congress Cataloging in Publication Data

Rankin, Don.
 Mastering glazing techniques in watercolor.

 Includes index.
 1. Watercolor painting—Technique. I. Title.
ND2420.R36 1986 751.42′2 86-13317
ISBN 0-8230-3024-5

Distributed in the United Kingdom by Phaidon Press, Ltd., Littlegate House, St. Ebbie's St., Oxford

Manufactured in Japan

3 4 5 6 7 8 9 10/91 90 89 88

ACKNOWLEDGMENTS

I thank God for my talent and for the many people He has sent into my life to help nurture that special gift. I thank:

—my parents for their neverending support.

—my teachers, especially Bill Yeager, who helped me to develop as a painter.

—my editors, Mary Suffudy, for her faith in my efforts, and Candace Raney, for her untiring efforts to put the book together.

—my designer, Areta Buk.

—my photographer, Robert Linthout, for excellence in photography.

—my typist, Martha Muckleroy, for her patience in preparing my final manuscript.

CONTENTS

INTRODUCTION

Plenty of words have been written about watercolor. Like any subject, some of the words are profound, and some are inane. There are those who treat watercolor as though it were some holy relic that should never be desecrated, in many cases luring students into accepting artificial limitations for this medium. Like any medium, watercolor has its place and distinctive physical characteristics. There are some things it cannot or should not be expected to do, and yet most of the real limitations lie in the artist using it. Obviously watercolor isn't recommended for impasto, yet on occasion some genius just might pull it off. That's part of the beauty and mystery of art. Sometimes things that shouldn't work do indeed work.

Watercolor is my favorite medium. I like its versatility and responsive nature. In order to clarify matters let me say that I am talking about transparent watercolors, not a variety of opaque techniques. To be sure, watercolor has a mind of its own, and at times that can prove to be more than a match for any artist. But the spirit of watercolor is part of its charm. Some of the more visible aspects of this charm lie in crisp clarity and vibrant washes. These qualities must never be destroyed, for when they are, watercolor ceases to be watercolor.

Watercolor has an intriguing ability to suggest certain aspects of viewing reality. Certainly your logic tells you that you are only looking at color upon a piece of paper, yet somehow your spirit is drawn into the "real" world of the painting. At least, that's what happens to me when I paint with watercolor.

Like most artists I went through an initiation of basic training. That introduction was only the beginning of a grand learning experience. During this initiation I adhered to all the rules. One of the most practical of these rules was: "Put it down once and leave it alone." I would hear this daily as I learned to apply washes. This is sound advice, but it is advice that should be thoroughly understood and not just slavishly followed. Any beginner knows that the more you fiddle with a wash the more likely you are to muddy or destroy its crispness. And applying another wash over a previous wash can be an invitation to disaster—unless you know *how* to do it. Which is why I am writing this book—to show you how to layer watercolor washes to achieve the effects you want.

I began to experiment with new ways of using watercolor after my foundation in traditional technique was firmly established. Then I began to work more instinctively. As time went by I came to rely more heavily upon my inner feelings and less upon textbook procedure. And like most painters I have adopted certain techniques to suit my temperament. Some watercolor painters make a big deal out of rapid execution; some fall into a trap of thinking that every work should be done quickly, like a fast food order. I prefer to allow the subject to dictate the approach. Of course, there are those works that would be ruined by too much layering, but some works need to be savored slowly and developed with a great deal of feeling. Obviously there must be a strong emotional drive to carry one through an extended period of time on the same watercolor. But for me, there are times

when my response to the subject demands that additional emotional effort.

I have always been fascinated by light. I marvel at its changing quality and its effect upon the objects it strikes. In many cases the subtlety of light is so temperamental that it cannot be fully interpreted without careful manipulation. In cases like these, the logical solution is to slowly develop the light and shade through the use of a controlled series of washes.

The layering approach to watercolor painting is sometimes referred to as the indirect or glazing technique. Both of these terms are used interchangeably, but both are an attempt at explaining what actually takes place. The English are credited with naming the method "indirect," which seems very logical when you consider the process. For example, in order to get a particular shade of green you must approach the problem indirectly. That is, you first apply a layer of yellow wash, and then after it dries you apply a layer of blue wash. The final color is a very special green. With a more direct approach, you would mix the yellow and blue on the palette and then apply it directly to the paper. Thus, these approaches are different and the resulting color is different as well. When the artist elects to use the indirect method, he decides to go around the long way to build up special color effects through the application of several layers of color. These colors can be harmoniously related to one another or they can be sharply unrelated. Regardless, they work together to produce delightful color effects.

Because these layers of color are very thin, transparent washes it is only natural to call them glazes, although by strict definition glazing refers to covering a painted surface or parts of it with a thin layer of transparent color in order to modify tone. And usually when you refer to glazing, most artists and students think of other painting mediums instead of transparent watercolor. That is unfortunate because transparent watercolor is readily adaptable to glazing techniques. Its chief advantage is that it makes a powerful statement by creating a luminous glow of

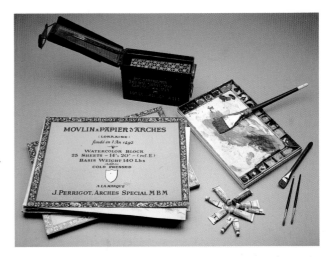

color when the washes are applied in the proper sequence. It is not a difficult thing to do once you understand the nature of watercolor pigments. Various pigments are like some people, they react in different ways depending upon circumstance and their neighbors. For example, when burnt sienna and ultramarine blue get together, they tend to create sediment. But if you like a grainy effect this combination is great. If you don't, then you best avoid mixing the two. On the other hand a lot of colors are very compatible and do not cause a great deal of visual difficulty. Many pigments are very clean, and yet there are those that will muddy a wash very quickly. Some colors like to stain the paper while others are easily moved and partially blotted off the surface of the sheet. Each color has its own place and there is an appropriate time to use even the worst offenders.

My approach to the indirect technique allows me to be flexible. I can use it only in the sky or the foreground or, if I choose, I can develop the entire painting using the method. The artist is always in control. All of these things make up a part of the technical aspect of watercolor. However, this is only the beginning. The real moment of truth lies within the heart and soul of every artist. The secret comes in choosing the proper time and place for using this method.

MATERIALS

The glazing technique requires no special supplies. However, good equipment and materials are important to any technique. The beginning artist should take a tip from the professional—buy the best equipment you can afford and take care of it. On such items as paint, paper, and brushes you should *not* try to cut corners. I am still using some brushes that I purchased nearly 15 years ago. Many of these brushes see action nearly every day. In the final analysis you will find that good equipment and quality materials will reward your efforts over and over.

By choice, my materials list is short. There is no need to acquire unnecessary gadgets. Some students make the mistake of buying every new thing that comes along. Now while everyone should remain aware of the latest developments, merely acquiring tools without developing skills or knowledge is not the answer. Avoid the "gadget" trap, learn to use the basic equipment. Become aware of how each painting item responds to your touch. While this may sound so very basic that it goes without saying, it is a vital link in the process of mastering the art of painting. The following materials are my personal inventory. Each item has proven itself over and over. While you may find it convenient to substitute various nonessentials, I strongly urge you to follow the recommendations for paint, brushes, and paper. Attempting to use inferior equipment or materials in this area will only set you up for failure and disappointment. Don't handicap yourself before you have begun by trying to use less than the best.

PAPER

I have a special appreciation for fine watercolor paper. I enjoy looking at good quality paper. To my mind it is a thing of beauty unto itself. Perhaps it is for that reason that I have developed an appreciation and interest in the subject over the years. However, in a way, it is somewhat akin to self-preservation. You simply cannot produce outstanding watercolors without decent paper. Therefore, I feel it is important for serious artists to know something about this important element in their work.

I have had the opportunity to use many papers ranging from exotic to domestic, from machine-made to handmade. I have made it a point to experiment with various brands, weights, and sizes. I am not impressed with sales claims or brand names. My only interest is in beauty and performance. There are many beautiful papers available; however, there is one brand that consistently performs well for glazing and is within the economic reach of most painters. This technique requires paper that can take repeated dampenings and washes without adversely altering or destroying the integrity of the original surface. Consequently, it is imperative that you use paper that gives consistent, predictable results. One kind of paper that I have found performs predictably time after time is D'Arches. Fortunately for the artist, D'Arches is available in a wide variety of sizes and weights ranging from 90 lb. to 500 lb. My personal choice is a paper size that is referred to as "double elephant" which measures approximately 26″ × 42″

(66.04 × 106.68 cm). The weight designation is 260 lb., but this figure is a bit misleading. In reality this paper is the same thickness as the regular 22″ × 30″ (55.88 × 76.2 cm), 140 lb. paper. In this case, the weight informs us that 500 sheets of 26″ × 42″ double elephant weighs 260 pounds, and that 500 sheets of 22″ × 30″ paper weighs 140 pounds. Both sheets are the same thickness, but the dimensions of double elephant are larger and consequently it weighs more.

If I want to paint big, I use the whole sheet, or, if necessary, I can tear it into halves or quarters. Although some art-supply stores don't carry the double elephant sheets on a regular basis, most of the larger mail-order art-supply houses do. However, if you have trouble finding this paper, don't despair; use the 140 lb., 22″ × 30″ sheet.

Most of the time I use the cold press surface, although I keep hot press and rough papers on hand. I favor cold press because the subtle texture takes washes very readily and allows me to work in fine detail. Rough papers are obviously great for texture, but they require a little more effort to completely cover some areas with wash without leaving small portions of the paper showing through. While this can be a great effect for some paintings, it can get to be tedious. Hot press paper is great for spontaneous painting, but its smooth surface can make glazing difficult. However, if you are patient, you can achieve some very nice results. I like the 26″ × 42″ size of the double elephant sheet for its versatility and it is available in all three surfaces: cold press, hot press, and rough.

Now I strongly recommend that you begin your work on the 140 lb. or 260 lb. paper. In the beginning you will be using more water than usual. The heavier sheets—from 300 lb. to 500 lb.—tend to soak up a great deal of water. This feature not only requires additional drying time, it can also produce some unnecessary disasters. For example, a heavy-weight paper can appear to be dry, but in reality the core of the sheet will still contain much water. The illusion of dryness can cause you to miscalculate and add another wash too quickly, causing the previous wash to be sullied or completely destroyed. At the very least, it can result in a loss of color intensity in your wash and give your work a washed-out look. For this reason, at least in the beginning, you should practice these exercises on the recommended weight of paper. Later, as you begin to understand the operation, you may decide to try the heavier sheets.

Although, I have placed a high recommendation upon D'Arches paper, there are other papers that also perform well for glazing. In fact, you may have success with any number of quality rag papers, then again you may not. Still, I would be remiss if I didn't tell you that Fabriano Esportazione 140-lb. cold press produces some lovely effects. One warning: this handmade paper may not be able to support as many washes as D'Arches. But if you are going to limit your glazing to a small portion of the painting, or if you are going to use only one or two overall washes, you will find the Fabriano a stimulating paper to work on. There are also other fine handmade sheets, but I suggest you wait to use them until you have developed the technique before you invest in them.

In addition to using loose sheets, I always keep a couple of D'Arches watercolor blocks handy. I prefer the 14″ × 20″ (35.5 × 50.8 cm) size. These blocks are excellent for field trips. This paper also works well for repeated layers of wash.

For convenience and economy, I buy watercolor paper in quire lots. I keep the paper in its original wrapper, stored flat, until I am ready to use it. In this manner I have a reliable source of paper whenever I need it. If you choose to buy paper in large lots, say a quire (25 sheets) or more, you should take certain precautions in order to protect your investment. I think the following points are the basic requirements:

1. Store your paper flat, in order to avoid curling or other damage.
2. Make sure that your storage area is relatively cool and absolutely dry. You don't want to invite mildew to eat away at your paper.
3. Keep your paper in its original wrapper to prevent dust or other materials from soiling the sheets.
4. Make sure that no oil-based contaminating sprays penetrate the wrapper. Watch out for insecticide sprays or various solvents, which can leave an oily residue and make the paper useless for a watercolor wash.
5. Take adequate steps to prevent insects from damaging or destroying your paper.
6. Handle your paper with respect.

It is important to be aware that quality paper is made under rather well-controlled circumstances. In contrast to most mass-produced items, quantities of paper, which are called batches, are rather small. And in order to help assure quality control, each run, or batch, is assigned an identifying mark or number. Sometimes you will come across an exceptional batch of paper—a sheet that responds to your touch and is a joy to paint on. Wouldn't it be nice if you knew how to find more sheets from the same batch? Unfortunately, even within the same quire, it's not always guaranteed that each sheet comes from the same

The newer system of batch marks utilizes a geometric symbol placed below the word FRANCE. The symbol will change location from batch to batch. For example, one batch will find a triangle under the F, another will be under the R, and so on. There are other geometric symbols as well.

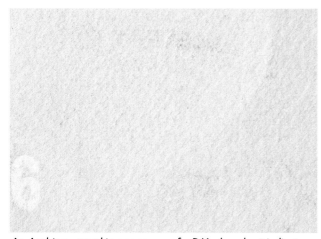

An Arabic numeral in one corner of a D'Arches sheet indicates an earlier batch mark than the ones that are being manufactured now. This paper is still in circulation.

With fine paper it has been traditional to determine the "right" side of the paper for painting by reading the watermark. When the mark reads from left to right you know you are looking at the "right" side of the sheet.

batch. This is usually the case but not always. On the other hand, you may find a particular sheet that is displeasing to you. Perhaps the sheet doesn't perform as expected or the color dries unevenly or spotty. However, be careful about condemning paper. Among the top brands, poor quality paper is a rare exception. Often the problem with the paper isn't in the batch, but in the artist's preparation.

Knowing how to identify individual batches of paper can be helpful to the watercolor artist. To do so, hold a sheet of paper toward the light so that you can read the watermark. You should do this anyway in order to determine the painting side of the sheet. Traditionally, when you are reading the watermark from left to right you are facing the so-called right side of the sheet; however, some papers don't seem to have a right side. But to go back to the issue of the batch symbol, scan the paper while you look for the symbol. This symbol can either be an Arabic numeral or a geometric shape like a circle, square, triangle, or a letter of the alphabet. If it is a numeral, it is often found in one of the four corners or in close proximity to the brand name. Just be patient in your search and you will find it. So if your paper is identified by a particular number, all you have to do to determine that another sheet is from the same batch is to find one with the same number *in the same place*. If you want a different batch, look for a sheet with another number. The D'Arches system presently consists of a geometric symbol (usually a triangle, circle, or a letter of the alphabet) under the word FRANCE. This symbol moves with each batch. For example, one batch will have a triangle under the "F," another batch will show the triangle symbol under the "R" and so on. Previously the D'Arches system consisted of an Arabic numeral impressed in a corner of a sheet. For the moment, both methods of identification are in circulation. Should you have a genuine problem with a paper, include a sample of the batch mark with any correspondence. This will help manufacturers as they research any problem with the paper.

BRUSHES

Naturally no discussion of painting and related materials would be complete without a survey of brushes. We all know that there is a wide variety of brushes available on the market. In the beginning you might be a little bewildered by all of the varieties and grades from which to choose. Perhaps it will help if you remember that the brush is a very basic tool. Like other efficient tools, each style of brush is designed to perform certain tasks. Personally, I like to

equate brushwork with written language. Each brush has its own unique language or signature. In order to do your best work you must learn to allow each brush to speak its own language. If this sounds mystical, stop and think for a moment. Each type of brush has its own special shape. When you apply paint to paper with a particular brush it will leave its own unique stroke. When this happens, you start getting into the beauty of painting. Now the greatest roadblock to expressive painting for many painters is that they try to force the wrong brush into performing a task that it was never intended to do. Watercolor is challenge enough without trying to force a brush to perform a task for which it was not designed. I have watched otherwise intelligent adults try to paint a full sheet of watercolor paper from start to finish with a number 4 round sable brush. That is a terribly difficult task. In almost all cases the finished piece will not be rewarding. In short, don't allow yourself to be set up for failure from the onset by attempting to use the wrong brush at the wrong time. Study my selection of brushes. Some of them may appear to be out of character for watercolor painting. As a matter of fact, when I was in art school, some instructors considered the use of bristle brushes to be absolutely inappropriate for watercolor. But I use them because they work well in any technique. As you study my selection, understand that each brush is there for a particular function within the realm of smearing color. Try not to get caught up in "gadget fever." Some people erroneously assume that purchasing all of the latest gadgets will enhance their painting ability. Don't fall into that trap. Select your tools carefully, then take the time to learn their proper use.

I strongly urge you to buy only the best out of each type brush listed. In this area you may have a little more freedom than you do in paper selection. There are several excellent brush manufacturers. If you are happy with one particular brand, fine. I do urge you to buy the best brushes you can possibly afford. In fact, even if your budget is strained, I suggest you go ahead and get yourself some good brushes. And I don't make this recommendation lightly: Only the best will perform the best. I have seen students destroy their own self-esteem with worthless equipment. In many instances a master can paint fairly well with a bad brush because a master has experience and knows what to expect. Obviously, a younger artist doesn't often have this backlog of experience. Painting is demanding enough without starting off with unnecessary handicaps.

My brushes are listed in the order in which I usually use them, an arrangement which I think will help you gain some insight into my approach. Many years ago a famous master was credited with saying "a good painting is begun with a broom and finished with a needle." In my experience this has proven to be a sound philosophy.

My "broom" is a bristle brush, a size 20 manufactured by Grumbacher, called a Gainsborough no. 1271B. This flat bristle brush has been an invaluable tool for the past nineteen years. As brushes go, it's not terribly expensive. I paid about three dollars for the first one I ever bought. In fact I still have it. Regrettably, the price has gone up a bit in the past few years. My use of the bristle brush is an example of some of my unorthodox procedures. I still hear remarks to the effect that you shouldn't use bristle brushes to do watercolor. I reject that sort of thinking. To be sure you must be careful; a bristle brush can scrub a hole in watercolor paper. But if you can't control your touch any better than that, maybe painting isn't for you. You will find that for your beginning washes, the bristle brush holds plenty of water. It covers a lot of paper rapidly and it's easy to control. One word of caution: don't *ever* use oil paint or any oily solvent with your bristle brush. If you do, it won't perform well with watercolor. Also, acrylic paints can dry out and damage bristle brushes.

I rely upon the bristle brush a great deal. I use it for all paint application until the painting forces me to switch to a smaller size. As the detail of the painting progresses it becomes necessary to change to smaller brushes. That is understandable; however, you should make it a rule of thumb to use the largest brush possible at all times. A larger brush forces you to work in a bolder manner, giving your work strength. Also, the larger brush helps you maintain a cleaner, crisper wash. Small brushes used too quickly in the painting sequence help contribute to dull, overworked paintings. I use the size 20 bristle on paintings as small as quarter sheets, so don't let the size intimidate you. And if you can find a bigger brush *that you can control*, try it!

The next brush in my arsenal is a red sable flat that is designated as a 1½″, no. 4119 Grumbacher Showcard. I have had this brush for a number of years. The action is quite nice and it holds a lot of wash. I also use another flat, the Grumbacher Aquarelle no. 6142, 1″ sabeline brush.

These three brushes constitute the square-edged brushes that I use in most of my paintings. Basically they all produce similar results and similar strokes. However, it should be obvious that the scale of the strokes changes with the size of the brush.

After my painting has progressed well toward the

Materials

final stages, I begin to use the traditional red sable rounds. My primary reason for using the red sable round is because it's resilient and versatile. It is a very sensitive instrument, capable of relatively broad washes as well as producing needle sharp lines. This is especially true when you have a high-quality brush made of red kolinsky sable.

In choosing my red sables I am very picky. I only want the best so I check them out by wetting them before I pay for them. Only when the brush is wet can you determine what type of point is on the brush. Sometimes even the best brand names have clunkers. You want a point that is sharp as a needle and well defined, with all hairs flowing in a uniform direction. Then wet the brush again, snap it with a downward wrist action, and look carefully at the point. Does the brush come to a point easily or do you have to shape it with your fingers? If you have to use your fingers leave it on the shelf. Some of you may be embarrassed to go through this procedure in an art supply store. But just remember, you are paying a lot of money for good brushes. I must confess that I don't do this in every shop. In the past few years I usually have been able to just look at a dry sable brush and determine its quality. A large part of my confidence lies in the fact that I buy only Winsor & Newton Series 7 brushes. Usually they come shaped with a light water soluble sizing to aid the shape of the brush. But again, if you are about to purchase a quality red sable round and the tip of the brush is not pointed in an orderly manner, you had better wet it to determine its real worth.

I use the following Winsor & Newton Series 7 sizes: nos. 4, 5, 6, and 10. I usually buy these in pairs so that I can rotate them. But what usually happens is that I start using one and hold the other in reserve. As for the largest, the no. 10, I find I don't use it much.

There are a few additional brushes that I use when the need arises. I am listing them separately because although they are useful, they don't constitute a part of my everyday routine. But from time to time I do need brushes that will throw a sharp, sensitive line. If my regular brushes are worn or if for some reason I can't muster the proper touch and control with a size 5 or 6, I will use a size 6 rigger. At times beginning students make a mistake with this brush. They become addicted to the fine lines the rigger can produce and they overdo it. The primary offense is fine limbs on trees. You are better off studying the species of tree you wish to depict and then use only a few lines to suggest it. Understanding form and suggesting it is far better than having a fit with a fine brush.

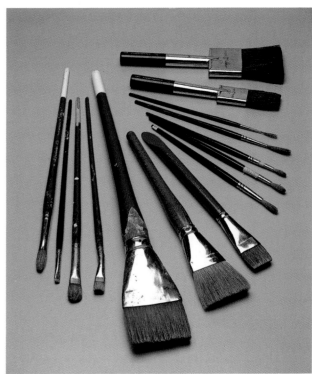

An assemblage of watercolor brushes.
From left to right: 4 worn-out bristle brushes used for scrubbing in washes and textural effects; a large no. 20 bright, used for most broad washes; a 2" pure red sable, an excellent wash brush; an Aquarelle red sabeline, good for both details and washes; 3 Kolinsky sable round brushes, excellent for detail work; 2 long-haired riggers, best for fine details and needlelike lines; and 2 varnish brushes (a 1" and a 2"), very useful for creating textural effects.

In rare instances I will use a 1" or 2" no. 3640 Grumbacher flat bristle brush. These brushes are great for indicating texture, such as grassy foregrounds. They really perform well on high surface or hot press boards; therefore, I don't rely upon them too heavily on cold press papers.

A final group of brushes I use is a variety of small wornout bristle brushes. Occasionally I use these brushes to scrub out harsh edges on washes or to scrub out soft highlights, although I prefer to plan my work so that highlights are developed from the beginning of the painting. I like to keep the beauty of the paper intact and you can't do that when you start sanding and scraping out highlights. I only use those techniques when I have miscalculated the effect I want. But nonetheless there are times when you can't beat the effect of a good bristle scrub out.

As you have seen, my brush list is small. However, I have striven to learn to use these brushes well and to allow their innate qualities to work for me. As I have said earlier, don't try to force a brush to perform a function that it was not designed to do. Certainly any good artist is going to attempt new things

and new approaches, but valid innovations are usually logical extensions of past disciplines. You must master the old before you can create the new.

If we only used orthodox procedures to create, painting would certainly be dull. Like many others, I have my moments when I will use unusual materials to spread washes and create textures. In these cases, I use anything that works without destroying the paper or placing the painting's permanence in jeopardy. I have painted with my fingers, my forearms, sponges of all sorts, twigs, and other assorted items. These methods will be discussed at greater length in the chapter on developing underpainting for texture and form. The guiding light should be to allow yourself to be open to experimentation.

PIGMENTS

I have said that my materials list would be short, and it is true that I have not listed a great deal of equipment. I see no need to refer to such basics as drawing boards, French easels, pencils, X-Acto knives, proper lighting, and all those things that are essential to a well-planned studio or painting space. In this book I am more interested in revealing information about items that make a difference in your approach to glazing techniques. Certainly the basic equipment, especially lighting, can have an effect on the quality of your work. But that holds true for all disciplines of art, not just my approach.

Just as paper should be selected with care, so should paint. If you pick up any art magazine, you will find a number of paint manufacturers advertising their products, presenting you with a vast array of available brands. With so many domestic and international paint sources offering products of varying quality and prices, the process of selection can become confusing. Because I am first and foremost a painter, not a scientist, my choices are based upon those paint qualities that have worked for me and on brands of paint that I have used for several years. Like many professional painters I receive samples from various manufacturers. At this point in my painting career I have not found any colors offered that would lead me to change from my present sources.

My working palette is derived from a combination of colors from Winsor & Newton as well as from Grumbacher. I use the Professional Water Color Series from Winsor & Newton and the Grumbacher Finest Series. Both of these manufacturers will provide information concerning the composition of the pigments used in their paints as well as make statements concerning the lightfastness and/or durability of their pigments. If you cannot get these booklets and leaflets from your local merchant, they are available for a small fee from the manufacturer. You can write to M. Grumbacher, Inc., 460 West 34th Street, New York, New York 10001, and request a general catalog, which will give you composition and permanence rating for all their paints. Winsor & Newton, Inc., 555 Winsor Drive, Secaucus, New Jersey 07094, offers two booklets, "Selecting Artists' Colours" and "Notes on the Composition and Permanence of Artists' Colours."

The information available from Grumbacher and Winsor & Newton will help you to understand a great deal about watercolor pigments and their behavior. Both companies also provide color charts that specify the permanence rating of each color. This idea of permanence or its lack can lead to some confusing assumptions. To clarify I think it beneficial to quote from Winsor & Newton's booklet, "Notes on the Composition and Permanence of Artists' Colours." Incidentally, this statement was first publicly issued in 1892. In fact, Winsor & Newton was the first manufacturer of artists' paints to publish a complete list of colors with details of their composition and permanence. That statement came about because of a publicized outcry in *The London Times* during the late nineteenth century to the effect that artists were kept in ignorance of the actual materials they were using and that in fact many colors were fugitive. Since its original 1892 issue, the booklet has been periodically updated in order to reflect any necessary revisions. The following is Winsor & Newton's definition of permanence:

By permanence of a Water Colour (transparent, opaque, gouache, or acrylic), we mean its durability when washed on the best quality water colour paper and, while under a glass frame in a dry room, freely exposed to ordinary daylight for a number of years, no special precaution (other than the usual pasting of the back of the frame) being taken to prevent access of an ordinary town atmosphere. By an ordinary town atmosphere we signify an atmosphere normally containing as the active change-producing constituents oxygen, moisture, and a small percentage of carbonic acid, together with chronic traces of sulphur acids, spasmodic traces of sulphretted hydrogen, and a certain amount of dust and organic matter in suspension.

In this context you can see that permanence is defined within the bounds of what is considered to be the normal and reasonable display of a watercolor painting. Most experts agree that a watercolor should

not be subjected to direct sunlight or other harsh lighting conditions, but that is not all of the precautions you should take. If you want to know more about this subject, I recommend a small booklet entitled "How to Care for Works of Art on Paper," available from the Museum of Fine Arts, 465 Huntington, Boston, Massachusetts 02115. Although its primary focus is on types of paper, it also discusses watercolors. You will find it a delightful introduction into a fascinating subject.

The major manufacturers of watercolor paints have developed methods for rating the permanence and/or durability of their colors. These ratings are intended to help you make wise selections when you choose your paints. It is important to know that not all manufacturers use the same criteria in developing their rating systems. For instance, some rely very heavily upon a lightfastness rating, but this is not the only factor involved. While lightfastness is important, there are such things as resistance to moisture, chemical stability, and chemical compatibility. In a factor such as chemical compatibility, some colors may work very well until they are mixed with certain other colors. When that happens, the reaction may be adverse, swift and sure, or it may be adverse but take a while to show up. Also, the manner in which you paint and apply the pigment can have a great bearing upon the permanence of the color used. In short, the issue is really quite complex, and many people devote their entire career just studying various facets of this subject.

Winsor & Newton classifies its paints into four separate categories: extremely permanent colors (class AA); durable colors (class A); moderately durable colors (class B); and fugitive colors (class C). Class AA colors are those colors that are considered to be extremely stable under all ordinary conditions of watercolor painting. Class A colors have a degree of weakness that prevents them from being included in class AA but their permanence depends to some degree on the condition of their use and exposure. Although the demarcation between class AA and class A colors is very sharp, it is impossible to make such a sharp distinction between class A and class B colors. It is also difficult to draw a hard and fast line between class B and class C colors. There are so many other factors to be considered, such as the strength of the wash, its purity, its ability to mix with another color or with white, and so on. All of these factors must be taken into account when assessing the permanence and durability of each color.

If you look at a Winsor & Newton color chart you will see that out of eighty-three colors, fifteen fall into the class B and class C rating. But you would be mistaken if you were to necessarily conclude that these paints are of inferior quality just because they are rated B and C. Like other quality manufacturers, Winsor & Newton makes every effort to inform buyers about the permanence of their pigments. Furthermore, Winsor & Newton's stated policy is to provide the best quality color regardless of permanence, so they strive to make the best paint possible even when the product is fugitive. You may well ask why fugitive colors are sold in the first place. The answer is simple: there is still a need and a demand that other colors cannot fill. carmine, rose carthame, chrome lemon, chrome yellow, mauve, and Van Dyke brown are colors that all possess a unique and beautiful color character. The same is true of moderately durable (class B) colors: sap green, gamboge, chrome deep, crimson lake, purple lake, purple madder alizarin, violet carmine, Hooker's green light, and Prussian green—all of these colors fill a need for many artists. Personally, I try to avoid the use of fugitive colors because I know that at some point they will change or fade. Since some of them can be unpredictable in their departure, I prefer to work with more stable colors. Also, I tend to work with very dilute washes and the colors I need to fulfill my requirements are available in class AA and class A.

In today's market, there are many choices for you to make concerning color and there are many claims made about quality. I think it is vital for every painter to understand that there are art materials, especially paper and water-soluble dyes and paints, that are intended primarily for the commercial art trade. While these materials are of fine quality and made by many leading firms, they are not necessarily intended for the fine arts. Products made for commercial art do not necessarily possess the qualities of permanence the serious fine artist seeks. For example, there are extremely brilliant transparent water-soluble dyes available that can produce fantastic ranges of color. These are great for commercial use where a lasting statement is not intended. Many of these dyes are extremely fugitive and will fade rapidly, sometimes within ninety days or less. While that is plenty of time to process a piece of art into film for a pressrun, it certainly doesn't meet most artists' expectations.

When you begin to make decisions about color for your own palette, there are several factors to take into account. First, you need to consider your own personal taste; it is only natural that your personal palette should be influenced by your feelings about color. As you paint, you will find that the shades of color in one brand will be more pleasing to you than

the same color in another brand. Now when you compare color from one manufacturer to another, you must make certain that you are comparing similar pigments. The only way to do this is to compare chemical descriptions. In some cases you can find out what is in the tube by reading the label. If the label doesn't tell you what you want to know, be careful. Watch out for catchy names like "daisy yellow" or "plum pink." This is usually marketing jargon to warn the educated that the paints therein are not of outstanding quality. Don't be surprised when you find that even though the pigments are chemically identical, paints vary from manufacturer to manufacturer. There are several reasons for this. To begin, each manufacturer may purchase a different variety of the same chemical ingredient. They may grind their pigments a little differently, one a little more coarsely than the other. In some cases one manufacturer may use more pigment, or another may use a combination of gums and other ingredients that alter the color. Again, many factors can play a part in a change of color. It is rather like one of Grandma's favorite recipes: someone else may use the same recipe and the same ingredients, yet the result just isn't the same.

The successful manufacture of quality watercolor pigments is a very complex process, in which many factors are involved. As painters we are usually only concerned with what comes out of the tube or pan. The manufacturer, however, has to consider such factors as tinting strength, mixing quality, natural transparency of the paint, and how well one pigment mixes with and reacts to other pigments. But that's just a part of the challenge. After a color passes all of the aforementioned hurdles, it must also be relatively lightfast, durable, and able to mix with other colors.

When you consider just how much is involved in producing *quality* watercolor paints, the price of these materials seems just a little bit more reasonable. So I urge you to stick with quality paints and choose only those brands that have a tradition for excellence.

Like most watercolor painters in this country, I purchase watercolors packaged in tubes. As a young artist I was taught that colors in tubes were superior to any other product. I didn't question that teaching. In fact, much of my experiences with pan colors helped to reinforce those early teachings. However, the pans I had been exposed to were not colors from the best companies. Because of my experiences, I told many of my students to avoid pan and cake watercolor. I can no longer hold that position. But for clarification, when I speak of pan watercolors I am

referring to those colors that are manufactured by top companies. I am most definitely not talking about inexpensive watercolor sets that are sold in variety stores or those intended for preschool children.

I am most familiar with Winsor & Newton's pan watercolors. Pan and tube watercolors are formulated differently, for specific reasons. Pan colors are designed to be used over a period of time in a palette situation where they may dry out slightly. Therefore, they are formulated to remain stable and workable with repeated wettings of the color. Pan colors also contain an amount of preservative intended to discourage mold or bacterial growth during their life.

The formulation of pan colors is intended to help the painter who doesn't or can't keep a wet watercolor palette. If you paint occasionally and your colors tend to dry out, then the pan formula could be better for you. Unfortunately, pan colors are not as popular in this country as they are abroad. But they are still available. If you wish to try them, contact your art supply dealer and ask him to help you out. Some painters prefer pan colors over the tube colors because of their particular texture and feel.

Most of my painting experience revolves around tube colors. Watercolor from the tube is intended to be used in the moist state. It is not intended to sit upon your palette, dry out, and sustain repeated wettings. That is not to say that it doesn't happen a lot. But it is *not* designed for that purpose. Repeated wettings of dried tube color tends to break the color down. This can result in inferior performance and permanence. To keep my tube colors moist, I rely on a John Pike palette. Now in some parts of the country at certain times of the year, some colors can develop mold because of this moisture. After all, you have an

Sometimes mold growth will develop in a moist, covered palette. You can combat mold by laying a paper towel soaked in a solution of mild household disinfectant over your colors before closing the lid.

enclosed palette, with all kinds of opportunities for mold growth. If you encounter this problem, take a paper towel, dampen it in a mild household disinfectant and lay it over your colors before you put the lid on. This will be helpful for a while because tube colors have enough preservative to protect them while they are in the tube. But once they are in your palette for an extended period of time, they will probably not have enough preservative left to combat mold.

Many watercolor painters tend to take water for granted. At times we have all probably been guilty of using water from some rather questionable sources. How many times have you used water out of the stream or lake while on one of your back-to-nature jaunts? Just remember your water source may not be pure, which can play a big factor in mold growth.

There are other factors to consider in discussing water. Modern drinking supplies are filled with all sorts of chemicals for one reason or another that may not be conducive to creating lasting watercolors. Some municipal sources are heavy in chlorine, a bleach. For a lot of reasons, you are better off using distilled water. In fact, have you ever noticed that on some days with different water supplies you paint better? Possibly you thought it was your biorhythms, or whatever. It could be your water source. Technical experts tell me that the chemical composition of the water can affect the performance of watercolor paints.

There is one other factor that you need to consider when you buy watercolor paint—freshness. Most paints will last for quite some time on the shelf. In fact, because of various market factors, it is possible for a tube of watercolor to be two years old when you buy it. So when you buy paint, inspect each tube beforehand. (Obviously, you should not buy any tube that shows signs of leakage.) Gently hold each tube; if the contents feel stiff or slightly rigid instead of pliable to the touch when you squeeze the tube, chances are the color is drying out. Also, as some colors begin to age, they tend to separate in the tube. That is, the pigment separates from the other ingredients in the tube. When you hold the tube, it feels just as it should, but when you open it you get some oily-looking goo instead of color. Don't panic. Put the cap back on and gently knead the tube to get the color back into solution. After a few moments of alternate squeezing of the top and bottom of the tube the color should be ready. This slight separation is a natural characteristic of some colors, and it often happens if the brand of paint contains quality ingredients. This may sound contradictory, but this is a predictable occurrence with some pigments unless you load the paint with chemicals to keep it in solution.

My color list contains only colors that are listed on the class AA or class A list. You will notice an "SL" designation on the tubes of the Winsor & Newton colors. This refers to "selected list," a term which means that these colors have a high degree of permanence and can be safely intermixed with other "SL" colors without fear of unexpected adverse chemical reaction. Grumbacher makes a similar claim for their "Finest Professional Quality" paints. My overall selection presently consists of twenty-eight colors. I am sure that everyone understands that I don't use all of these colors all of the time. In fact, most of my paintings are executed with a rather limited range of colors. I use an expanded primary system which makes it possible for me to express a wider range of coloration. In conjunction with the reds, blues, and yellows, you will see some colors listed under miscellaneous. The miscellaneous section contains some accent colors, several greens, an orange, and a purple, as well as other colors that I use on an exceptionally rare basis.

Yellow
 cadmium yellow
 Indian yellow
 new gamboge
Red
 vermilion
 Winsor red
 Grumbacher red
Blue
 cerulean blue
 manganese blue
 cobalt blue
 permanent blue
 ultramarine blue
 Thalo blue (Grumbacher)
 Winsor blue
Miscellaneous Colors
 lemon yellow
 cadmium yellow pale
 cadmium yellow deep
 gamboge hue (Grumbacher)
 cadmium orange
 cadmium red deep
 Winsor violet
 Thalo yellow green (Grumbacher)
 sap green (Grumbacher)
 Hooker's green deep (Grumbacher)
 olive
 raw sienna
 burnt sienna
 raw umber
 indigo

THE GLAZING TECHNIQUE

In the preceding pages you have had an opportunity to become acquainted with some of the materials that I feel are vital for painting in the glazing technique. For most of you these items are already a part of your personal inventory and will probably not require you to obtain anything else. Now we shall begin analyzing the glazing approach to painting. As with any style of art, some of you will be automatically drawn to this method for it will satisfy some need in your creative pursuit. On the other hand there will be a few readers who will have to adjust their thinking about watercolor in order to benefit from this material.

If you talk to many watercolor painters long enough, and ask them why they like the medium, at some point I think you will hear such terms as transparency, spontaneity, and speed. These are three qualities that are unique to watercolor painting. In my approach, however, some compromise is made on the speed of application because certain stages of this technique require a little more thought and time. But even though you spend a little more time using this technique, you never want your work to look tired and worked over. By following the right sequences you can avoid the tired look. Watercolor is a spirited medium; that is part of its charm. Some of the more visible aspects of this charm lie in crisp clarity and vibrant washes. When these qualities are lost, watercolor can become something very ugly. Personally I favor the medium for its challenge, versatility, cleanliness, speed, and most of all for its ability to imitate a sense of reality. Watercolor has the virtue of being pastel-soft and ethereal on the one hand and bold and heavy on the other. This balance suits my temperament perfectly.

When you strip away all of the adjectives and think for a moment, the art of watercolor begins to develop with the application of tinted water to a white sheet of paper. If all of the elements—your spirit, your ability, and your materials—are working in harmony together, something magical happens. The visual aspect of that magic can be compared to viewing a stained glass window. Let your memory carry you back to the most beautiful stained glass window you have ever experienced. I say experienced because the sheer beauty of the color and the subject translated into those colors had a visual impact upon you. Some of the colors were jewellike in quality. The yellows and reds were sparkling in clarity. The blues were a little quieter in their display, except for areas where a lighter shade of blue or violet were interspersed. If you were lucky, you got to see a cathedral window that contained the darker, heavier color quietly displaying its strength while more delicate pastel hues of color danced about. The impact of this sight would be a visual delight.

In many ways good watercolor has the same qualities as the stained glass. To be sure the scale and the impact may not be identical, but there are similarities just the same. When you look at a watercolor, the light passes through the washes, bounces or reflects off the white sheet of paper, and returns to your eyes. When the image returns, the work brings either a visual delight or a less than best image. It all depends upon what you did when you made your

The glazing technique

"stained glass window." Did you use the best of transparent color at the right time or did you muddy up the sequence by applying the wrong wash at the wrong time or by overworking your washes?

Timing is essential in watercolor. Observing certain rules is very important in order to create a particular effect. I want to emphasize the idea of creating an effect. In too many cases artists are lured into adapting to a wide variety of rules that almost always degenerate into a list of don'ts. Maintain your sense of wonder. I prefer to encourage you to explore possibilities, even the potentially disastrous ones. You will find that even the worst painting fiasco can teach you something constructive about painting. Part of the secret lies in learning how to predict the consequence of a certain procedure with at least some scant degree of accuracy. While this is happening you must remain open in your ability to accept and adapt to sudden change in the direction of your painting. If you find comfort in absolutes or are concerned that this sounds too vague, don't forget that practice will bring you the experience you need to determine with some degree of accuracy what will happen when you lay one wash over another. But remember too that to become so precise in your prediction that you lose the enchantment of seeing

your painting develop as you struggle between the tension of success or possible failure would render painting a very dull activity. For painting to be of value and for you to create your best, you must be able to risk failure.

In the previous section you took note of my basic inventory of pigments. The palette that I use will be drawn from that selection. It is my custom to work from a small group of colors on any given painting. My palette shifts from painting to painting depending upon the mood I am trying to convey. You may recall that I segregated my colors into yellows, reds, and blues. Colors that are used on a sometime basis are relegated to a miscellaneous section. These colors can be further subdivided into additional categories, such as opaque, slightly opaque, transparent, very transparent, ground mineral pigment, or dye pigment. All this information is included in the two charts shown on pages 22-24. The first chart shows you the technical information concerning the ingredients in each pigment as well as my experience with each color. Do understand that the terms opaque and transparent are somewhat relative. The second chart will help you to understand this, but at first you will have to draw upon my written account. In actual practice you may find your results a little different

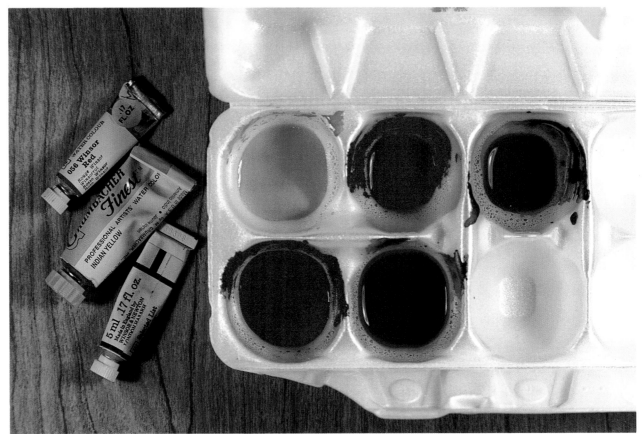

A Styrofoam egg carton makes an excellent receptacle for mixing your glazing washes.

from mine. This can occur because of uncontrollable factors. For instance, your washes may be heavier or lighter than mine. So be kind to yourself—allow for a little variation. If you find your results way off, go back and study the charts.

Twenty-eight colors are represented in these charts. Note that my selection of paints includes a wide variety of yellows, reds, and blues. Each paint has been chosen for a particular quality; while some are very similar, no two are exactly identical. This expanded primary system gives me a tremendous potential for coloration. In conjunction with this selection I have added some additional accent colors. While the primary system allows me the opportunity to mix many ranges of color, there are some cases where an orange or violet is needed in a more brilliant hue. In that case, I find it a good idea to have the right tube color to rely on. The same idea applies also to varieties of green. While most of my greens are mixed from primaries, there are some accents of green that help to augment my palette.

Note also the relative absence of ochres and that umbers and siennas are placed in the miscellaneous section. It comes as a surprise to many viewers that my work is not based upon a heavy use of the umber and sienna family. In fact, it was the umbers and siennas that helped prod me into developing my approach to watercolor. I favor the earth tones and when I began to paint watercolor, I relied very heavily upon them. I especially loved the rich hue they displayed while they were wet, but I didn't like the way they lost that richness when they dried. So, in order to pump more color into these earth tones I began to experiment with a yellow underwash. Finally, I found that I could achieve the rich wet look when the paint had dried by layering a controlled sequence of the primaries. As I continued to experiment I began to learn all sorts of wonderful things about glazing.

All of the technical information concerning pigment composition is derived from current published materials from the manufacturer. These chemical descriptions are intended to help you gain an understanding of the physical properties of paint. Some of the names are difficult to pronounce and you may feel that you don't really need to know what's in paint in order to paint. And to some degree this is true. Certainly, I am more concerned about conveying how a color behaves on paper and in combination with its neighbors. But I feel strongly that some knowledge of the chemical composition of pigments will benefit your painting career. For example, after you have gained some experience, you will be able to translate this information into helping you anticipate the behavior of various colors that are related chemically.

In regard to composition, watercolor pigments fall into three categories: ground mineral or earth pigments; organic dyes; and synthetic dyes. Each type of pigment has certain peculiarities in its behavior. Pigments made from minerals tend to settle or float upon the surface of the paper, and pigments made from dyes tend to stain the paper fibers or to sink into the surface of the sheet. That sounds simple enough, doesn't it? Unfortunately, reality makes it necessary to complicate matters just a little. Some mineral pigments are quite transparent in appearance. For example, genuine ultramarine blue, burnt sienna, raw sienna, cobalt blue, viridian, and manganese blue are categorized as transparent pigments. Since these pigments are transparent in nature, it seems that they would make good pigments for basic beginning washes. This may or may not be true; it depends upon how you apply them. In very pale washes, these colors might work very well, but heavy washes of these same colors could create sullied, muddied washes. Why? The answer lies in their basic nature. Remember, that mineral pigments have a tendency to float upon the surface of the paper without penetrating. If they do stain the surface, it is somewhat minimal. In this state they are vulnerable to being dislodged by additional passages of color, a process similar to stirring up the mud at the bottom of a clear stream of water. The result is a muddy cloud of disturbed particles. Some mineral colors also tend to create sedimentation, or granulation. When these colors are mixed together, they often create a tremendous amount of sediment. After a wash has dried, a typical mixture will give the appearance of a lot of grainy particles. This is a great effect for a sandy beach or a roadbed, but it can be very frustrating in a sky or a body of water. Incidentally, genuine ultramarine and French ultramarine are not the same: genuine ultramarine is now very difficult to obtain and it's very expensive; French ultramarine is produced synthetically from natural substances that are mixed and transformed.

The dye pigments present a challenge also. When you think of dye colors, you may assume that they are very transparent. But this is not the case; it is more accurate to say that some dye pigments are very transparent while some tend to be fairly opaque. This variation in opacity exists because some colors are derived from dyes that are combined with a transparent white filler. So in effect the transparent white particles are dyed with a stain to produce a colored pigment. This combination of white filler and pig-

The glazing technique

1. lemon yellow

2. cadmium yellow pale

3. gamboge hue

4. new gamboge

5. cadmium yellow

28. raw umber

27. burnt sienna

26. raw sienna

25. Thalo yellow green

24. Hooker's green deep

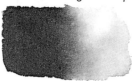

CHROMATIC SCALE This chart contains the manufacturer's stated composition as well as my personal observations on color behavior. The colors are listed in chromatic scale in order to help you compare each shade. Note that some very transparent colors are not a part of this inventory. Only colors that are in my palette are shown.

1. Lemon yellow (AA) extremely permanent Chemical composition: chromate of barium. A very transparent mineral pigment with good staining power. Lemon yellow is a delicate, sensitive yellow.

2. Cadmium yellow pale (A) durable color Chemical composition: sulphide of cadmium. This mineral yellow is not as transparent nor as delicate as lemon yellow. However, it is very good for accent areas.

3. Gamboge hue (Grumbacher) (AA) extremely permanent Chemical composition: substituted anilines coupled with arylamides of acetoacetic acid and natural yellow iron oxide. This color is more opaque than new gamboge and adds a slightly greenish cast to the wash.

4. New gamboge (A) durable color Chemical composition: a blend of arylamide yellow and toluidine red. This is a very transparent staining yellow. While not rated as being as transparent as gamboge, it has a brighter undertone and it is more permanent to light.

5. Cadmium yellow (A) durable color Chemical composition: sulphide of cadmium. This color has all of the characteristics of cadmium yellow pale except that it is composed of a deeper shade of cadmium. When mixed with various blues, it gives an even stronger range of greens than does cadmium yellow pale.

6. Indian yellow (A) durable color Chemical composition: arylamide yellow. This is another one of my favorite yellows. Like new gamboge it has a slightly reddish cast. This color tends to give a transparent look to a wash; mixes very well with other colors; and is a very powerful influence even in very pale washes.

7. Cadmium yellow deep (A) durable color Chemical composition: sulphide of cadmium. The darkest of the cadmium yellows, cadmium yellow deep is light orange in appearance. It's quite opaque, so if you apply it over dark passages, you will get an opaque effect.

8. Cadmium orange (A) durable color Chemical composition: a mixture of sulphide of cadmium and selenide. This is a color I use seldomly but keep around just in case I need the impact of a prepared orange.

9. Cadmium red deep (AA) extremely permanent Chemical composition: concentrated cadmium sulfo-selenide. This is a very opaque red that is applied toward the later stages of painting.

10. Grumbacher red (AA) extremely permanent Chemical composition: naphthol red. I use this red because of its warmth and vibrancy. In heavy washes it behaves in a somewhat opaque manner, but when diluted it works as a beginning wash.

11. Vermilion (A) durable color Chemical composition: mercuric sulphide. This color works well as a beginning wash. It works especially well in mixture with new gamboge or Indian yellow to produce a glowing light.

12. Winsor red (A) durable color Chemical composition: naphthol. Winsor red is a perfect companion to Grumbacher red. They are very close in coloration, but Winsor red is cooler.

13. Winsor violet (A) durable color Chemical composition: a blend of lakes made from naphthol and azine dyestuffs. This is a very clear transparent color. It can be used quite strongly or diluted into a very pale, subtle wash.

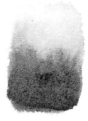

23. sap green

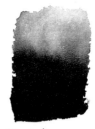

22. olive green

21. indigo

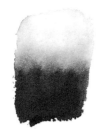

20. Thalo blue

6. Indian yellow

7. cadmium yellow deep

8. cadmium orange

9. cadmium red deep

10. Grumbacher red

14. Manganese blue (A) durable color
Chemical composition: barium manganate on a barium sulphate base. I love the spirit of this color. It can either lose itself in a mixture or really shine.

15. Cobalt blue (AA) extremely permanent
Chemical composition: cobalt aluminate or phosphate containing some alumina. Cobalt is ranked as a very transparent mineral color. I like its lively, clean color, and I find that it mixes well.

16. Cerulean blue (AA) extremely permanent
Chemical composition: stannate of cobalt. Cerulean mixes well with other colors to produce some very fine grays and greens. Although the color is easily diluted, it also has a strong tendency to be opaque.

17. Permanent blue (A) durable color
Chemical composition: complex combinations of silica, alumina, soda, and sulphur. This is another transparent mineral blue somewhat stronger in value than cobalt blue.

18. Ultramarine (A) durable color
Chemical composition: genuine—choicest extract of lapis lazuli French—complex combinations of silica, alumina, soda, and sulphur. Ultramarine is a very regal blue and is a classic mineral color.

19. Winsor blue (A) durable color
Chemical composition: copper phthalocyanine. Winsor blue contains the same ingredient as Thalo blue. However, I find the Winsor & Newton variety to be cooler, darker, and more intense.

20. Thalo blue (Grumbacher) (AA) extremely permanent
Chemical composition: copper phthalocyanine. This is one of the most powerful staining colors on the market. Clear, deep, cool, and transparent, this color is an excellent mixer.

21. Indigo (A) durable color
Chemical composition: a mixture of alizarin crimson, lamp black, and Winsor blue. Indigo is a very good staining color and can produce a tremendous range of coloration.

22. Olive green (A) durable color
Chemical composition: mixture of raw sienna and Winsor green. I often use this color straight out of the tube. It is almost a perfect landscape color.

23. Sap green (AA) extremely permanent
Chemical composition: polychloro copper phthalocyanine and quinacridine-based pigments. Sap green is a clean, transparent color that is very helpful for setting the tone of a landscape painting.

24. Hooker's green deep (B) moderately durable
Chemical composition: copper phthalocyanine and substituted anilines coupled with arylamides of acetoacetic acid. While Hooker's green deep is not rated as a very durable color, I still like to use it. Its primary function on my palette is to help take the blue edge off Winsor blue and indigo in shadows.

25. Thalo yellow green (AA) extremely permanent
Chemical composition: substituted anilines coupled with arylamides of acetoacetic acid and chlorinated copper phthalocyanine. A very pale yet vibrant color, Thalo yellow green dilutes readily and helps to set the tone for beginning landscape washes.

26. Raw sienna (AA) extremely permanent
Chemical composition: native earth containing hydrated ferric oxide. Raw sienna is a very transparent mineral color. Although I rarely use it, it is a very stable, useful color. It works especially well in later passages of color.

27. Burnt sienna (AA) extremely permanent
Chemical composition: calcined raw sienna. Like its relative, raw sienna, burnt sienna is a very transparent color. However, like raw sienna, the same warning applies concerning its use in the proper sequence: if not properly diluted in early washes, it produces a muddy wash.

28. Raw umber (AA) extremely permanent
Chemical composition: native earth containing ferric oxides and manganese dioxide. Raw umber is a little more opaque than are the siennas. I use it as an accent or in limited areas.

11. vermilion

12. Winsor red

13. Winsor violet

14. manganese blue

15. cobalt blue

19. Winsor blue

18. ultramarine

17. permanent blue

16. cerulean blue

The glazing technique

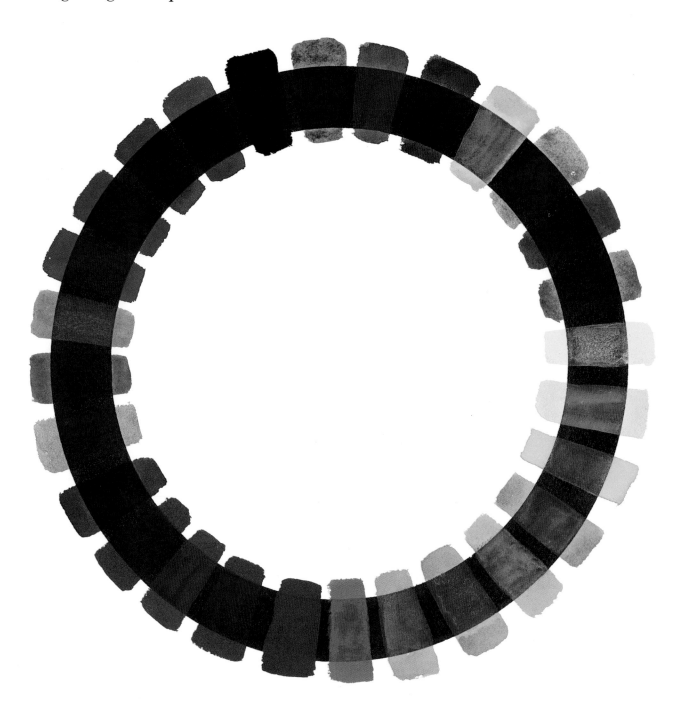

OPACITY/TRANSPARENCY SCALE This scale is intended to help you compare the degree of transparency or opacity for each color found on the previous chart. These colors correspond to the colors on the chromatic scale and are placed in the same order beginning with lemon yellow.

As you study the scale you will see that some colors have the ability to cover the black. These colors are opaque. And other colors tend to disappear as they cross the black; these colors are transparent. Finally, some colors fall somewhere in between the two extremes.

Beginning glazes should be mixed from transparent staining colors. Keep in mind, however, that some mineral pigments are naturally transparent but not necessarily suitable for beginning glazes. And opaque colors tend to create a chalky surface when applied layered over other colors. Semiopaque colors can be diluted and used as satisfactory glazes when they are mixed with transparent staining colors. In this chart, the colors were applied in direct heavy washes in order to emphasize the color. In actual use, these effects won't be quite as pronounced.

ment causes some of the dye paints to be light stainers. The heavy stainers do not contain any or as much white filler. It is like comparing degrees of transparency; the higher the ratio of filler, the lighter the staining property.

Because some of this material is difficult for a beginner to absorb, a chart is provided for you. When you begin to work with watercolor, I strongly suggest that you use the transparent colors found on the chart. To be even more specific, I suggest that in the first few exercises you use Winsor blue or Thalo blue, Indian yellow, or new gamboge, and vermilion. They are all relatively clean colors, that is, they produce a crisp transparent wash without any noticeable degree of sedimentation. But don't think that I am implying that sedimentation is an undesirable characteristic. Far from it, in many cases it gives a delightful effect. But in the beginning, it's better to grasp the basic procedure before contending with an extra element of difficulty.

Most watercolor painters are aware that it is possible to paint one wash over another. The big question is how many washes can you successfully overpaint? The next question might be, why should you want to? To answer the first question, it is possible to paint many layers of wash without destroying the natural charm of watercolor. I define natural charm as being a fresh crispness combined with a clean transparent glow. In some cases I have washed in as many as twenty layers without destroying the crispness or clarity of the passage of color. In that extreme example the secret lies in applying each wash in the proper sequence to a thoroughly dry sheet of paper. Now why should you want to do this? I think the answer will vary for each artist who uses this technique. It is similar to asking why anyone does anything that is the least bit inconvenient. Why do some of us go to the trouble? We like the rewards. *Learning to control watercolor through glazing gives you, the artist, more command over the execution of the painting. By using layers you can produce shades and subtle nuances of color that are impossible to duplicate in any other way.* That is only a part of the story. Properly applied, layers of washes produce a characteristic glow that can't be achieved by any other means. You recall the comparison of watercolor to the stained glass window? Well, transparent watercolor has the natural tendency to give the effect of producing a glow from within. In this glazing technique you are merely taking advantage of and intensifying this natural tendency. Many painters from the past have achieved a remarkable state of luminosity in their watercolors. J.M.W. Turner, the noted British painter, is probably one of the greatest masters of this approach. As you continue to work with glazes you will find that pigments applied in glazes have more luminosity than the same pigments mixed and applied in a single wash. In fact, you will find that the pale washes on your palette, when properly applied, can have the force of dynamite in a painting. Finally, there are some other advantages to utilizing the glazing technique. As the artist you are in control of the situation. You make the decision about the amount of glazing you wish to employ in any given situation. You may elect to glaze only the sky, or you may use the approach to enhance only the center of interest. Perhaps you may decide to develop the entire painting in this manner. Whatever the case, glazing will work for you.

STARTING TO PAINT

I want to begin with very simple but informative exercises. For this first demonstration the colors are Indian yellow, Winsor blue, and Winsor red. These colors reflect a basic primary arrangement which is a part of the expanded primary system I use. As you review the selection of color, you will see the vast potential for creating diverse colors for a few primaries. I encourage you to experiment with all of the colors listed by combining various yellows with various reds and blues. Some of these combinations may not please you, but others will delight you. Allow yourself to be curious about color. Take the time to explore the possibilities. You'll be glad you did. For future reference I also suggest that you make notes on your color charts so that you will be able to remember some of the recipes. As we begin the exercises, you'll need to follow the few important ground rules listed below:

1. Develop your glazes from transparent watercolors only.
2. Begin with your lightest pigment, usually a yellow.
3. Keep your washes diluted and transparent.
4. Make sure, absolutely sure, that all previous washes are completely dry before a new wash or glaze is applied.
5. Use the most opaque paints toward the final stages of your painting. Using them in the initial stages runs the risk of creating mud or chalky washes.

Take a piece of watercolor paper and your 1″ Aquarelle brush. Then mix up a wash of each of the three colors in separate containers. Make up enough to complete several washes. These washes should be equal to a 30 percent tone.

The glazing technique

In this first exercise, we will be exploring what happens when simple washes of primary colors in varying strengths are placed over a single pale stripe of Indian yellow.

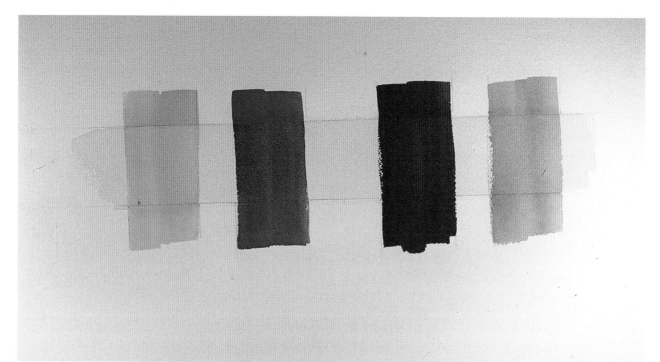

Take your brush and dip it into a pale wash of Indian yellow. Paint a strip of Indian yellow down the sheet for about 4" or so. Let the wash dry thoroughly.

After the Indian yellow has dried, lay two intersecting washes of Winsor red, one as a pale tint, one as a heavier wash. Clean out your brush and repeat the step this time using the Winsor blue. Follow the same procedure with one pale tint and one heavier wash. Let all washes dry.

When all the passages are dry examine them. Don't be overly alarmed if you don't see any dramatic or drastic color changes or contrasts. This is a very subtle method of coloration. You can apply several layers of the same thin or pale wash and each wash will darken and strengthen the passage of color. The effect of the layers of wash is cumulative. Look very closely at your painted swatches. This simple exercise gives you an opportunity to compare a single wash to a multiple wash. Now look at the red and blue washes. On the left and the right of the yellow strip you have a single wash on a white support. In the center you have a red and blue wash on a yellow underpainting on a white support. Even under the darkest red and blue wash, you will notice a difference in the appearance of the color. The red is richer and the blue tends to have a greenish cast. You should also notice that the pale tints show a greater or more abrupt change than the heavier washes.

As you experiment you will also note that the transparent colors work better than the opaque colors. But even the more opaque pigments can be used in this process. You must exercise caution and plan their use carefully. Save them for the latter part of the painting, unless you are trying to achieve a special effect.

In our second simple exercise we are going to explore the cumulative effect of transparent washes. Again, the colors are Indian yellow, Winsor red, and Winsor blue. Let's begin with yellow.

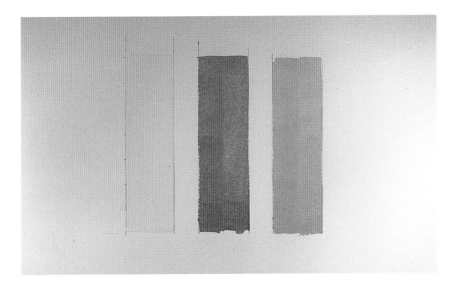

STEP 1 With your Aquarelle, lay in other strip of wash approximately 7" long. While this is drying lay a strip of red the same length next to but not touching the yellow. Finally lay in a strip of blue.

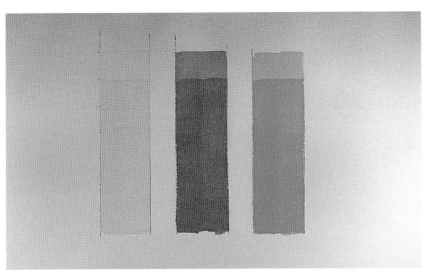

STEP 2 When each strip is dry, apply another layer of the same wash, yellow on yellow, red on red, blue on blue. This time make a strip 6" long.

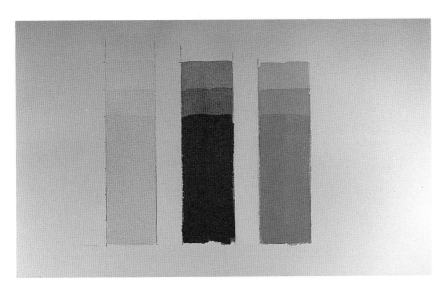

STEP 3 After the preceding wash is dry, repeat the second step again but this time make the strips only 5" long.

The glazing technique

STEP 4 Make each strip of color 4"
long.

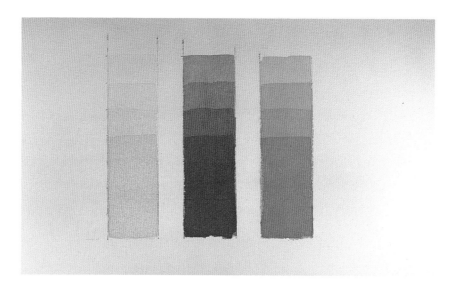

STEP 5 Make each strip of color 3"
long.

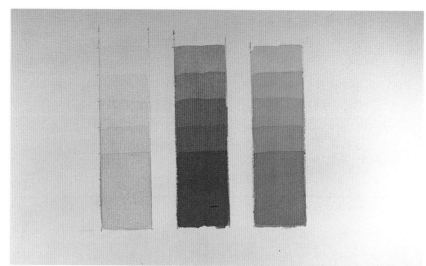

STEP 6 Make each strip of color 2"
long.

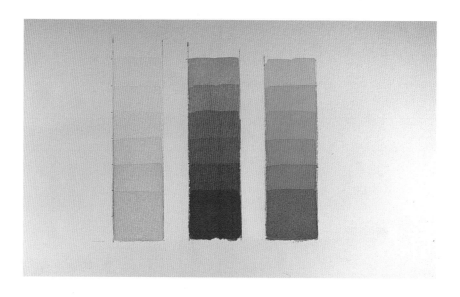

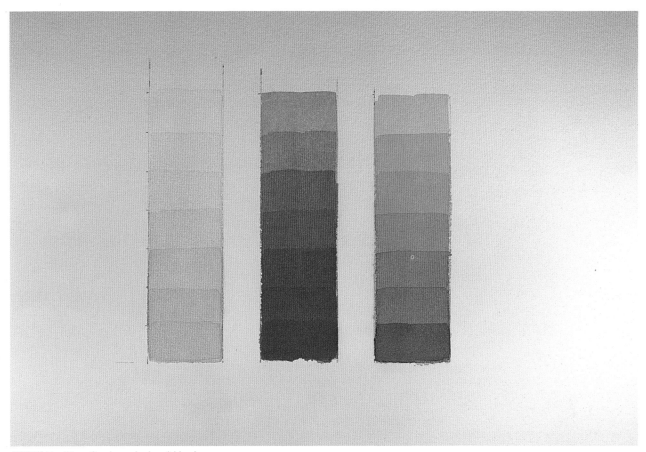

STEP 7 *Your final result should look like the example above. You should have seven steps of value for each color.*

This exercise should clearly demonstrate to you the power of successive washes. As the artist you are free to carry the process as far as you like. You will find it possible to carefully model values and shadow passages with subtle gradations of wash. In this manner you have another effective mode of expression to add to your storehouse of knowledge.

I do want to emphasize that it is possible to overdo this method of painting. You will soon learn that an economy of means is usually more productive. However, there will be times when you will find it desirable to place many washes in a given area in order to achieve a certain effect. If you will allow each wash to dry completely before you introduce another wash, you will find the prospect for success to be good.

Up to this point the approach has been rather mechanical. I feel that this is necessary so that your results will be predictable and that you have some degree of control over the process. As quickly as possible you should absorb the information you have learned in these quick exercises. The better you understand what is happening here the faster you will progress. These exercises may seem unimportant in relation to getting on with "real" painting, but don't let the basic ways in which this medium behaves slip away from you. Many of the decisions you will make later will depend on this invaluable information.

At this stage you have been through a few simple exercises designed to help you understand effective glazing methods. Now we are going to move into a few simple painting projects to further demonstrate some of the versatility of glazing.

PRELIMINARY PAINTING EXERCISES

By this time, you should be mixing your color on your palette. (Don't forget about the mixing cups, however, there may be times when you will find them helpful.) Palettes were touched upon only briefly in the materials section because most palettes work well. In recent years I have switched to the John Pike plastic palette, but enameled butcher trays are also good. Just make sure that your palette allows you plenty of mixing room. For the first fifteen years of my painting career, I used a plastic dinner dish from the 1950s; it was one of the best palettes I ever had.

The following paintings of apples are obviously very simple, but each one is designed to help further your understanding about the glazing technique. The first phase demonstrates the "correct" method of applying the lightest colors first, followed by the darker values. The second phase alters the sequence of the washes: a lighter color is sandwiched between two darker colors. The third phase uses the same colors but reverses the color order.

Everyone is familiar with the apple, a common object that is readily available. The following three exercises were chosen to show you that you can exert as much control over tonality as you wish. Whether you paint loosely or more realistically, the approach will work. You have the freedom to choose your route.

PHASE ONE

In the first operation you will build the study from light to dark. Many people feel that this is the correct way to paint transparent watercolor because it almost always insures good results. Also, when painting from light to dark, you have the opportunity to modify and refine previous passages of color with a stronger wash of color. The painting is created by developing it in successive stages of color. In some cases, the same wash of the same value is repeated; in other cases, the wash is either strengthened or changed.

STEP 1 Lightly sketch in the apple. You can omit this step if you feel confident enough to lay the first wash without any guidelines.

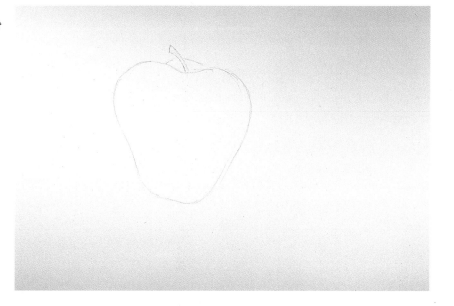

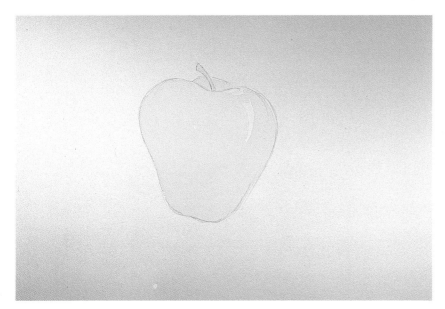

STEP 2 Apply a simple flat wash of Indian yellow. Except to follow the contour of the apple, note that the wash is laid in very evenly without any harsh or abrupt edges. Cover the drawing fully and carefully with this first wash; these first few washes will set the mood for the whole painting. Although this is a rather tight rendition, try to strive for a controlled looseness in all of your washes. Remember, in this medium every stroke and every layer of wash leaves their mark.

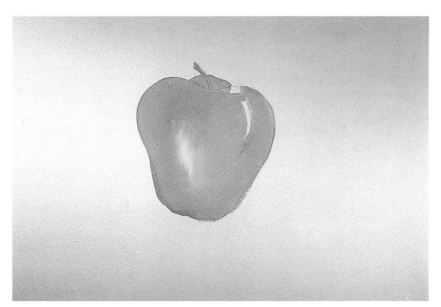

STEP 3 Make sure the paper is bone dry before you apply the next wash. You can test for dryness with your hand—if the sheet is cool, the paper is still wet. Once you feel confident that the paper is dry, dampen it with clear water and lay in a wash of Winsor red. The wet into wet effect magically suggests the beginning of form in the apple.

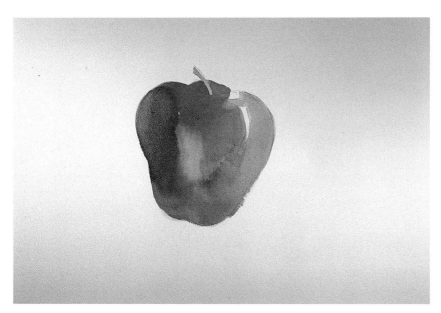

STEP 4 Wait again until the paper is completely dry and apply another wash of Winsor red, keeping it at the same intensity as the first red wash. Look closely at the left side of the apple. Note that the wash is diluted in that area, an effect that helps to heighten the illusion of form. I discovered this technique one day when the color in my brush ran out. Instead of dipping it back in the paint, I diluted a portion of the wash with water. So in this case, a simple accident led to discovery instead of disaster.

The glazing technique

STEP 5 In this step an added feature is introduced—a color square with the step number under it. It's meant to help you by indicating just what shade of color I am applying to the painting.

 At this stage, the apple is beginning to come to life as another layer of red wash is applied. Two changes occur here. First, a very small amount of Winsor blue is mixed into the Winsor red. This is done in order to intensify the red and to come closer to the true color of my model. Second, only a portion of the apple is painted. Once more you should rely on color to develop the form of the apple, so that you feel as though you are painting and not merely applying color to a shape. Finally, note that the top highlight has been colored in with the last red wash.

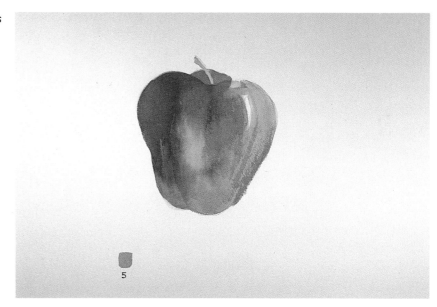

STEP 6 In the final stages begin to apply darker tones of color toward the sides of the apple. Here, as in step 5, use a brush loaded with clear water to feather the edges of a heavy stroke. With this technique, you will combine the soft or blended edge characteristic of the wet into wet technique with the strength of a direct wash. The final result is a wash with one definite edge and the other edge softly blended or feathered.

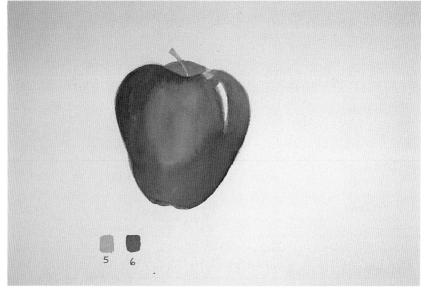

STEP 7 This is the time to add some of the darkest tones, mainly in the areas of the stem and on the sides of the apple. Use various kinds of brushstrokes to suggest texture and variety in the skin of the apple.

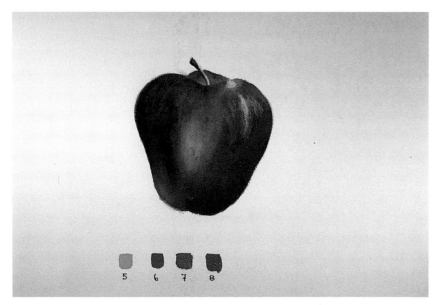

STEP 8 To further develop the tonality of the apple, apply another wash of Winsor red. Remember that successive washes of the same color tend to darken the overall tonality of the passage. By darkening the shadow values, you can make the highlights and middletone values appear more distinct because of the contrast.

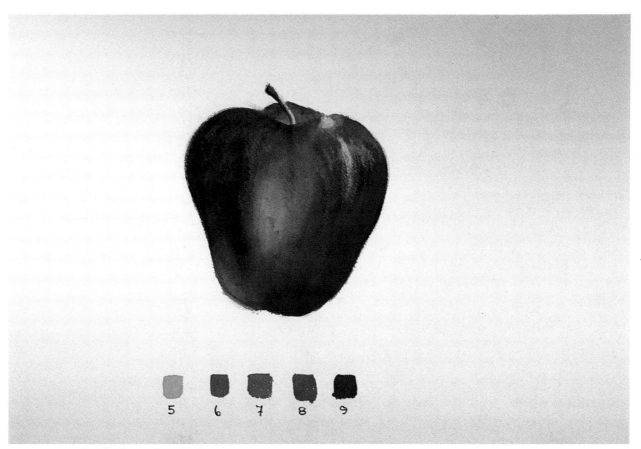

STEP 9 Apply a final overall wash of Winsor red and Winsor blue that is considerably stronger than the previous washes. For the shadow areas, use a darker, cooler wash to adjust the values.

 The apple was painted in the strict manner of applying succeeding washes of at least equal if not darker value. The result is a transparent glow.

The glazing technique

PHASE TWO

In this exercise, you will paint the same apple with the same colors. However, the order or sequence of colors is reversed. This time "correct" procedure will be altered slightly.

STEP 1 Sketch in the same apple as your model.

STEP 2 Wet the entire sketch with a uniform wash of clear water. Make sure that the entire drawing is uniformly damp or unexpected dry spots may show up suddenly as you apply the wash. Then with a dilute wash of Winsor blue, lay in the first preliminary wash, planning your strokes to imitate the basic form of the apple. Since this is pure wet into wet technique, don't try to control the washes except by the general pattern of the strokes. As the wash dries, note that it takes on a very soft, subtle appearance. This effect will be very beneficial in the later stages because it convincingly conveys the feeling of mass and form.

STEP 3 In many ways this step is a continuation of step 2. Its purpose is to help you see the initial wash. At this stage, it may be helpful for you to create your underpaintings in two or three phases. As you gain experience and confidence, you can condense these stages into one or two operations. So at the end of step 3, your apple should look very much like the example. You should have a fairly well-finished monochromatic painting. Experience tells me to refrain from carrying the shadow values to a very deep state. Right now they are just a little lighter than they should be in the finished piece, so that in the final washes, blue tones will not overpower the red tones.

STEP 4 In this step a traditional rule of watercolor is broken: lighter wash is applied over a darker one. Normally, this will produce an opaque effect. But you can avoid this effect here by using a very transparent light wash. In this case, apply a wash of Indian yellow and allow it to flow over the entire piece including the shadow and highlight areas.

STEP 5 At this stage, you need to refer back to the color bar. It will inform you about the correct strength of Winsor red wash that you'll need. You might find it helpful to paint a few small swatches of color and let them dry before comparing them with the color bar. This way you will know just how strong to make your wash. As you apply the wash, study its effect. Suddenly, the apple comes to life. Notice how the blue underpainting suggests the pattern of the apple's skin and that the secondary highlights are becoming apparent in the middle area of the apple.

STEP 6 Apply an additional wash of Winsor red. At this stage the primary objective is to increase the red tones of the apple without destroying the effect of various middletone values and reflected lights that have been developed in the underpainting. In order to accomplish this, dilute the red wash with clear water in the middle area of the apple where the Indian yellow shows through.

The glazing technique

STEP 7 Add a very slight amount of Winsor blue to the red wash in order to make the red tones more intense and cool. Concentrate the color over the shadow areas and make the wash more dilute near the highlights.

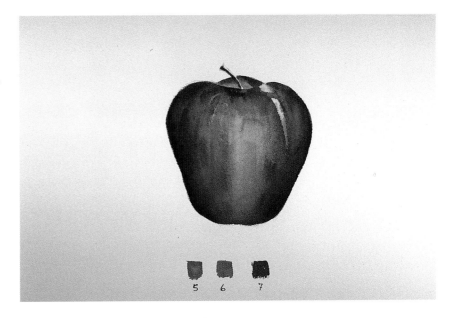

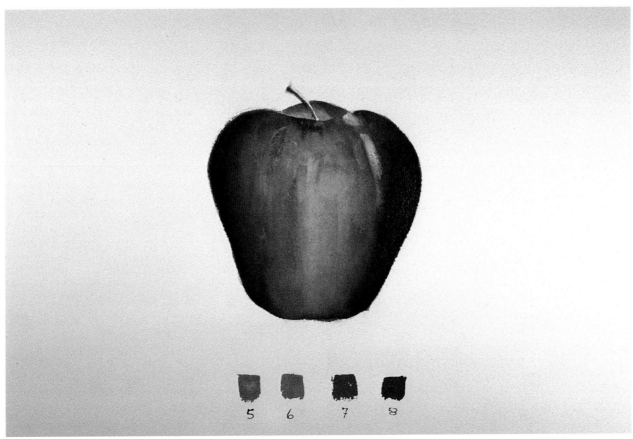

STEP 8 Apply the final wash, which is the strongest red of all. Now the color values progress in a steady, convincing relationship. At this stage stop or continue to define detail.

PHASE THREE

This is the final phase of this exercise. Here the same colors are used once more, but in a different sequence from the first two phases.

STEP 1 *Start with a pencil sketch or paint in the basic contour of the apple without a guideline.*

STEP 2 *Apply a diluted wash of Winsor red to a thoroughly dampened drawing. Note the soft edges at the center of the apple created by the wet into wet effect. Once the paper is completely dry, apply a second wash of Winsor red. (Although at this stage the apple has more the look of a ripe tomato, be confident that this bright tone will change.) Dampen the center of the apple with clear water to preserve the wet into wet look of the first wash. As the second wash is applied, it will naturally flow in toward the center, imitating the effect of the previous wash.*

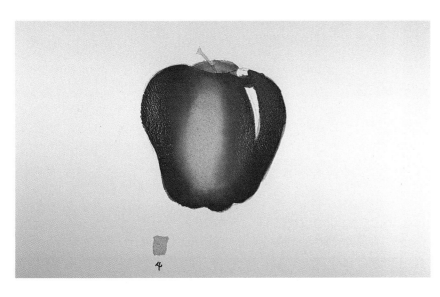

STEP 3 *Apply a wash of Indian yellow to thoroughly dry paper. Note the strength of the color by examining the color bar at bottom.*

The glazing technique

STEP 4 Introduce Winsor blue to the sequence of color.

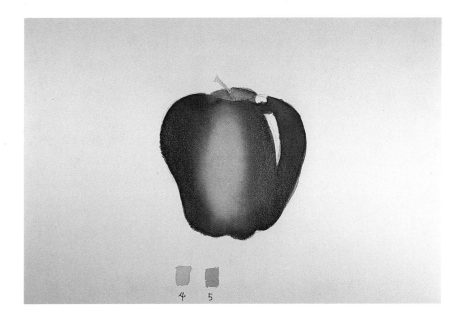

STEP 5 Add a little more blue mixed with a slight touch of Winsor red. Note that in this phase, the tones of the apple are different from the first two exercises.

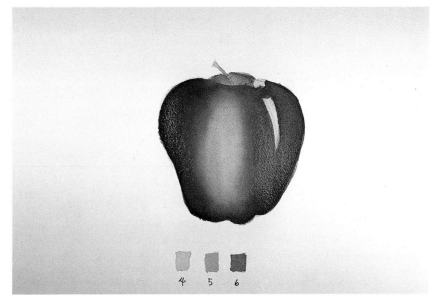

STEP 6 I continue to add even stronger washes at this stage. The color is a combination of Winsor red and Winsor blue. The intention here is to continue to suggest the development of form. The darker wash only helps to emphasize how different this apple is in appearance.

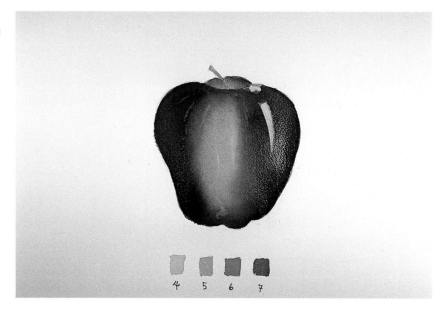

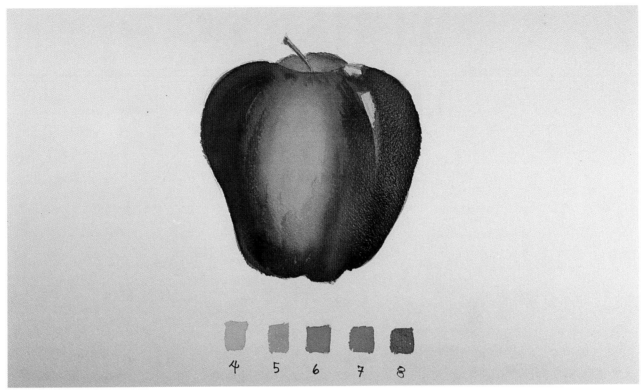

STEP 7 This is the final attempt to strengthen the form of the apple. While this mixture of Winsor red and Winsor blue definitely establishes the shadow values on the apple, it doesn't do much for traditional apple color. Note that although I have balanced the contrasts to suggest the form of the apple, the color value has been drastically altered.

Different colorations occur when you alter the color order of your washes. These apples all have a different appearance even though only the color sequence was changed. Remember, you are applying layers of color over white. Each layer influences the layer above it. In some cases the first layer of color will dominate the final color. In other cases this effect will not be as apparent. In phase one yellow was the first color down; it had the effect of warming up the red and making it a bit more lively. After the yellow came the blue, and then the final washes were in the red family. The final result: a red apple with warm undertones.

Phase two uses the same colors (examine the color bars) as phase one, but this time the staining value of Winsor blue was used to advantage to execute a detailed underpainting. This underpainting was then modeled with washes of yellow and finally red. Note the character of the finished apple. It somehow seems to have more weight than the phase one apple. I attribute this to the effect of the blue underpainting, which is exerting a lot of influence on the final color.

The final result is a harmony of all of the colors used.

Phase three is a clear demonstration that underglazes don't always dominate the final color. You have to give the reds credit though; they are trying to come through. But the Winsor blue is just too powerful to take a back seat to the red and yellow underglazes.

The conclusion drawn from these exercises should be obvious. The order in which you apply color has a direct impact on the final color achieved.

ASSIGNMENT
Follow the basic progressions in these exercises, using other combinations of red, blue, and yellow as listed on the chart on pages 22-23. Compare your experiences with these colors to my notations. Observe the changes in colors and any unexpected changes. Take notes and compare the results from color combination to color combination. After you make these observations, choose some of your own favorite colors. Experiment with them and note any variations.

WORKING METHODS

The preceding exercises were designed to introduce you to the basic procedures of painting with the glazing technique. The following exercises are arranged to go from simple to more complex tasks. They are meant to give you an idea of my working methods. Study each demonstration, then try it for yourself. Keep your studies small at first; you will have enough to concern yourself with without the added problems of handling a large area. Concentrate on understanding the motive behind each step. After you have mastered each exercise, try to incorporate these methods into your own personal work. For example, you may want to use some of your favorite subjects as models and paint them again in light of what you have learned from these exercises. Although my approach is not the only way to paint, it is a method based upon years of experience. My hope is that it will save you time and effort if you follow my procedures at first. Then, as you begin to understand the way paint works, create your own variations in order to make the material a part of your personal painting experience. Examine the washes closely and be very watchful for subtle variations of color.

As you tackle these demonstrations, keep in mind that it is absolutely vital that you really think about what you are doing. Many a painting is ruined *before* it's begun because the artist failed to focus his/her thoughts on the challenge at hand. So before you begin to paint you must learn to ask yourself some basic questions. Stop and analyze the subject; determine what it is that you want to show and what you want to say in this work. Decide upon a center of interest, then consider what should be played up and what should be omitted. Think about your mood. How does the scene make *you* feel; is it happy, sad, somber, thoughtful? Respond to your emotions.

Finally, technical mastery of a medium is always an advantage. You will need it to skillfully handle pigment and water on paper. However, don't let technical achievement become your master. A slick technique won't cover up a lack of conviction. You are a unique individual, not quite like anyone else on earth. Aside from a certain degree of necessary talent, daring to be yourself is the only chance for success that you have as a painter.

SEA MIST

This is a very simple exercise. You will not need a great deal of preparation or materials. The actual piece is very small, approximately 8″ × 7″ (20.3 × 17.7 cm). Most of the work was accomplished with a 1″ Grumbacher Aquarelle flat brush. The finishing stages of the boat were done with a Series 7 Winsor & Newton round size 6. Examine the stages of color. Each layer is a little darker than the preceding wash. Notice how the pale washes accumulate to create a color that is stronger than you would ordinarily expect.

Begin the exercise with a brush. If it makes you feel more comfortable, lightly pencil in the boat before you start.

STEP 1 Lay a wash of new gamboge in a rectangle approximately 8″ × 7″. Don't try to make the wash smooth and even. Notice how the color gets less intense toward the bottom. A little clear water was added to the brush as it neared the bottom of the paper, which allowed for some variation in the strength of the wash. The water thins out the remaining color in the brush, so from the very first layer of wash a degree of contrast is established between sky and water.

STEP 2 As soon as the paper is dry, add another layer of color—a very pale wash of Winsor red. Look at the number 2 color bar in order to determine the strength of this wash. Apply this layer rather flatly with very little variation in the strength of the wash from one end of the work to the other, except at the bottom where the wash is feathered with clear water to produce a very weak tint of red. Examine this step very closely and notice the way the paint evokes certain images. It doesn't take a great deal of imagination to see a possible horizon appearing in the upper one third of the painting. With this thought in mind, you can almost see water in the foreground.

STEP 3 When the paper has dried again, apply a blue wash very evenly over the previous layers of color. Notice how the blue is clearly visible in some areas but blends in with other layers to create new colors. This is a part of the beauty of glazing. Think about how each step has contributed so far to the building of a painting.

Working methods

STEP 4 Once more the paper must be completely dry. Then dampen the center portion of the paper along the horizon, using an Aquarelle brush, lay in a mixture of Winsor red and Winsor blue. Allow this wash to dry naturally and watch for any large puddles that might form on the paper. As this passage dries, it becomes evident that the wet into wet technique is the perfect solution for creating a hazy atmospheric effect. Notice, too, that the wet into wet technique works predictably well over the previous passages of color. As this passage of color dries, in order to apply a little extra color, it may be necessary to gently touch the tip of your brush into select spots of the damp wash. A wet into wet wash tends to lose a great deal of intensity because so much water is present. Adding color to the passage can be tricky, however. Only add color while the passage is still visibly damp. Also make sure that your brush contains a strong solution of wash and not a great deal of water.

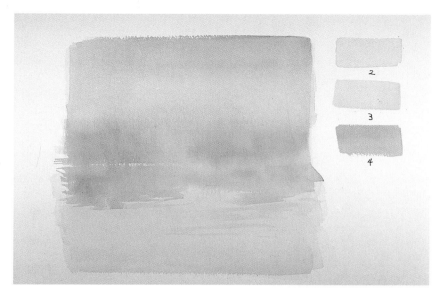

STEP 5 When the paper is thoroughly dry, paint in the boat with a Series 7 Winsor & Newton brush. Examine the color bar for this step. Notice that the boat is comprises only a few shapes.

Congratulations! You have just finished your first seascape using the glazing technique. As you study my example and your own work, it should become very obvious that by merely shifting the strength of the red or blue passages of color you can create an entirely different mood in the painting. It would be a very good idea for you to try this exercise again and select one color, say the blue, and increase its strength by about 20 percent. Then you might want to paint the scene again for the third time and increase the red or the yellow. Layer the washes in the same sequence, merely altering their strength. These variations are fascinating and it all comes from just three colors.

COUNTRY LANDSCAPE

This exercise applies the glazing technique to a landscape. Obviously, it makes no difference whether you are painting a landscape, a seascape, or a still life, the principle is always the same, but in order for you to truly believe this, it is necessary for you to really see it.

In both of the following, everything is kept very simple without any complicated areas of wash. In both exercises you need to build color upon color without reserving any white paper. In this manner you can focus your attention upon the layering process without worrying about composition or difficult passages.

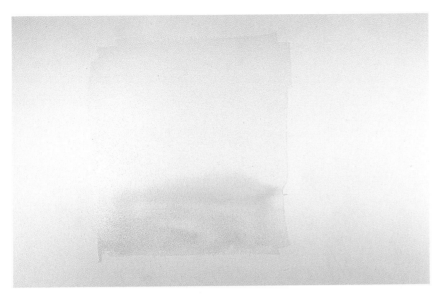

STEP 1 *Begin with a wash of new gamboge approximately 8" × 7". Dilute the wash as you paint toward the horizon. At the horizon add additional color to the brush. Think of this as an essentially yellow landscape, complete with yellow sky and yellow foreground.*

STEP 2 *As soon as the paper is dry, paint in a mixture of Winsor red with a slight trace of new gamboge mixed in. For this landscape, you are building toward a golden reddish glow.*

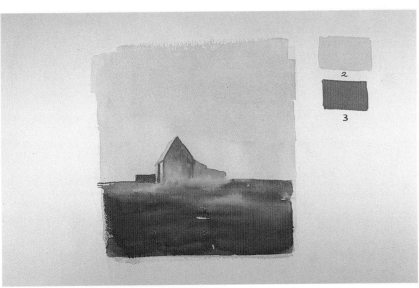

STEP 3 *Paint in a strong neutral color composed of Winsor blue, Winsor red, and new gamboge. Examine the color bar 3 and compare that color to the wash in the painting. The previous washes have set a stage for this neutral brown. Load a 1½" sable flat with wash 3 and keep it on the palette ready for use. Then, take a Winsor & Newton Series 7, size 6, and load it with clear water. Apply the water to the shape of the barn in the large shadow side facing the foreground and into this dampened area, introduce the wash. The water will dilute the strength of the color. While this is still wet, pick up the large sable flat and apply the wash full strength to the dry foreground. You can see where the color merged at the base of the barn, which gives that area a nice atmospheric effect. While all of this is drying, dilute the wash even further and apply it to the roof area.*

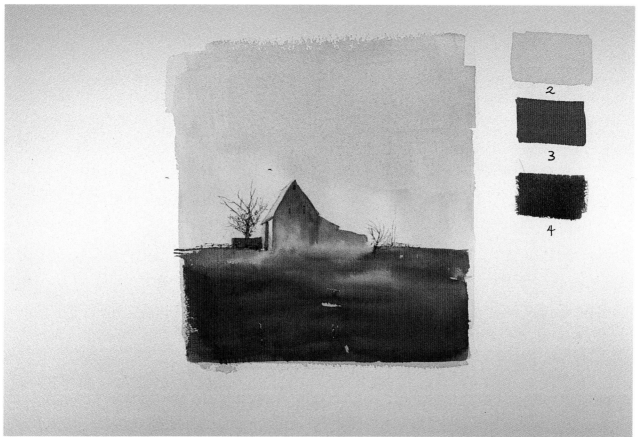

STEP 4 The same basic neutral is used here except that more Winsor blue has been added. Note the tree on the left side of the barn. It is composed of a combination of the neutral wash from step 3 and the same wash with the additional amount of blue. The consequent contrast of limbs helps to provide depth to the tree. The trees were painted in with a fine sable round and a no. 4 rigger.

Now you have successfully completed two very simple exercises using the glazing technique, and no doubt are developing a basic understanding about the possibilities inherent in glazing—a technique that allows you almost unlimited freedom of expression. For now, however, acquaint yourself with basic procedures.

THE MUD FLATS

This exercise is a bit more complex. Set up your palette with new gamboge, Winsor red, and Winsor blue. The brushes needed will be 3″ and 1″ squared-edge brush, and sizes 6 and 4 red sable rounds. Lay in the first wash with the largest square-edged brush you have.

STEP 1 Develop a simple sketch to lo-
cate the elements involved in the draw-
ing. Each line you draw is a personal
shorthand to tell you where to stop or be-
gin a wash.

STEP 2 Notice the configuration of the
wash—a diluted new gamboge. At the
uppermost section of the sky the wash is
very pale, yet it gains strength as it comes
toward the horizon. Then the color gets
most intense in the foreground. You are
building up to the golden glow of the final
image. To achieve the soft effect shown
here wet the entire sketch with clear wa-
ter. Make sure that all areas are wet and
flow in the new gamboge, taking care
that no unsightly harsh or broken edges
are left. Lay the wash in with the general
shapes of the landscape, allowing it to
flow freely. As the wash begins to dry,
add additional color to the foreground.
Use your largest bristle square-edged
brush for this stage.

STEP 3 When the paper is bone dry,
prepare the blue wash. Look at the color
bar marked 3 for an indication of the
color mixture—a combination of Winsor
blue and a slight amount of Winsor red.

45

Working methods

STEP 4 The painting is now starting to take shape. Sometimes it takes a great deal of faith to see one of these pieces through the first few stages, which is one of the strongest reasons for having a clear-cut image in your mind of exactly what you want to achieve. It never hurts to have a good sketch, too. As you study the horizon, notice some slight variation in the color. In those areas, merely dilute the color just a little to give the effect of atmospheric perspective. At this stage use a 1" Aquarelle flat brush.

STEP 5 From this step forward, begin to add detail and refine the existing masses. Aside from adding essential darks, there should be no radical changes in the lighting and mood of the watercolor. Pay close attention to the colors used thus far. In reality they are very closely related to one another. It is by the careful manipulation of these washes that a definite mood has been set.

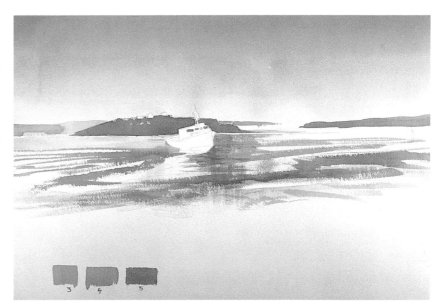

STEP 6 Look at the color bar for this step. Note that it is related to all of the preceding colors. At this stage you are merely increasing the contrast in the island and the beach. Remember, these colors are in close harmony because of the nature of the scene. The light is falling fast as the sun goes down and all of the colors are beginning to merge into a monochromatic scale. The mud in the middleground is wet and reflects the sky like a mirror.

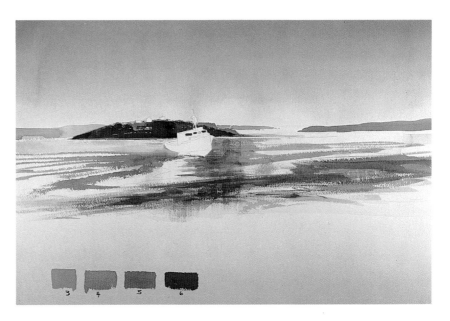

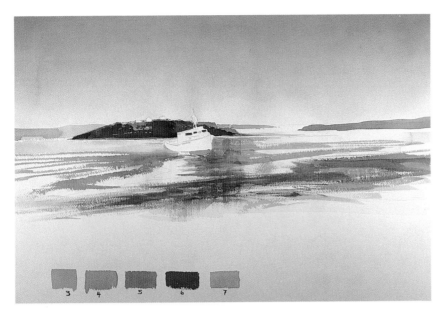

STEP 7 After you allow the paper to dry, it's now time for some striking contrast. Apply a dilute wash of Winsor red as contrast to the bottom of the boat hull. While this wash is drying use the same wash under the boat for reflected color. In a final sweep, pull some of this wash through the foreground.

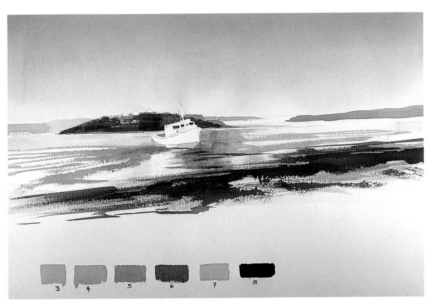

STEP 8 While the previous wash is drying, begin to consider the additional contrast needed in the work in order to convey the mood you want. Being careful to avoid disturbing the damp areas, begin applying the darkest values of the painting. These areas of application are readily apparent and help to define the painting. In the foreground area, allow the brush to skip along the paper rather quickly in order to create texture. In the areas where the brushstrokes are less quick, the wash is more even.

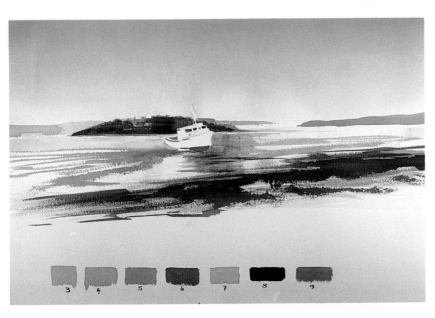

STEP 9 The last color bar to be shown is washed in upon the hull of the boat and in some surrounding reflections. Once more, remember to wait until the painting is completely dry before applying this last wash. At this stage, change to Winsor & Newton Series 7 round sizes 6 and 4.

Working methods

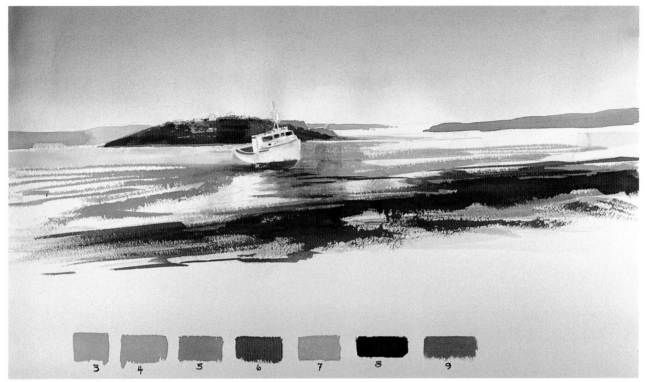

FINISHING TOUCHES This is the final stage of the work. The mood has been set and this segment consists of refining and detailing. Probably most of your attention should be focused on the boat. Most of the changes or developments here are obvious: the darkest shadow areas are mixtures of color from step 6 and step 9; the result is a very dark red. Use this strong color sparingly. Notice that the darks that are applied under and to the left side of the boat. A darker mixture of red and blue is used to define the windows in the cockpit.

Study each step of this demonstration, noting how the first two overall washes help set the mood for the entire painting. These washes were applied with a large brush. Working with a large brush is not only easier, it helps give a unity to the work; there are no fragmented washes shouting for attention. This painting creates a quiet mood, the effect of a sundown on a desolate beach, with nothing but the light, the boat, and the water for companions. In order to create this mood effectively, you need to analyze what is happening in the scene before you. Since this scene reveals a quiet time, the washes are laid in on a damp sheet to insure that the edges are soft and that the colors blend together in a very subtle relationship. Remember that it is not always advisable to lay washes in so flat a manner that it looks like you are painting a house. The yellow wash (step 1) and the blue wash (step 2) are dissimilar in coverage. Where one is strong, the other is light. If you clearly observe nature, you will notice very subtle and sometimes very striking differences in sky colors. Notice that the sky wash of blue is stronger at the top of the piece and begins to dilute as it comes toward the horizon. Once the blue passes the horizon and moves into the middleground and foreground, it gets lighter. This graduation of color toward the horizon is done to achieve the effect of depth.

As I have said earlier, the shades of color were chosen for their harmonious relationship to one another. The beauty of using the primaries lies in the fact that you can shift the color predominance by merely intensifying either the red, blue, or the yellow.

One final word: the proper use of brushes is very important in this technique. Do not attempt to paint these steps with only a small watercolor round. To do so would be the height of futility. If you don't have a large brush and for some reason you can't get one, you might try using a sponge. This actual painting measures about 20″ × 9″ and yet the first three steps were executed with a 3″ square-edged bristle brush. Steps 4 through 8 were accomplished with a 1″ Aquarelle watercolor brush. When I started on step 9, I started using Series 7 red sable rounds. Avoid using tiny brushes before the painting is adequately developed. To ignore this point is to severely handicap your progress as a painter. Using smaller brushes at the wrong time in a watercolor only sets you up for mediocrity at best. At worst it sets you up for disaster.

UNDERSTANDING NEUTRALS

Now you have had an opportunity to explore glazing in a few simple exercises. In the first exercises, primary colors were used in a nearly pure state to create blended color. In the last exercise (*The Mud Flats*) the colors were blended and modified on the palette in order to depict the mood of the scene. Both approaches can be used in a very powerful manner to create strong paintings. In each case I have suggested the use of transparent colors that closely approximate the pure process colors of cyan, magenta, and yellow. Please note the word "approximate." If you have painted for any length of time, you no doubt have had occasions when color theory didn't line up with the results you got. There were times when red and blue gave you brown mud instead of violet. In order to prevent such nasty surprises, you have to learn to look past the label on the tube and compare the pigment with actual hue. One way to begin to understand the way in which color works is to start with the primaries. The first exercises were concerned only with primaries, because we can more or less trust the way primaries behave. However, an important characteristic of primaries is that if primaries are mixed or layered over a third primary, the resulting color tends to be a neutral.

So far, I have chosen exercises that demonstrate that layering primaries results in blended color. In this section, the primaries' tendency to create neutrals will be explored. The subject will certainly not be exhausted because that would require more pages than this book contains. If you are mathematically inclined, you can sit down and figure the odds of

variation on just the primaries alone. If you then add every possible variation involved with every color on the palette, you will find it to be a very involved task. If my reasoning is correct, there should be a possibility of creating at least one thousand different shades of neutrals from the primaries, provided you limited the variations to 10 percent increments for each color used. For example, one neutral would be mixed from 10 percent yellow, 100 percent magenta, and 100 percent cyan.

If you look closely at nature, you'll soon see that the landscape is made up of many neutral colors.

These samples are typical neutral colors mixed from varying strengths of Indian yellow, Winsor red, and Winsor blue. Notice how increasing the strength of just one of the color elements causes a variation in the color. These washes were produced wet into wet on the paper.

Understanding neutrals

These neutrals blend in and adapt themselves so well to our surroundings that we tend to overlook them at a casual glance. However, the painter's eye should begin to discern them at a very early stage of study. In many cases painters are too busy painting traditional ideas about color instead of interpreting color for themselves. For example, I have had students absent-mindedly splashing a blue wash upon a painting when there was not even the slightest hint of blue in the sky on that day. Certainly the artist has the right to modify nature when painting, but in this case the painter's defense was that skies were supposed to be blue. This student was bending to symbolically held viewpoints instead of seeing the world in its true color. In order to learn you must strive to really see what is before you.

GOOCH GAP

Gooch Gap is a perfect example of a truly neutral painting. I think of this piece as an exercise in abstract design. It was painted on the spot without a great deal of preliminary drawing. I didn't know how much time I would have to finish the piece without interruption, since I was working on staff for a watercolor workshop. It was one of those mornings on the Blue Ridge Parkway when everything was covered in clouds and no one could go out to paint on location. Visibility was approximately ten feet. I went inside a small cottage and closed the door. The light coming through the window began to intrigue me because it was like a white sheet had been draped across the

outside of the window and no detail of the landscape was visible. Concerned that the light might suddenly change, I began to work immediately without aid of preliminary drawing, my only concern the effect of light upon the window and the room. I tagged the painting as a pre-study for a larger painting. So far I have not returned to the subject, but when I do, I will have the experience of this on-the-spot study to aid me. In analyzing the work I feel that anything other than neutral color would diminish the effect of the light coming through the window. I wanted to capture the sheen of light glistening off woodwork in a low light situation. I am sure that a camera would have recorded this scene on a much darker note than my eyes did. The light area of the windowpanes is the pure white of the paper, as is the windowsill and the edge of the window. I reserved these whites from the very beginning, taking care to paint around them. The highlights in the ceiling were cooled down with a little cobalt blue. The rest of the color in the painting consists of new gamboge. My first wash was very pale. Winsor blue was my second wash and the final washes were Winsor red mixed with a slight amount of Winsor blue. Except for the coat hanger the entire painting was executed with a 1½" flat sable brush. Toward the end of the painting, I decided to give the work a slight red cast so I increased the intensity of the Winsor red in the final washes. During the final stages of the painting, I began to wonder about adding additional detail. Rather than jumping right in, I made a few sketches for future reference.

Initial sketch for Gooch Gap

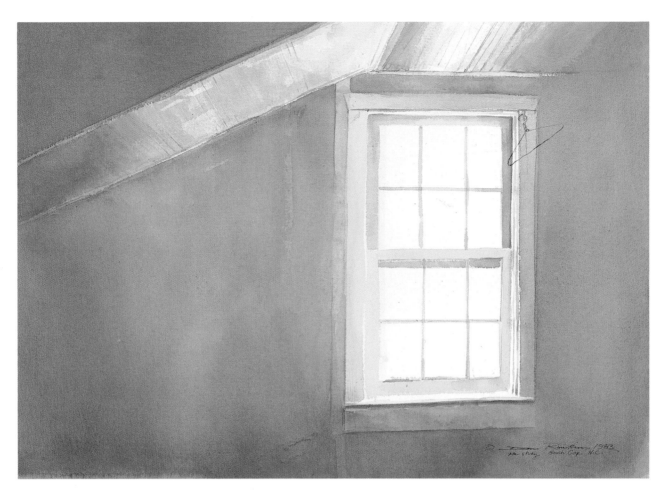

GOOCH GAP
19½″ × 14″ (49.53 × 35.56 cm)
Collection of the artist

1 The windowpane, windowsill, and doorjamb areas are not painted; they are merely the white of the paper.

2 These shadow areas are red-dominated, with new gamboge being the second most powerful color followed by Winsor blue.

3 After the painting was completed, a small amount of cerulean blue was washed in to cool some of the highlights in the shadow areas.

4 This shadow area is basically the same mix of colors that was used in area number 2. However, the strength of the Winsor blue has been increased.

5 A diluted mixture of Winsor red, new gamboge, and Winsor blue was used here to contrast with adjacent areas.

THE HORNET'S NEST

The Hornet's Nest is one of my first neutral paintings. In this particular case, I was totally captivated by the subtle colors that had been mingled and woven by a group of chewing insects. One of my students had given me the nest and I hung it in my studio. Early one February morning while looking at the nest I decided to attempt to capture it in watercolor. I was inspired and began immediately to paint. There were no preliminary drawings, nothing but a driving emotion to paint. As I began to work I calmed down and began to carefully analyze the work as I progressed. I had been carefully studying the color in the real nest for several months, and it was a challenge to attempt to capture its color on paper.

The entire painting was developed using new gamboge, Winsor blue, vermilion, and some Winsor red. The beginning washes were very pale. In fact, the first wash of new gamboge was so dilute that it was barely visible on the sheet. I wanted the warming influence of the yellow, but I didn't want the color to be easily identified in the painting. After the pale yellow wash was dry, I applied a dilute mixture of Winsor red and a small amount of vermilion. Again this wash was very dilute. If you look closely at some of the areas you can still see some of this wash down near the bottom where the nest is frayed. With careful observation you can discern the lighter layers of wash and you can see where darker washes are layered in order to create form. The darkest passages are very obvious and were added last. These washes are mixtures of Winsor blue and Winsor red.

The leaves were painted in two main layers. The first layer was a mixture heavy in new gamboge but tinted with vermilion. If you will look at the highlight of each leaf you will be able to see the base wash. After the first wash was completely dry, I painted the contrasting areas in with very direct strokes. While the contrasting section was still damp, I painted in a little mixture of Winsor blue and Winsor red to create the darkest part of the shadow. I did this while the paper was damp in order to get a softened edge. In this instance the base wash was completely dry and the shadow merely merged with the contrasting wash that had just been applied. The main thought in producing this painting was to capture those beautiful, yet subtle neutral colors. Once again this is a neutral color scheme using basically the same colors as *Gooch Gap*. The important consideration is that the colors were used in different proportions.

1 Shadow value comprised of Winsor blue and Winsor red followed by a layer of new gamboge.

2 Leaf colors composed of vermilion and new gamboge; Winsor blue was added to the mixture to create the shadow value.

3 This neutral is still dominated by Winsor blue; however, the new gamboge underwash is quite strong here.

4 In these sections vermilion and new gamboge are almost equal in strength, while the Winsor blue is very weak.

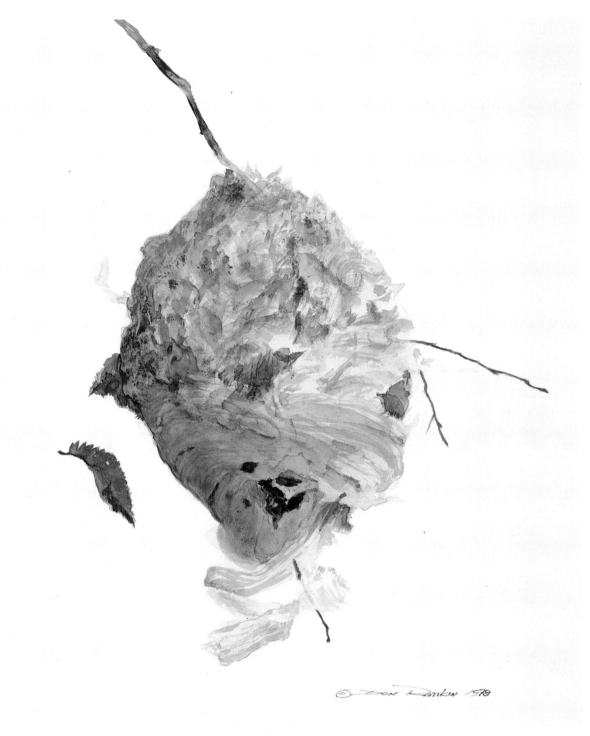

HORNET'S NEST
14″ × 16″ (35.56 × 40.64 cm)
Collection of the artist

OCTOBER

October was painted with the same palette as the two previous watercolors. It was executed on a rather large double elephant sheet, but the final work was matted to show a smaller portion of the original watercolor. The painting began to develop when I was exploring the grounds around an old Mennonite Church near Allentown, Pennsylvania. The basket had been left near a door in a small room on the end of the church. When I first saw it I was aware of the glow of sunlight upon the basket rim coupled with the angle of sunlight that was softly filtering into the room. I wanted a dark, yet sensitive painting. The last thing I wanted was for the darks to be opaque or dead. Fortunately, that condition can easily be avoided, if you know how. In this type of situation, merely applying umbers or similar darks would lead to a frustrating conclusion. To the uninitiated, beginning with a wash of strong new gamboge might sound absurd, yet that is the best approach. I wanted the warmth of a strong yellow, but I didn't want to destroy the beautiful patina of age that was on the basket. Therefore, the strongest yellows were applied in the deep shadow areas. In the first two applications of wash, the entire painting received dilute coats of new gamboge. After they had dried, I began mixing vermilion in dilute measure with new gamboge. If you study the door highlight near the center, you will see this shade of color. I was careful to wash the entire

Study this example very carefully, for in it are the secrets of the light in the finished painting. The white areas have been left for emphasis; but in the actual painting they were later modified with color. This first layer of wash sets the direction for the eventual pattern of light flow in the work.

painting with this wash. But there was one area of exception. Study the rim of the basket closely: in some areas I reserved the highlights of the rim by not allowing all of the washes to cover selected portions of the rim.

These first preliminary washes had helped to set the stage for the overall mood and the directional flow of the light. The sweep of the light and the sweep of the shadows were indicated from the very first wash. Then as subsequent washes were applied, they merely helped to reinforce what had already been done. I wanted the basket to melt into the background just as it had when I first encountered it. Consequently, I allowed the shadow side of the basket to melt into the shadows. The form of the rim tells you the basket is there even though you don't see all of it. It is important to understand that the shadow values in this work are extremely powerful. But with all of their power they are still transparent and lively. This is a situation where almost twenty washes were applied to achieve the full shadow effect. When dealing with extremely dark passages of color, some painters begin to experience difficulty. Some painters get the shadow color too thick and it looks dead; others get it too thin, and the shadows appear ineffective, weak, and washed out. It is very difficult to mix dark washes by swirling color on the palette. Try this approach: get a Styrofoam coffee cup or some other suitable container and place a small amount of each pigment you want to blend in the cup. Use a palette knife and mix the color with a little water. Watch the consistency as you don't want it to be too thick—you want it to be like an average wash. The objective here is to saturate the brush with all of the dark wash it can hold. When you mix in the cup you are concentrating the strength of the wash. When you dip into the cup with your brush you are then concentrating more pigment into the brush than you could possibly pick up on your palette. Be careful with this procedure; test a little of your mixture on a scrap piece of paper just to make sure you don't have too thick a wash that will be too opaque. Also, don't use this approach too quickly. Mix the same dark wash on your palette and work from it for the first few layers of wash. Then use the cup mixture only if you need the extra intensity. Using the cup mixture too quickly can give you a dead opaque look.

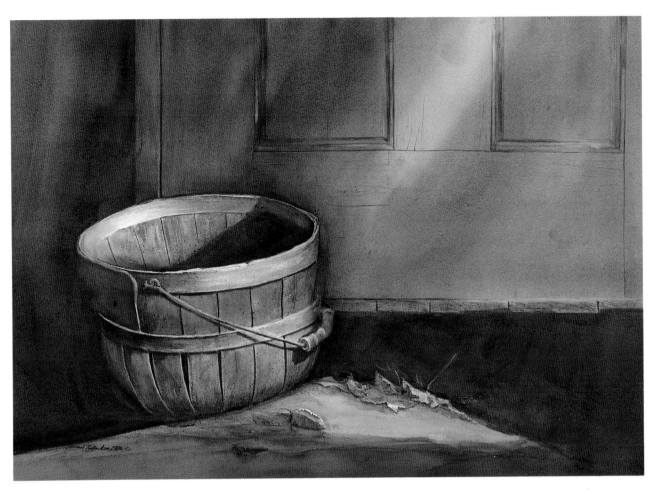

OCTOBER
34″ × 24″ (86.36 × 60.96 cm)
Collection of Mrs. Don Rankin

1 The lighter values in the door area show the initial washes. This is a red-dominated neutral, with new gamboge and Winsor blue subordinated.

2 In this highlighted area the new gamboge is the stronger element in the mix; the Winsor red and Winsor blue are barely discernible.

3 This shadow area is composed of Winsor blue and Winsor red washed over new gamboge.

4 The same colors that are used to produce the shadow area on the far right are used here. However, the proportions of each color are increased to create a stronger wash in this area.

WAITING FOR WORK

Mastering the use of neutrals in painting gives you a tremendous color advantage. Not only do properly concocted neutrals have their own luminous beauty, but they are readily adaptable to any painting color scheme. If you like to paint naturalistic works, understanding neutrals is absolutely vital in order to get the "right" color of many objects you will encounter. Not only are neutrals readily adaptable, but they also play a vital role in setting the stage for other colors. For example, consider the painting *Waiting for Work*. It depicts a cold, hazy winter morning. Much of the painting has been developed by the use of neutral color. In this instance the hazy look was created with

neutrals and then the road was defined with the addition of blue in a very dilute state. The figures and foreground stand out in contrast because strong color was used in both areas. The application of various colors in the foreground also helps to give texture to the damp ground. This painting has a very unified feeling because only three colors (new gamboge, vermilion, and Winsor blue) were used throughout the entire work. One final word: the smoke coming from the barrel is the white of the paper. I used a combination of wet into wet as well as blotting with tissue in order to keep the white paper. Some modifying washes of Winsor blue were used to give depth to the smoke.

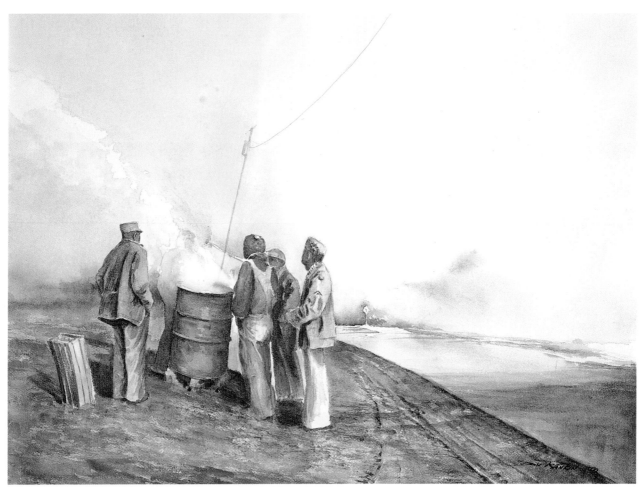

WAITING FOR WORK
24″ × 18″ (60.96 × 45.72 cm)
Collection of Mr. and Mrs. Lon Schreur

Texture in the foreground was created by many applications of diluted neutral tints in red, blue, and yellow. Much of the rough texture comes from using the side of a Aquarelle brush and the texture of the paper. Very controlled lines and detail were kept to a minimum and confined mostly to cast shadows in the roadbed.

WILLIAMSBURG, SUMMER OF '81

This watercolor was painted several years later than the first four paintings shown in this section, but basically the same palette and approach were used. The only variation this time was that Winsor red is included in the flag and coat hanging on the wall. My interest in this scene focused on capturing the glowing quality of the figure sitting in the window. I had happened upon this situation quite unexpectedly.

The young man was not even aware of my presence for a moment or so. The lighting was very complex, strongly focused in one area and subtle in the shadows—a powerful combination. While the room was dark, the white homespun outfit and the sheet on the barrel acted like a reflector lighting up a portion of the room. In fact, the light was so strong that it even lit up the wall below the window. The sudden impact of seeing this was like walking in on a ghost.

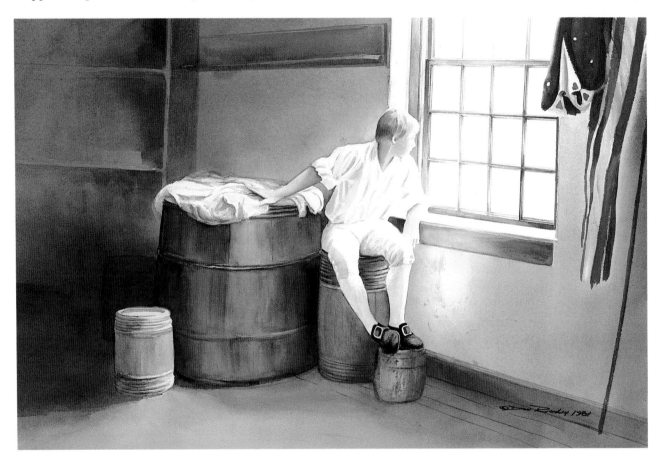

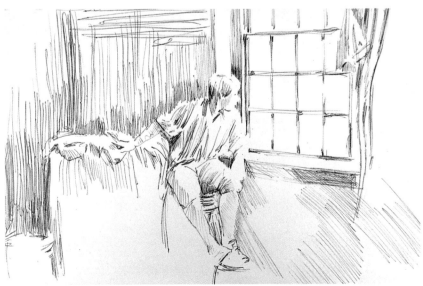

WILLIAMSBURG, SUMMER OF '81
28½″ × 19″ (72.39 × 48.26 cm)
Collection of Mr. and Mrs. Lon Schreur

Preliminary sketches show my concern with the placement of the figure in the painting. The final painting has been altered from the sketches.

Use your preliminary drawings as a thinking stage, not a straitjacket to confine you and keep you from improving upon your initial idea.

Understanding neutrals

Now we have reviewed five strikingly dissimilar paintings that evolved from the same palette. In each case certain challenges were handled in different ways. Various shades of color were created to solve specific problems and to convey certain moods. At this stage the most important thing to understand is that all of these variations came from the same palette. As I have indicated before, this should not come as any great surprise—the printing industry has been making use of it for years. It is certainly not my intention to limit the artist's palette to only the primaries and black. However, consider the control you can exert over your colorful creative endeavors once you begin to understand the nature of color. As I indicated earlier, you can produce at least one thousand totally different neutral shades by merely mixing new gamboge, Winsor blue, and Winsor red. Think what happens each time you add a new color to the list. The variations are almost infinite.

ASSIGNMENT

Neutral colors abound in nature and are vital to painting convincing naturalistic watercolors. There are six swatches of primary colors shown here for your examination. Each one is painted with the same value. Study each one carefully. The strength of the yellow, blue, and red has been balanced in order to approximate an equal value for each color. And each one is identical except for the difference in sequence of color. As you examine the samples, take note of the effect that sequence of color has upon the final color. With double and sometimes triple layers of wash, the first wash generally dominates the final color. But as you apply additional colors (under some circumstances) this becomes less true. For example, a very intense color, such as Winsor blue, on top of a series of washes, will dominate. As you examine the shades of neutrals created in the centers of these swatches, note how the central area color takes on the characteristics of the dominant color in each swatch. To test this out, take a piece of white bond paper and carefully cut out six diamond shapes that expose only the centers of each swatch. Compare the centers of the six swatches. What do you see? What does this tell you about pure neutral color?

If you followed the suggested exercise, you probably were surprised at the results. Without using the templates, it's almost impossible to tell that the centers of the swatches are identical in color. This should tell you that a true neutral will blend or take on the cast of the nearest predominant color. Regardless of the sequence of the color layers, the resulting color is the same. The explanation for this is that the colors are all balanced in intensity, so regardless of the position of the color in the layer sequence, the effect is the same. Keep in mind, however, that this is a controlled experiment. When you apply washes in a random fashion in a painting, the results will not always be the same, unless you deliberately balance all of your color to the same intensity.

LAYERING SEQUENCE *At left: red, yellow, blue. At right: yellow, red, blue.*

LAYERING SEQUENCE At left: red, blue, yellow. At right: blue, yellow, red.

LAYERING SEQUENCE At left: yellow, blue, red. At right: the same layering of colors mixed wet into wet on paper.

LAYERING SEQUENCE At left: blue, red, yellow. At right: the same layering of colors mixed wet into wet on paper.

DEVELOPING UNDERPAINTING FOR TEXTURE AND FORM

Underpainting is a technique that has been in existence for many years. Many approaches have been developed around various painting media from egg tempera to oils. Except for certain periods in art history, watercolor painting has not been a popular medium for underpainting. At least it has not been widely acclaimed as a perfect medium for involved underpainting in the eyes of the casual observer. However, once you begin to learn the essential differences between staining pigments and floating pigments, underpainting becomes a powerful, useful tool.

In the apple demonstrations, underpainting was used as a technique to create form and depth. Because of the nature of transparent watercolor, underpainting can be used most effectively. In this section, various colors will be examined for their use in underpainting. Color is used not only to enhance form, but to create texture and increase color intensity.

There should be nothing mysterious about underpainting. If you have performed the previous exercises you are becoming aware of some of the predictable as well as unpredictable characteristics of watercolor. You have learned about the way in which underlayers of color affect the final washes. You have also seen demonstrations that show how to set a mood for an entire painting by selecting a specific color for the initial washes.

In order to clarify the intent of this section, a working definition for the term underpainting needs to be established. After all, in a sense, the entire book deals with underpainting in one form or an-

other. But more specifically, underpainting refers to a planned execution of design using a color of unusual contrast or a color of harmony. Its purpose is to enhance the form, the contrast, or the detail of a painting. Although an underpainting is most often something more than merely laying in a color wash on a piece of paper, there are times when a simple underpainting is nothing more than a colored wash.

With this working definition in mind, I want to review a few texturizing techniques. Although many of these methods are neither novel nor unique, their use in combination with pale tints to create subtle effects may be a new twist for some painters. As a general rule many attempts at watercolor painting spring from the desire to be bold and free. While there is nothing wrong with that approach, it should be reassuring for a few that there is another way to work with watercolor. There are times when the quick, glib statement must give way to the more deliberate, meditative approach to painting. The wise painter is prepared to communicate on both levels as the need arises.

In the section on materials, I spoke of the unique language of the brush, that each kind of brush has its own unique mark or statement to make upon the painting surface. While I favor brushwork for most painting situations, there will be times when you will not want the effect of the brushmark to be apparent in your work. You may feel the need of creating texture that is not similar to any brush. In an effort to create textures, it is possible and often advisable to allow your imagination to run rampant as you seek ways to

accomplish varied effects. There are times when I use sponges, paper towels, hands, fingers, forearms, fingernails, twigs, nylon mesh, and all sorts of items to create new textures. However, when you use these things, be careful not to go overboard. One case in point: for years watercolor painters have used spatters of wash to create texture in a painting. This is done by tapping a brush loaded with wash against either your hand or a brush handle. It can also be done by rubbing the bristles of a toothbrush that has been loaded with color. Spattering is an appealing technique that can be used to create some very nice effects. However, several years ago it almost became a fashionable necessity in some painting circles. In looking at some exhibitions, it was almost like a mindless exposition of spatter. Every work was dotted with a vast array of flyspecks. The only problem is that not every painting should be spattered. Spatter is just one tool among many; each tool has a specific time and place where it should be used.

TAFFY

Taffy is a typical example of a painting whose foundation is a combination of a simple pre-wash and a more complicated underpainting. It is a portrait of a beloved family member. Taffy is my daughter's cat and enjoys the privilege of being the oldest cat in the house. Since this is a portrait of sorts I wanted to make sure that I maintained a likeness of my subject. Therefore, in keeping with the general tones of Taffy's coloring, I have used light washes of Winsor blue and Thalo blue to carefully underpaint portions of Taffy's body, as well as selected areas of the quilt. In this painting I am dealing with a subject that I know well. I have had many occasions to observe Taffy and my choice of a blue underpainting served two purposes. First, Taffy's coat displays a slight hint of blue in certain lighting conditions, so this factor was important to me in capturing as much of a likeness as possible. As a calico tabby, Taffy's blend of colors ranges from a pale champagne to pale blue grays punctuated with chocolate markings. Second, both Winsor blue and Thalo blue are excellent transparent stains. This physical characteristic allowed me to create as involved an underpainting as I liked without fear of it spoiling the finished painting. Since these colors stain, they sink into the fibers of the paper making it difficult if not impossible to remove them. Because this stain is indelible, once it dries, it stays in place without lifting as I go through the course of painting. In situations where you are dealing with a likeness, this approach liberates you from the concern of losing the likeness as the painting develops.

An initial sketch of Taffy, one that precedes the more detailed sketch below.

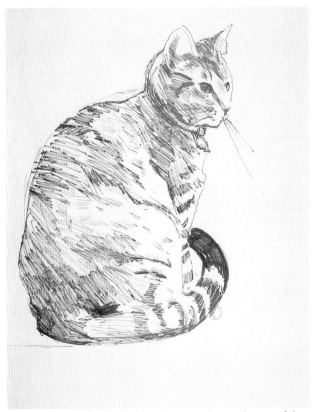

This sketch was done in order to better understand some of the particular forms, such as stripes and other fur patterns, found in Taffy.

Developing underpainting for texture and form

A word of caution: underpaintings of this nature can cause problems if you get too strong with your color. Now the word strong can be defined in two ways: first, you could get too heavy-handed and use washes that are too intense; second, you could leave abrupt harsh edges that will not mellow as you apply additional color. Remember, you are dealing with transparent watercolor washes; even the most opaque colors will still exhibit a degree of transparency. Therefore, the watch word is sensitivity. Be sensitive to your subject. If it happens to be soft fur, convey that feeling in your underpainting by feathering and blending edges to create softness. Experience will show you that soft blended washes will have less tendency to produce harsh, jarring edges when and where you don't want them. Also they will be easier to modify if you need to do some altering of the image.

As stated earlier, *Taffy* contains a pre-wash that serves as an underpainting. After my sketch was translated into a working line drawing on the sheet and the blue underpainting was completed, I laid in the background. This bright orange background was created by mixing cadmium orange with a small amount of vermilion to make it hotter. In fact this color was so bright that I found it repulsive, but the brightness was soon modified by the darker washes that were subsequently laid over it. However, I used this bright color for a purpose. I wanted a vibrant dark background. The orange acts like a super-charger under the intense mixture of dark washes, which are composed of a mixture of Thalo blue and vermilion mixed. The wash was applied with a 2" (5.08 cm) bristle brush. Just before it dried completely, I ran a dry bristle brush through the wash to disturb it and create texture. As you study the finished painting, note the lighter color adjacent to Taffy's back. In that area the water used to dampen the paper before the dark wash was applied diluted that wash and allowed some of the basic underpainting to shine through.

STEP 1 The underpainting is a vital part of the beginning of a watercolor painting. It was planned and executed to freeze the likeness of the cat and to build the flow of the design. Note those areas that are strongly colored and those that contain much weaker passages of color. Compare these areas to the same areas in the finished painting.

In this particular case, I used a combination of brushes to build my "road map" or underpainting. In the beginning the cat was dampened with clear water and the initial Winsor blue washes were applied in a broad manner with a 1" Aquarelle brush. Some of the blue wash was allowed to freely flow within the confines of the drawing space. While this basic passage was still quite damp, additional color (blue) was applied in shadow areas around the neck and on the middle portion of the back. These washes were allowed to dry. Since the paper was damp, the shadow washes dried with soft edges. In this manner, I was able to begin conveying the feeling of soft fur. After the sheet was dry, more specific detail was added, such as the eyes, the shadows inside the ears, and the arrangement of Taffy's stripes. The smaller details were painted in with a Winsor & Newton Series 7, size 6. For a final effect, Winsor blue was drybrushed, with a light concentration of color, along Taffy's back and under her chin.

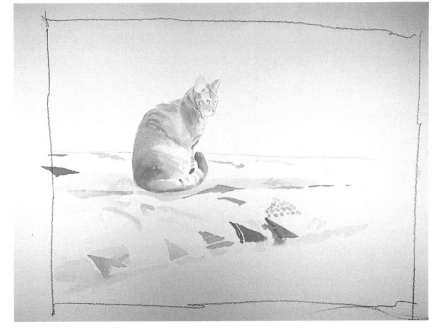

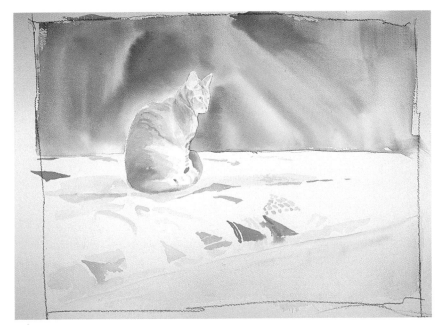

STEP 2 The background wash is composed of cadmium orange with a slight hint of vermilion to warm it up. The wash was applied with a lot of strength. I wanted it to be bright, in order to supercharge the dark washes that would come later. Note that this wash is not smooth and even across the paper. Instead, it has variation, but that variation is designed to help create the effect of light. Examine the background wash and compare it to the finished work, where it looks as though light is glowing and reflecting off the unseen side of Taffy's back. This auralike effect can be produced by manipulating the underwash. If you look at the orange area near Taffy's back, you will see that it is not as strong as the wash in the upper portion of the paper, where I had dampened the paper with clear water before I applied the orange wash. As I carefully painted around the image of Taffy, the water flowed to this lower point, which naturally created a wetter area on the paper. As the wash was laid onto the paper and allowed to spread out, it became paler in this area of concentration.

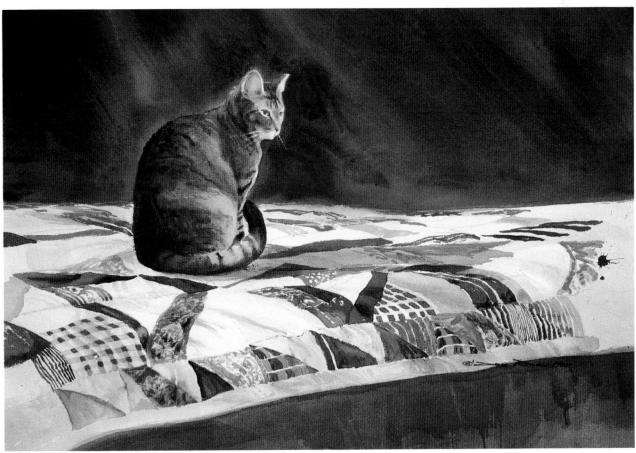

TAFFY
28″ × 15″ (71.12 × 38.10 cm)
Collection of Carol Rankin

DEVELOPING THE TEXTURE OF FUR

These detailed sequences are recreations of the actual painting; they are intended to reveal the development of the fur in Taffy's coat. Because these steps were done after Taffy was completed, there may be some variation in color when compared to the painting.

STEP 1 After the blue underpainting was completed, the orange background was laid in. Its bright orange is created by mixing cadmium orange and a small amount of vermilion together in a small cup. Although this color approaches the garish, I used its intensity to shine through the darker washes that will be applied later.

STEP 2 Here I began to concentrate on developing the texture. My first wash was dilute new gamboge and Grumbacher red. Notice that I reserved the white of the chin and I left the eyes white. While this first wash was still quite damp, I applied additional passages of wash in order to strengthen such areas as the shadow side of the neck and the face. These washes were done while the wash was damp in order to promote a sense of softness. Remember, fur is soft; take advantage of the soft effect of wet into wet.

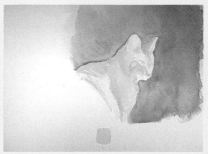

STEP 3 At this stage the colors are beginning to mingle. The second wash is a repeat of the first one, but this time the value is darker and thus the color is intensified. These two washes establish a unifying tone that is found all over the cat's body. To further suggest the look of soft fur, I dragged a brush across the paper, letting the texture of the paper itself break up and create fur-like strands in the preceding wash. Note that at this point the likeness and character of the cat is beginning to develop.

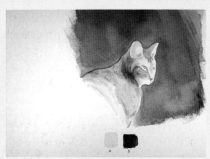

STEP 4 The dark portion of the background and the darkest patches on the fur were achieved with a mixture of Thalo blue and vermilion. When you mix these two colors together in generous proportions the result is a rich brown. A slight alteration in mixture, say more blue than vermilion, will produce a purple. Too much red will produce a red brown. In the background this mixture was allowed to flow across a dampened sheet. Care was taken to keep the cat dry while the dark passage was applied to the damp portion of the paper.

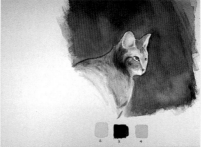

STEP 5 Several washes of Thalo blue were applied here to define and cool shadow areas as well as to build up more fur texture. Also, some darks were adjusted and the expression in the eyes was refined. The last step consisted of scratching out the whiskers with the point of an X-Acto knife.

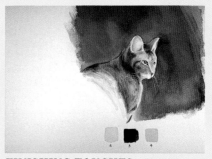

FINISHING TOUCHES Keep in mind that even though these steps appear to be very ordered and precise, the actual painting sequence is not always that easy. While in general it followed the sequence outlined, there are times when several washes have been carefully applied in order to achieve the look of one step. The reason for this is because it is always easier to look back upon a completed painting and analyze the steps taken. However, when you take those steps for the first time in a new painting, you will find it a good idea to be cautious as you develop your work. Think each step through as much as possible. Then, as you develop a backlog of experience, the progression of a watercolor will become much easier.

LATE SUMMER

This painting is another example of using a basic underwash of contrasting color. In addition, many of the shadows in the basket were developed by using a Winsor blue underpainting. The contrasting color is a mixture of cadmium orange and vermilion. When this mixture had dried, a darker mixture of Winsor blue and Winsor red was blended over the predominantly red initial wash. The suggestion of light was created by allowing the washes that make up the floor area to be partially diluted, thereby creating a contrast to surrounding darker values.

Both *Taffy* and *Late Summer* were created from the same colors: Indian yellow, new gamboge, Winsor blue, Winsor red, cadmium orange, and vermilion. In both paintings, the cadmium orange and vermilion were used to create the background underwash. This technique goes against some of the ideas expressed earlier. While the lighter washes in the painting are very transparent, the underwash is quite heavy and therefore tends to be somewhat opaque. This is partially due to the nature of the paint used and the strength of the application. This type of application can be somewhat tricky, so you must be careful when you put darker washes over this combination of orange, otherwise you might stir up the preceding wash. Remember that it almost goes without saying that the orange underpainting *must* be stone dry before you attempt to flood the darker passages in. Also, the dark passage will flow better if you carefully dampen the sheet with clean water, taking care to go around any areas that need to be kept dry. One saving grace of darker washes, however, is that they are so strong that they often help cover up any tendency toward smearing or lifting of the previous wash. As in *Taffy*, the reason for the bright undercolor is to intensify and enliven the dark passages. But orange is not the only color you can use for this effect. The entire spectrum of color lies before you. Experiment: the results and the unexpected may reward you.

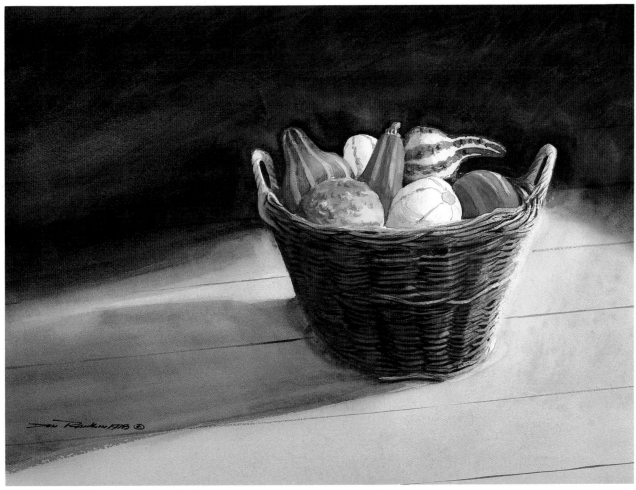

LATE SUMMER
20″ × 13″ (50.8 × 33.02 cm)
Collection of Robert Linthout

DEVELOPING THE COLOR AND TEXTURE OF GOURDS

In this recreation of the original, I want to show the development of the yellows and oranges that serve as a focal point in this work. Much of this painting was done in a quick, spontaneous manner. However, a great deal of the painting energy was focused upon developing the color and texture of the gourds in the basket. In my mind I broke the picture plane into a strong contrast of light against dark. The simple sketch amplifies this scheme. As you carefully examine the work you can discern a pattern of movement in the lines of the painting. While the application of wash is very simple, the arrangement of the values is quite sensitive.

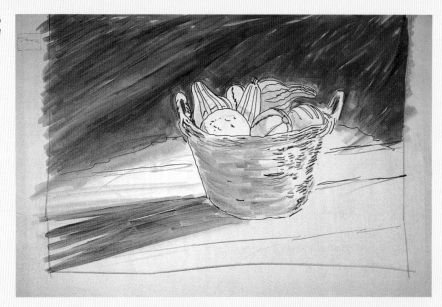

STEP 1 The first layer of wash on the gourds is diluted new gamboge. Notice that the wash is graded from dark to light in some key spots; these lighter areas will help give a sense of form and highlight as the work develops.

STEP 2 The second layer of wash is a mixture of cadmium orange and vermilion applied in a very direct manner to dry paper. While the wash was still damp, I added some extra color in order to help enhance the form.

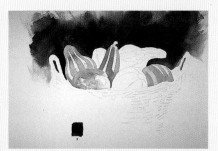

STEP 3 The dark background was developed by using a mixture of Thalo blue and vermilion. In order to control the flow of the wash in a smooth, orderly fashion, I dampened the background area with clean water before the wash was applied. When you use this procedure, carefully avoid those areas you do not wish to color with wash, making sure all of your edges are smooth and clean.

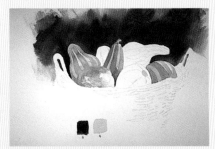

STEP 4 While the background was drying, I applied a lighter wash of brown to some of the gourds in order to modify the contrast on the variegated colors. From time to time you may find it helpful to use modifying tones like this in order to bring some elements into harmony with the overall work.

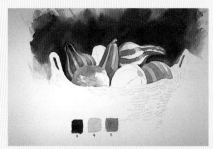

STEP 5 Here I mixed Winsor blue and new gamboge in order to get a cool green. This wash was applied directly to two of the gourds. Notice that the yellow gourd helps to warm up the green and intensify its character. The same color applied to the white gourd gives the appearance that two separate greens were used. Once again the power of an underlayer of color is clearly demonstrated.

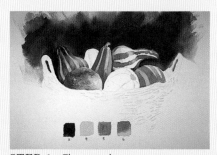

STEP 6 The gourds are nearing completion at this stage. The darker orange (shown in the color bar) was used to help define the bumps found on the orange gourd at the front of the basket. At this stage most of the work is complete. All that remains are a few minor details, such as shadows on the white gourds and the Thalo yellow-green stripes on the white gourds.

JENNIFER

The last two paintings are somewhat different from the usual approach I adopt when developing under-paintings. Usually the underpainting is a very subtle framework upon which the painting is built. Properly executed, an underpainting will not be apparent to most viewers. This is why I have stressed feathering edges and applying the underwash in a very careful and thoughtful manner. In many ways the under-painting is nothing more than a monochromatic rendition of the painting. The underpainting in *Jennifer* is somewhat subtle but will be obvious later on. In fact, the shadow area of this underpainting is any-thing but subtle. The underpainting color for the entire work is Winsor blue, but the shadow area was underpainted in a very strong manner. If you look at the shadow areas of the girl's dress you can see form in that shadow. In other areas, the underpainting is very delicate. For example, the girl's hair was care-fully developed with varying strengths of Winsor blue wash; and certain shadow areas in the dress were put in almost full-strength.

I was very careful to avoid placing the blue on the flesh, except for a very pale amount on the forehead and at the base of the neck. When I use the word pale, I mean that the wash is so weak that very little of its blue character is discernible—it is probably less than a 5 percent value. Although these pale washes don't seem to be of great significance, they have a powerful accumulative effect. As you become more familiar with the approach you will be amazed at the power of these delicate washes.

Flesh tones should not look muddy or dirty; that is why I tried to keep the blue away from the child's skin. The flesh tones in this picture are predomi-nantly diluted vermilion, and a small amount of Winsor blue was added to the wash to keep the flesh from becoming too orange. The left arm was washed in blue to complete the shadow effect.

The texture of the soil near the bucket was created with a sweeping motion of a 1″ aquarelle laying flat on its side and tapped across the surface of the paper. Texture on the soil has been further suggested with spatters of various degrees of blue wash.

Much of this underpainting was done to create form without relying upon conventional methods of creating shadows. In a more traditional method, the painting would be near completion before the shadows were developed. Then, when they were painted in, the shadow would be dominated by the color that has been applied. Although there is noth-

ing particularly wrong with this approach, there are times when shadows seem to defy color definition or identification. In some instances, a color value is arbitrarily assigned to them, when in effect that color is not a true representation of what is there. But when you build a successful underpainting, the shadow areas are developed along with the glazing technique. If you determined your shadow values correctly, you will not need to do much adjusting of the value as you near completion of the painting. If you did miscalcu-late, only minor adjustments should be necessary. But the beauty of this is that the shadows develop almost automatically and are very naturalistic in appearance. In addition, the effect of the underpaint-ing shadow tends to add an air of mystery to the overall work while giving the piece a feeling of weight. A good example of delicate shadow work can be found in the shadow in the bucket. When you first look at this painting, all you *think* you see is a pink-ish color. But under that pink is a very dilute wash of Winsor blue. Although it's not strong enough to exert its own coloration, it's strong enough to considerably cool the pale red wash that passes for pink.

Perhaps some of you may find it difficult to see the blue, but once you understand the way glazing works, you will begin to see the blue's influence. One way to observe this effect here is to look back at the shadow. Notice that the shadow gets stronger but neither the temperature nor the value of the pink wash increases. That is a sure sign of another wash affecting the final color. Learn to look for these subtle value relationships. They can be tremendously help-ful in developing texture and form in your paintings.

Preliminary sketch

Developing underpainting for texture and form

STEP 1 Initially, I laid in a pale Winsor blue wash to block out the area. At this stage the initial design concept is established: most of the painting is locked up in a close relationship between the object and the shadow cast from the object.

STEP 2 Here, I began to slowly strengthen the value of the blue wash. Look at the shadows on the ground and in the clothes. On the ground I wanted a shadow that conveys character and that contains texture and detail. Although these characteristics are merely suggested at this stage, they are definitely starting to develop here. To develop the underpainting further, I allowed for some variation in the strength of the wash. I also made use of wet into wet, direct washes, and drybrush to develop the texture.

STEP 3 In this final stage of underpainting, most of the shapes and textures that dominate the finished work have been developed. Take notice that many of the shadow areas are not merely raw dabs of color; instead, they have been carefully blended to suggest a smooth texture. Look at the modeling of color in the hair, all of these elements will strongly contribute to the look of the finished piece.

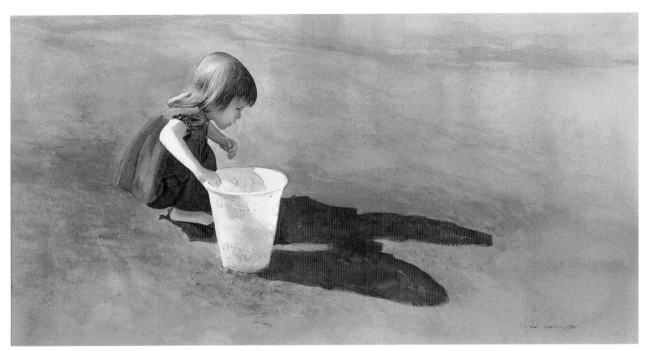

JENNIFER
30″ × 16″ (76.2 × 40.64 cm)
Collection of Mrs. Don Rankin

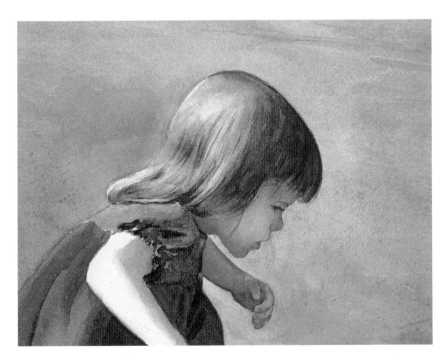

DETAIL Study the highlights in the
hair and compare this with the final stage
of the underpainting on the previous
page. If you look closely, you will detect
the underpainting in the finished work.
Although in some cases its presence is
very subtle, it still exerts its own
influence.

DEVELOPING THE TEXTURE OF HAIR AND SKIN

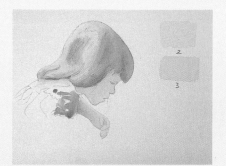

STEP 1 Winsor blue underpainting is used to develop the form and shadow values of hair and head. Notice the range of shadow and the texture of soft hair that is already suggested by these blue washes. This is accomplished primarily through the use of a wet-into-wet technique.

STEP 2 This step is divided into two parts. The first layer of wash can be clearly seen in the child's face. The stronger yellow color on the shadow side of the hair is a double wash of the same color used on the face. I strengthened the wash in the hair because more strength would be needed on the shadow side later in the painting.

STEP 3 This wash consists of pure diluted vermilion. When painting children, it's better to keep your fleshtones clean and fresh. Lay them in simply. Too much work on a child's flesh will cause it to appear aged and much too old for your subject. Note that the vermilion crosses the hairline and goes well up into the shadow portions of the hair.

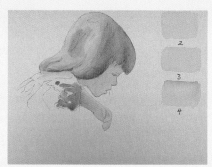

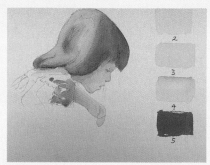

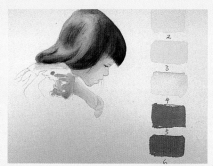

STEP 4 At this point, a stronger wash of new gamboge is added to the hair only. This helps to create the brown color of Jennifer's hair.

STEP 5 Here, new gamboge and vermilion are combined to create a rusty orange that further strengthens the hair color. Note that this color is confined almost exclusively to the shadow areas of the hair.

STEP 6 If you study the original work Jennifer, you will see a much greater array of pale washes built up to create texture and sheen in the hair than can be seen here. In this re-creation the basic steps and the sequence used for applying the washes have been followed. The final drybrush effects and washes were accomplished primarily with the dark mixture found in color bar 6. If you find that your attempt needs additional color, merely add an extra wash of any deficient color. The key to this work is a great number of pale washes.

AUTUMN LIGHT

In *Autumn Light*, which is also built upon an under-painting, the coloration is purposely limited to a neutral range. The palette consists of new gamboge, Winsor blue, and Winsor red. In some ways this piece is similar to *October*, which also deals with a critical light angle. In *October*, however, the light was interior light, and in *Autumn Light* the light conveyed is a much harsher outdoor evening light.

The idea for this painting developed rather quickly. Several years ago a wooden hamper was placed against the rear wall of our house. I couldn't help but notice it at different times of the day. For the most part it was just a forgotten and derelict old hamper propped up against a pale shingled wall. For most people it was not a very exciting subject, but as warm sunlight found its way into the interior of the hamper, a humdrum everyday scene turned into something fascinating.

At first, I set about to freeze the time of day with a thorough underpainting. A highly detailed under-painting was kept to a minimum, but you can still see some of it in the corner of the house and the down-spout. This area was rendered rather carefully but care was taken to keep the detail in a linear pattern. In this manner I didn't overwork or overstate the area. Actually, I merely interpreted what I saw, but I chose to convey it by a careful delineation of the shadows. Notice the strap on the downspout. Only the shadow and later the middletone are painted in order to define the form. The next critical area was the cast shadow on the wall. This area required some thought in order to capture the feeling of the shadow creeping along the ground and up the wall. As I recall, I took some liberties by lengthening the shadow in order to enhance the design.

The old hamper is a perfect study in neutral color. The entire color range was accomplished by using the three primaries. If you study it carefully and recall the earlier section on neutrals, you will see that form was created by allowing the yellow to dominate in the highlights and blue to dominate the shadow. The feeling of light is amplified by allowing some of the highlight to spill out through the slats that are in shadow. The wall, foundation, stone patio area, and ground area started out as the same color. The ground is dominated by a red-toned neutral; the stone patio is blue dominated; and the foundation above is just slightly darker than the stone. The piece of concrete block jutting out of the ground near the downspout is of the same value as the shadows on the stone patio. By analyzing the painting this way you can begin to think about the color relationships that have been developed in order to convey a mood.

Value study

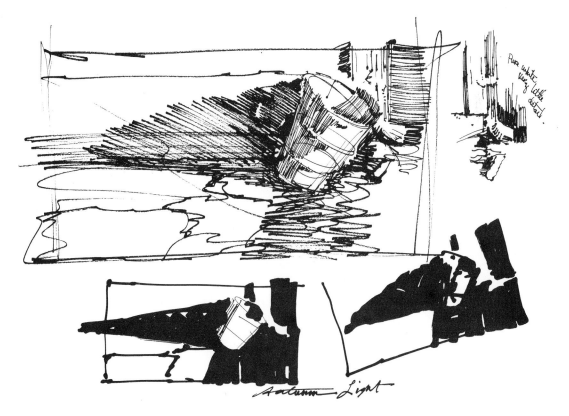

Developing underpainting for texture and form

The very detailed leaves lying on the patio floor were painted in last. In many cases the shadow was painted first, and then a little wash was applied in order to define the shape of the leaf. In some instances, when I applied a wash to define the mortar joints, I merely left a leaf-shaped portion unpainted. After the mortar wash was dry, I worked in the detail of the leaf. It is only natural for someone to assume that it would be more efficient to mask out the leaves with a maskoid and finish them after all of the other washes are completed. I dislike that approach, however, because it causes a disruption in the glazing process. If you have taken the time to build neutrals in all other areas, you wouldn't want a group of bright leaves jarring the color balance. In this respect maskoid gives the painting an artificial, contrived look. Although there are effective ways to use a masking agent, at this stage of development I am not sure that maskoid is really worth the effort. At one time I used maskoid a great deal and for certain problems, I would still use it. But I have found painting to be more fun without it. If you feel that you can't live without the stuff, try using it after you have applied one or two washes to your work. Better yet, try using it at different stages in the work, so that not all of your watercolor is masked out at the same time. In this manner you won't have so many unsightly harsh edges with which to contend.

STEP 1 From my standpoint this sketch tells it all. These simple arrangements of black create a visual message that gives this painting its feeling of strong movement.

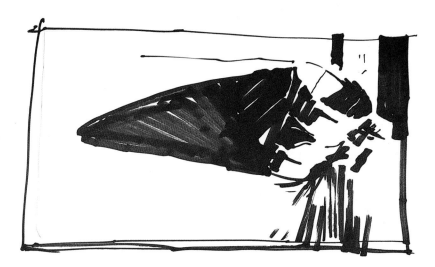

STEP 2 Here, the picture plane has been broken into thirds. Note that most of the positive shapes are in the section at right, so that by conventional design standards this composition would be considered off balance. But the placement of the darks and the strong sweep of the shadow makes the painting work as a unit. Through the use of off-balance masses and the sweep of the shadows, a sense of movement is created. The green arrows indicate the direction of movement.

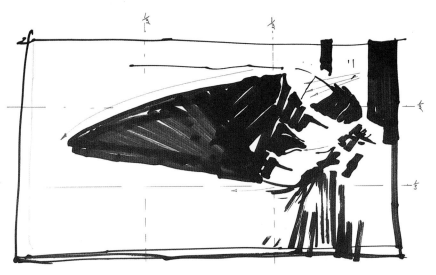

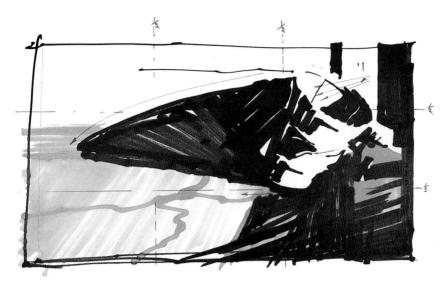

STEP 3 Once the strong darks were determined, the various colors begin to work together. Look at the gray tones found in this example: they consist mostly of broad areas of wash that are used to build the stage upon which the shadows play. Note that most of the detail in this painting is centered in and around the hamper and downspout. As your eye travels away from this area, the detail becomes less definite and more suggestive. Had the entire work been very detailed, the painting could have become less than interesting. But since the scene is a commonplace one, the effective use of strong darks and a subtle play on light helps to make the painting work.

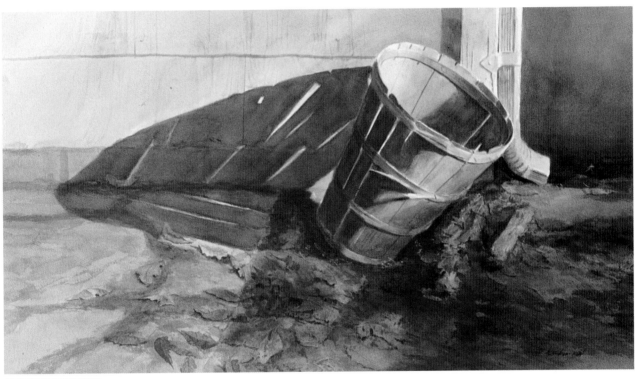

AUTUMN LIGHT
38″ × 28″ (96.52 × 71.12 cm)
Collection of Sonat, Inc.

DEVELOPING THE TEXTURE OF WOOD

In this demonstration, I am only showing a portion of the detail, concentrating upon the hamper itself. The entire work was developed simultaneously, with a great deal of the background and foreground being developed before the hamper was finished. The initial step was a sensitive underpainting of Winsor blue that served to delineate the basic design and structure of the painting.

STEP 1 After the underpainting of Winsor blue is dry, a wash of new gamboge is applied. In order to maintain a smooth, calm feeling, the sheet is dampened before the new gamboge is applied. Note that a part of the hamper remains white. This is because the hamper was dampened but the color was not applied. In this case, stray color could have bled into adjacent areas and created softened edges, thus destroying the variations of light intensity found in the hamper.

STEP 2 Before applying any additional color, I waited for the paper to dry. The color is a mixture of new gamboge and Winsor red. This combination and variations of it will be used to develop the hamper as the work progresses.

STEP 3 A mixture of new gamboge and Winsor red is applied to the hamper. Note its effect upon the inside right of the hamper. This color is also placed upon the shadow side of the hamper. In this step most of the color is applied directly to the dry paper without any prior moistening. Any abrupt edges are softened with a brush dampened in clear water.

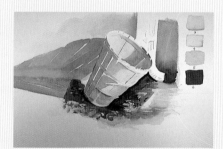

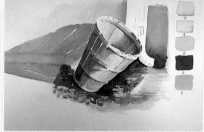

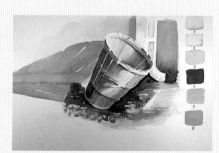

STEP 4 Now is the time to apply some powerful color. The use of this dark mixture will help bring several elements in the watercolor into focus. This wash is a combination of Winsor blue and Winsor red in a fifty/fifty mixture. The wash is then diluted for the shadow areas of the hamper and the cast shadow upon the wall.

STEP 5 This wash is a product of mixing Winsor blue, new gamboge, and Winsor red. The color bar shows the color in a diluted state. In reality some of the wash was used in a stronger mix on some of the darker shadows of the hamper. This will be evident as you look at the base of the shadow side of the hamper as well as the upper portion that is in shadow on the right side nearest the sunlight.

STEP 6 This is the final wash in this series: a mixture of Winsor blue and Winsor red. It is applied to the side of the hamper directly to the dry paper.

FRANNY'S BASKET

Just a few feet from the hamper of *Autumn Light*, *Franny's Basket* was born. Just as the subjects are similar, so too is my approach to painting them. I began *Franny's Basket* with a fairly well-developed underpainting in one area of the paper. As before, I fell in love with the light as it played upon the basket, casting shadows and rays of light throughout. Because of the clarity of the light and the way it illuminated the basket, I knew that for this painting I would need to make a very accurate drawing of the subject. This is one of those times when I felt that the success of the work rested to a degree upon the likeness I was able to capture of the basket. So I began to study it very closely, memorizing to some degree the weave of the white oak strips. After I was confident that I understood my subject, I began to draw. Since most of my attention was initially focused upon the basket, everything else was secondary.

When the underpainting of Winsor blue was begun, most of my effort was directed toward the shadow and a few key elements in the white oak basket. One area of particular interest was the shadow that was in the basket's interior. Some Winsor blue was also splashed in a rather free manner upon the concrete block foundation wall. When the underpainting had dried, the washes began. In the first wash everything got bathed in Indian yellow. On the second wash everything except the highlight portion of the basket got another layer of Indian yellow. Both of these washes were moderately dilute so that the yellow was not dominant. The washes that followed were alternate red and blue until I achieved the tone of the dirt you see immediately in front of the basket. If you examine the shadow as it creeps up the wall, you will see the same color that's in the dirt in highlight up there. I had washed this neutral dirt color over most of the painting except for the basket. I began to work the detail of the basket and balance it with the strong shadow on the wall. The front of the basket is rather detailed while the interior is somewhat understated. I did this to enhance the illusion of depth and to keep that portion of the painting from becoming overly detailed and boring.

Once I was fairly satisfied with the center of interest and the wall, I turned my attention to the foreground. The texture of dirt was created through the use of spatters of neutral color and brushstrokes. The leaves were painted in last. You will notice two lighter leaves in the immediate foreground. I was able to reserve the neutral color in this section as I applied cool washes to the rest of the foreground. This helped to serve as a lead into the painting and

gives a little relief to the rest of the darker leaves. If you look at the leaves carefully, you will see that some of them are only indicated with shadow work. Many of the washes are sharp on one side and feather off on the other.

This is a basic line study to help you see the arrangement of the individual elements and how they relate to one another.

In this sketch the red directional arrows indicate the light source and the movement of the shadows.

Here, the arrangement of leaves creates a circular sweep to counteract the strong diagonal rush of the light. This composition helps to create tension in an otherwise serene painting.

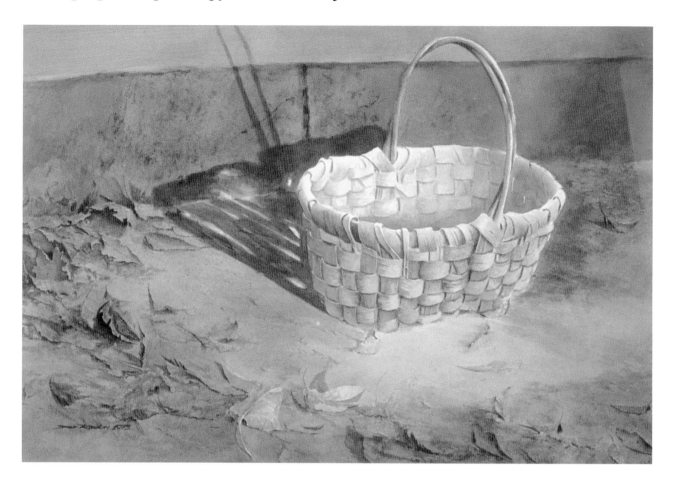

FRANNY'S BASKET
32″ × 21″ (81.28 × 53.34 cm)
Collection of Mrs. Frances Faile

The underpainting forms the foundation of your painting. It can be used to create a striking contrast or a noticeable harmonizing tone. In Franny's Basket, the underpainting helps to create an overall tonal effect. At the same time, however, it is difficult to tell that the underpainting is there.

DEVELOPING THE TEXTURE OF LEAVES

STEP 1 The first wash is merely a diluted layer of new gamboge applied directly to the dry paper.

STEP 2 The second application is a diluted wash of Winsor blue, also applied directly to dry paper.

STEP 3 With this diluted wash of vermilion, a pleasing earthtoned neutral is created.

STEP 4 Now is the time to add texture: a mixture of vermilion and new gamboge is stippled in with a worn-out toothbrush. This wash is merely spattered on. For added depth, you may want to spatter additional colors, such as diluted Winsor blue or Winsor red.

STEP 5 Once the texture is firmly established, a shadow value composed of Winsor blue, Winsor red, and new gamboge is introduced. Notice that there are three distinct values of this wash, all developed with repeated layers of wash applied to various areas while the initial shadow wash is still damp. This helps impart a natural blended look to the watercolor.

STEP 6 In this final step, the darkest shadow values are added in order to clearly define various areas. The wash is a stronger mix of Winsor blue, Winsor red, and new gamboge, with the blue and red dominating the mixture.

OXMOOR CHURCH

Oxmoor Church is a painting of a very old primitive Methodist church. The church was standing before the Civil War, and until recently had an active congregation. In fact, it was used as a mustering point for some Alabama regiments. Oxmoor Church is just minutes down the mountain from my studio, and one hot, steamy August afternoon I saw the light playing on the white of the church and its new tin roof. (Some of the color in the roof is very delicate and I hope it holds up during the printing process.) In this work the underpainting takes a little different direction in that some of it was left untouched in the finished work. The palette is expanded a little, consisting of Winsor blue, Grumbacher red, new gamboge, Hooker's green dark, indigo, and cerulean blue.

I began to define the church by laying washes of Winsor blue into the pine trees surrounding the church building. I also allowed some fairly strong wash to flow under the church to create shadow values there. While I was developing the areas around the building, I played up the effect of reflected light by grading the value of the blue wash on the side of the building under the eaves. If you study the value of the wash under the eaves and look above the door, over the little roof, you will see that the wash is graded out to a very light value. And if you examine the shadows under the gable you will see a similar effect. These underwashes turned out to be the only washes in these particular areas.

Three different blues were eventually used for the windows. The first washes were Winsor blue, but as the painting developed indigo was used for the darkest shadows and for the reflections of the trees in the double windows farthest to the right. Inside the windows, some cerulean blue was combined with Winsor blue for the curtains. Note that the three windows on the right all reveal a slight touch of Winsor red.

The trees were developed with several washes of color. In the first sequence, after the sky had been washed in with a mixture of Winsor blue and cerulean blue and then allowed to dry, I applied a wash of new gamboge and red. I wanted some yellow in this area in order to give additional life to the greens. And then to set the stage for the dark pine trees that come later, the next few washes were of new gamboge and Winsor blue. If you look through the trees, you can see the green value that was established by these washes. The dark of the trees was accomplished by mixing Hooker's green dark and indigo. This mixture was applied in a very direct manner with a large flat brush. If you examine the movements you can determine the direction of some of the strokes. Note that not all of the previous washes of yellow and green were overpainted. Careful examination will reveal that the grass around the rear of the church is the same as the earlier green washes under the pine trees. This grass becomes darker as it nears the front of the church. The area that contains some of the most delicate and sensitive underpainting is the foreground. The values there are very close, an effect I believe was necessary in order to achieve the desired look of well-used, dried-out Alabama soil in the heat of summer. The parking area to the left contains underpainting spatters, as well as later additional color spatters. Some of the pebbles have been highlighted with the point of an X-Acto knife.

Underpainting for Oxmoor Church

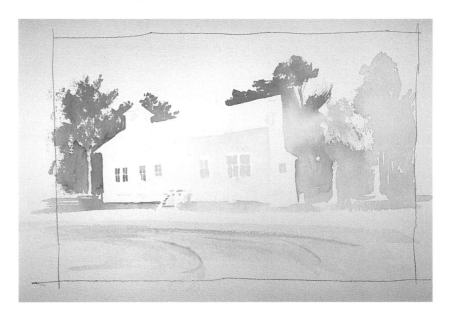

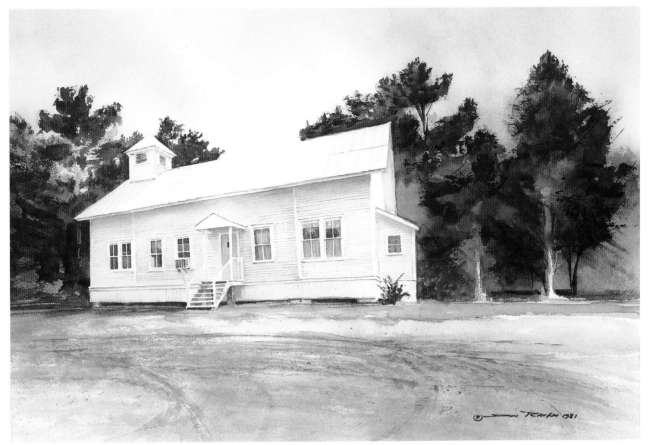

OXMOOR CHURCH
24″ × 16½″ (60.96 × 41.91 cm)
Collection of the artist

DETAIL The three sets of windows found on the side of the church were handled in subtly varied ways. The two at left, which are darkest, were created from a combination of Winsor blue and Winsor red. To build up their dark color, repeated applications of wash were applied. The windows left of the doorway were created from a diluted mixture of the same blue color. At farthest right, the windows were developed from a mixture of indigo and Winsor red, although in the reflections of the trees, you can see more indigo. The curtains were achieved with pale washes of cerulean and Winsor blues applied directly to the white paper.

DEVELOPING THE TEXTURE OF DIRT

I used a 2" flat sable brush to build the dirt texture in Oxmoor Church. The colors are three primaries: Indian yellow, Winsor blue, and Winsor red. Remember to allow the paper to dry thoroughly between each step.

STEP 1 I applied a weak wash of Indian yellow to dry paper in a rapid sweeping motion. The side of the brush instead of the tip was used in most of the operation. Note the random pattern of the areas where clean paper shows through. Later, some of these white spots will be transformed into rocks and pebbles.

STEP 2 The wash used here is actually a repeat of step one. However, this time the wash is just a little stronger and not a precise duplication of the first layer. Sections of the previous wash have been covered, creating a stronger tone, while other sections are not covered, thereby creating a random texture.

STEP 3 At this stage a pale Winsor red wash is introduced. It is applied in the same manner as the two previous washes. As stated earlier, the coverage is not a precise replication of the past washes. Its slight alteration is a key techniques for creating the textured look.

STEP 4 In order to help neutralize the orange color that was developing here, I carefully applied a dilute wash of Winsor blue. Note that several areas of the paper are still untouched by wash.

STEP 5 At this stage I wanted to alter the overall color in order to more closely approximate a neutral, warm, earth color. To achieve this effect, I laid in a very dilute wash of Indian yellow, covering nearly all of the previous washes.

STEP 6 Since the color balance was developing in the direction I wanted, I felt it was now time to intensify some of the textured areas. To do this, I used a small piece of a slightly damp natural sponge to stipple in mixture of Winsor red and Winsor blue.

STEP 7 The colors applied here are basically a mixture of the preceding colors: Indian yellow, Winsor blue, and Winsor red. Note that this mixture was selectively washed into specific areas of the foreground around the large pebbles and into a portion of the faint tire tread in the upper right.

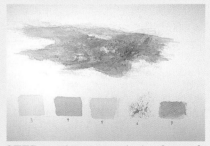

STEP 8 There is no color bar for this final step. The color used is basically a repeat of step 4—Winsor blue. But this time the wash is applied with a great deal of selective control. Specifically, it was used with the tip of a Winsor & Newton Series 7 brush to cast shadows from various pebbles and to apply color under some of the larger stones. A few small pebbles were highlighted with the fine point of an X-Acto knife by picking the color off the sheet.

PILGRIM HEARTH

Pilgrim Hearth was inspired by a fireplace in the church I used to attend. For seven years I had the opportunity to observe the effect of changing light on this hearth. One morning when the light was especially beautiful, I knew that I had to paint this scene. The light on the stone hearth and stone floor helped to wash out unnecessary detail in the light areas but much detail remained in the shadow areas. After I had developed a very involved sketch of the key elements, I underpainted the dark detail of the basket and the pine cones. I also used a large flat brush and splashed and textured the stone on the hearth with several applications of Winsor blue. This was done in a rather loose, yet imitative manner of the original hearth. Some underpainting was done on the bright side of the hearth near the poker handle, but these washes were kept very delicate. The first full washes to be applied were a mixture of new gamboge with just a hint of Winsor red. In this case I was going after the character and color of the stone. I avoided painting the highlight area of the pinecones since this color mixture would not be appropriate for them. After I had achieved the golden tan color that I wanted, by using new gamboge and Winsor red I began to develop the basket. Note that I have allowed the detail on the shadow side of the basket to fade into a field of color. Much of the painting's strength comes from the careful placement of light against

dark. This is especially true in the handles and rim of the basket. The shadow values in the fireplace were washed in with several layers. The base color was similar to what you see in the foreground. Upon this base, alternate washes of Winsor red and then Winsor blue were applied. Naturally, I allowed the paper to dry thoroughly between each layer. The final three washes were mixtures of Winsor red and Winsor blue; their combined strength was equal to black.

The first alternate washes may seem to be a waste of time, especially since I subsequently covered them with a dark series of similar color. But this combination of washes created an atmospheric effect that I could not have achieved with one or two heavy washes. If you study the fireplace, you will see that on the side nearest the light source the color is almost pure black (optical black, not tube black), yet as the wash moves to the left it begins to dilute. This effect gives relief and interest to what would otherwise be a black hole in the painting.

The texture of the stone in the hearth was completed with the same type of brushwork that was used to apply the underpainting. I merely changed the color dominance of the neutral color from time to time in order to create the texture. The mortar joints were left in highlight just as they were in the actual scene. In the joint that almost touches the shadow side of the basket, I used a graded wash to give the joint a concave curve.

Preliminary sketch and value study

Developing underpainting for texture and form

The concept for Pilgrim Hearth developed from this simple line drawing. Here, I was concerned mostly with drawing the pinecones accurately. I knew that I had better handle them just right or the whole painting would lose its impact.

In this sketch, the concept expanded. What had begun as a small, detailed sketch had now taken on the proportion of a much larger work. This is a development that proceeds at its own pace. In some cases, the concept is crystal clear and immediate; at other times it develops more slowly.

In this final stage before painting, I decided to see how the shadow masses would work. Notice that in the use of the markers I am looking for movement in the masses.

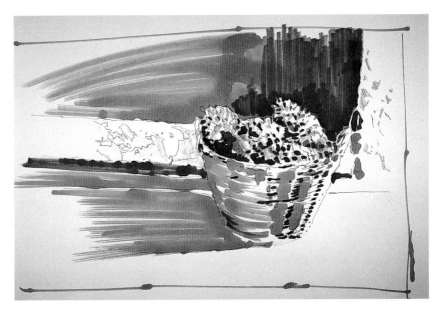

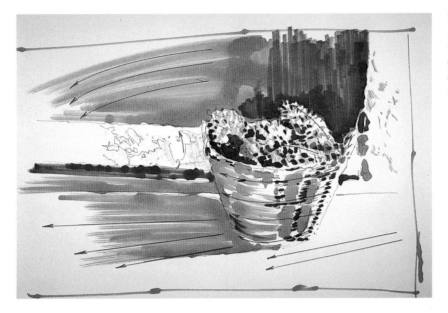

This sketch helps to clarify the movements I am trying to describe. Although sometimes we take these movements for granted, their proper use can spell the difference between a dull work and one that really delights the eye.

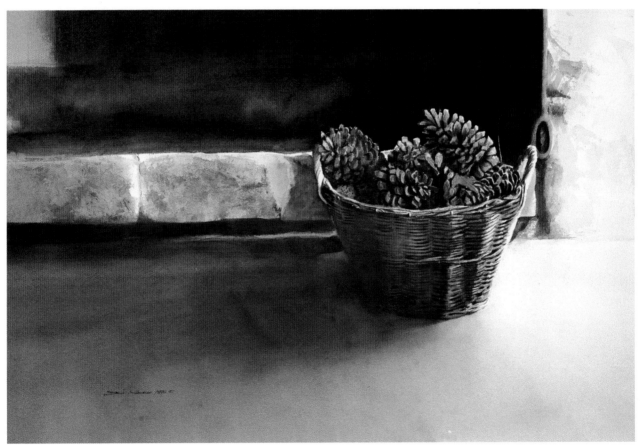

PILGRIM HEARTH
29" × 15" (73.66 × 38.10 cm)
Private collection

DEVELOPING THE TEXTURE OF STONE

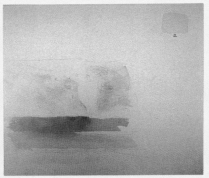

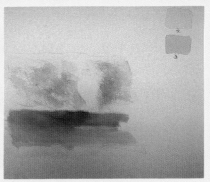

STEP 1 This stone texture began with the use of a blue underpainting. Using a chisel-edged Aquarelle, diluted washes of Winsor blue are applied with the side of the brush. The object is to take advantage of the texture in the paper to create random patterns of light and dark upon the hearth.

STEP 2 After the underpainting is completely dry, a pale wash of new gamboge is flooded over the painting. Notice that not all of the hearth received color; the mortar joints were left white on purpose, in order to establish a highlight area.

STEP 3 At this stage a mixture of Winsor red and new gamboge is washed onto the dry paper using the side of the brush. Once again, the grain of the paper is allowed to create a random texture to imitate the texture of stone.

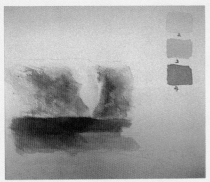

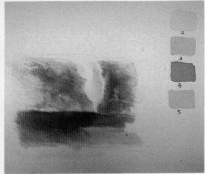

STEP 4 Once the paper is again dry, a stronger mixture of the previous wash is added. Notice that this color is not applied evenly and that previous washes have been allowed to shine through in places. This wash is also applied with the side of the brush; but some of the harsh edges rising toward the top edge of the hearth are blended with a brush dipped in clear water.

STEP 5 This wash is a blue-dominated neutral, created from a mixture of Winsor blue, new gamboge, and Winsor red. It serves as a cooling and unifying glaze when brushed over the major portion of the hearth area.

STEP 6 The final application of color is used to strengthen the shadow detail on the hearth and under the ledge. In this mixture the same colors are used as those found in color bar 5, but the relative amounts of Winsor blue and Winsor red are increased.

NANTUCKET LIGHT

By this point it should be obvious that I am absolutely intrigued by light's effect on ordinary objects. As the years go by I am increasingly sensitive to its slightest change from season to season and from place to place. Several years ago I had my first encounter with light in New England. One of my most memorable encounters was on the island of Nantucket, where on that particular day the light was extraordinarily clean and vibrant. As I was developing *Nantucket Light,* my intention was to communicate the feeling of cleanliness that is characteristic of that area. I also wanted to convey the incredible glowing quality of the light. Because of the light's intensity, I thought it better to leave certain portions of the white paper untouched. So half the foreground is pure white, as are the tops of the gunwales on the dory, the highlights on the lobster traps, and the highlights on the bow rope. You can see the underpainting showing through in certain key areas of the wooden shingles. It is also present in the boat and the dark shadow on the left as well as the shadow side of the wall and the shadow in the foreground.

The barrel was very carefully modeled with Winsor blue. The yellow washes (Indian yellow) were applied very carefully and selectively. As you can see, it is apparent that not every area got a yellow wash. In fact, the yellow was confined to the brick areas in sunlight and to the barrel. When the wash was applied to the brick wall, it was graded out without an abrupt edge showing, which makes it difficult to tell where it starts or ends. but in the sunlit spots, the intensity was increased. This intensity is further enhanced by the painted bricks. The bricks were created with Winsor red, Grumbacher red, vermilion, Winsor blue, and Indian yellow washes. If you recall the color chart on page 23, you will remember the difference in temperature between the reds. Some of the washes are almost full-strength washes, straight out of the tube. In this lighting situation I wanted to play up the effect of the light as it bounced around between the buildings. Much of this light play was subtle and required a very delicate interpretation. Therefore, I not only used light and dark for contrast, I also relied upon subtle as well as striking shifts in color temperature to convey mood.

Value study

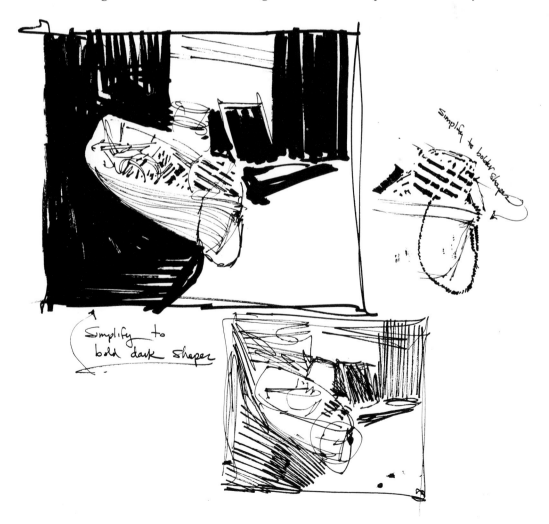

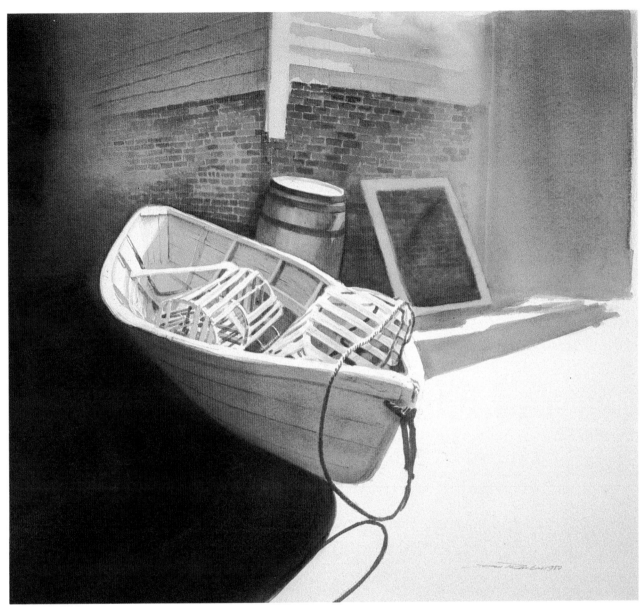

NANTUCKET LIGHT
26″ × 24″ (66.04 × 60.96 cm)
Collection of SouthTrust Bank

DEVELOPING THE TEXTURE OF BRICKS

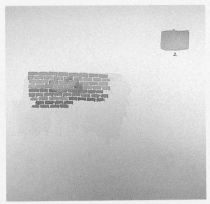

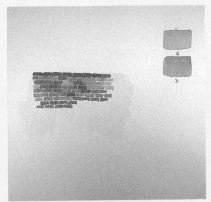

STEP 1　The initial step is to apply a diluted wash of new gamboge; this will give warmth to the brickwork that follows.

STEP 2　A mixture of new gamboge and vermilion is applied in a direct manner to suggest the texture of bricks. Note that this pattern is irregular and the color is varied. To suggest the texture of old, worn brick, don't try to be too neat and precise.

STEP 3　Here, some of the bricks are painted with a mixture of Winsor red and new gamboge. You can spot them because these bricks are darker. While the individual bricks are drying, a diluted wash of Winsor red and new gamboge is swept across some of the previously painted areas in order to blur the mortar joints.

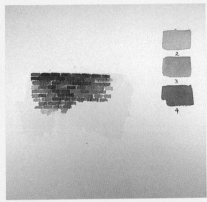

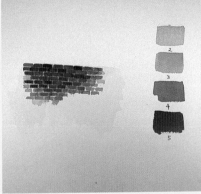

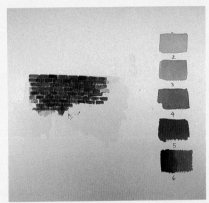

STEP 4　This wash has a deeper value than the last two wash applications. Once again, random bricks were chosen to receive a direct application of wash. While the individual bricks are drying, a diluted wash is splashed across the bricks creating a shadow pattern. These diluted washes help to mold the individual brick strokes into a unified wall.

STEP 5　Once the wall is fairly well developed, it's time to re-establish some of the mortar joints by painting in a few of the bricks with darker washes. This color is a combination of Winsor red, Winsor blue, and new gamboge.

STEP 6　In this final step a variation in the intensity of the wash is applied. Look at color bar 6 and note the variation in color from color bar 5. The lighter wash was used as an overall wash; while the darker one was used to create shadows and texture.

EARLY MORNING

Early Morning is a classic example of the use of underpainting to develop both form as well as texture. In some ways I consider this a fantasy work. In reality, the goose in the basket was not a Canada goose but an ordinary domestic goose. The painting began with a domestic goose from a small nearby lake as the star model, but as I was working on the sketches for this painting, a flock of Canada geese decided to visit our neighborhood. I was so delighted with their unexpected arrival that I reworked the sketches to take advantage of what I thought was a rare opportunity. This year twenty pair of Canada geese have returned to spend the winter here, thereby giving me additional chances for more studies. But in my initial encounter I had no way of know-ing that there would ever be a return visit. I was so impressed with the beauty of the bird that I just had to incorporate it into my painting.

In the conceptual stage, I had to decide just how I would develop the design of this work. The beginning rough sketches you see show you how the painting progressed as it developed from an idea to a finished watercolor. In the beginning I was most concerned with placement and effect of light. In the later stages of sketching, I became more concerned with scale and accuracy of detail. Finally, I had a drawing that was pleasing in concept and design. Shortly after that I developed a sketch of the bird and the basket.

The palette used for *Early Morning* consists of Indian yellow, Winsor red, Winsor blue, Thalo blue, cerulean blue, and indigo.

I quickly sketched my initial idea with a ballpoint pen. In these first sketches, I was not concerned with placement and light.

While planning the work, I tested my initial idea by developing alternate possibilities such as this.

All of the alternates I explored did not work as well as had the initial concept.

I returned to my original idea satisfied that it would produce the feeling that I desired.

In the final sketch I explored turning the head of the goose in various directions. Even at this stage, I was open for any unexpected change that would enhance the strength of the watercolor.

STEP 1 The beginning stage is the creation of a full underpainting in Winsor blue. Examine this stage very carefully. In some areas the wash is very simple and flat; in others the washes are graduated in value and have been applied using the wet into wet technique. Certain portions of the piece contain very dilute washes while other areas are fairly strong in coloration. The overall effect is meant to convey an atmospheric, ethereal feeling.

After the underpainting was dry, I placed the entire watercolor sheet into cold water. Once the paper was soaked, I placed the wet paper on a plywood board and removed all air bubbles between paper and board. Before the paper is dry, I staple it all around the perimeter of the sheet to insure that it dries flat without wrinkles.

STEP 2 In this case the paper is still quite wet and I take advantage of that and apply the first wash in a wet into wet manner, using my largest bristle brush. The first wash is a diluted Indian yellow, which is allowed to flow quite freely over the entire sheet. Note that the yellow does not flow into the white of the breast or the neck. It's not hard to avoid painting large areas like these, even when the paper is wet. If you do happen to paint into an area when you don't intend to, you can blot out any unwanted color by carefully using a tissue. If you do blot, be vigilant as the color will sneak in on you if you're not careful.

Developing underpainting for texture and form

STEP 3 While the last wash was drying, I was busy making decisions concerning my next move. The first yellow wash has given the work an overall greenish cast. I wanted to preserve some of this color, but I didn't want it to dominate the foreground. The next wash was almost a repeat of the first Indian yellow wash. In order to start the color shift I wanted in the foreground, I added a very minute amount of Winsor red.

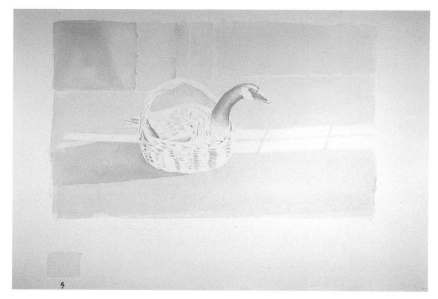

STEP 4 When the paper was thoroughly dry, I applied a mixed wash consisting of Indian yellow and Winsor red, but I increased the ratio of red to make a stronger reddish-gold wash. Note that this wash is applied in selective locations, and that certain areas have received every application of color while others have not. Those areas that have received every layer are those points where the darkest washes need to be developed. In effect, I am using all of the previous washes to help pump warm color into darks that are to be applied later.

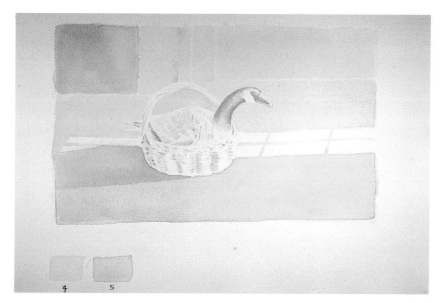

STEP 5 While the previous wash was drying, I began to assess the mood that was being created. This mood called for the full effect of warm sunlight slanting across the floor. In order to enhance this effect of strong light, I decided to cool off the rest of the interior with a blue wash. Once again, note that certain portions of the painting have not received a wash. Now is a good time to study this stage and compare it to the finished watercolor. In six steps, the painting is developed to the point where a controlled completion of the painting, such as alterations and adjustments in color values, can be achieved without a great deal of difficulty. Note that while the tones have been building in strength, no firm darks have yet been introduced.

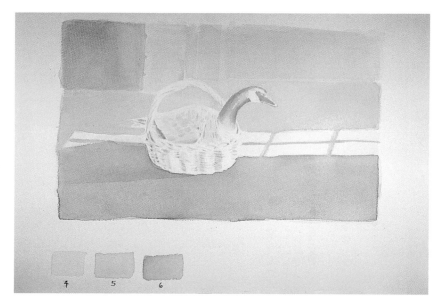

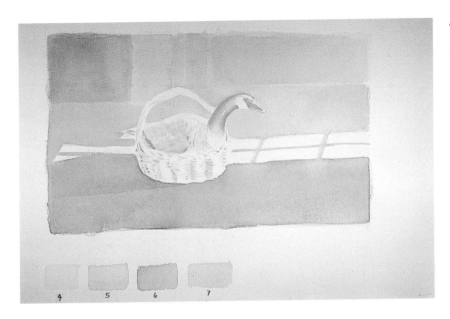

STEP 6 After the last wash had dried, I applied a dilute layer of Winsor blue to the areas behind the basket, around and in the hearth, and on the wall. And as the work developed, there were additional washes of blue.

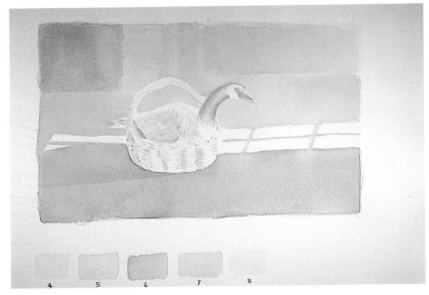

STEP 7 At this point it would have been unwise to develop the background and foreground any further without directing some attention to the goose and basket. Although it is apparent that throughout the various steps I had been applying washes to both the basket and the goose, I had confined most of the work to the larger sections of the painting. In the remaining steps, I will balance my efforts to make sure that the painting develops in a uniform manner. It may look as though the wash that was applied at this stage is very weak and could have been applied much earlier. However, the effect created by waiting is of more importance. By waiting to apply this faint wash, I was better able to determine just how strong the light on the basket needed to be in relation to the rest of the piece.

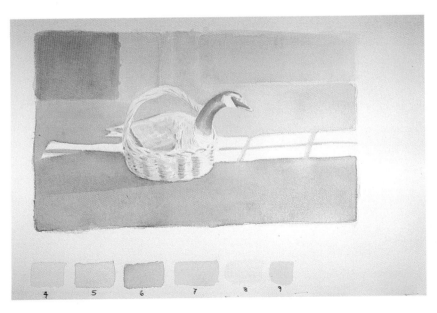

STEP 8 This step is composed of two parts because the same wash is laid in twice. First, I applied the wash to the hearth and allowed it to dry. Once the paper was dry, I carefully dampened it and applied the same wash to the hearth, around the basket handle, and behind the basket. I was very careful to watch the color as it dried in order to prevent any abrupt edges from forming. You can discourage these hard edges by blotting them with a tissue and by dampening the paper a little farther beyond the point where you expect to paint, so that your wash will have additional room to expand or bleed and thus automatically dilute to a feathered edge in the excess moisture. This may sound a little tricky, but with practice it becomes very easy.

Developing underpainting for texture and form

STEP 9 After the two blue washes had dried, I was ready to continue developing the basket and portions of the goose. At this stage, many of the washes are very direct and much like conventional water-color technique with not as much emphasis upon glazing technique. Here, I began using Winsor red to define and develop the texture in the basket. Light washes of this color were also applied to the goose's back in order to model the form and texture of the feathers. Many of the basic feather shapes were painted with individual strokes of the brush; in that way I was able to imitate the shape of a few individual feathers, thereby giving the illusion of a large mass of well-defined feathers. The same wash was also applied to the brick in the fireplace and to the right foreground.

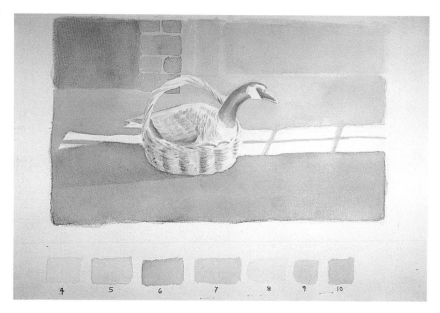

STEP 10 Once again the paper must dry between washes. Then I washed in a stronger blue in order to slowly bring the entire painting to a finished state. Note that the tone in the neck of the bird has been strengthened, as well as in certain shadows in the wings. The wall has also been darkened and the beginning of definition can be seen in the panel by the fireplace. The fireplace also becomes darker by this stage.

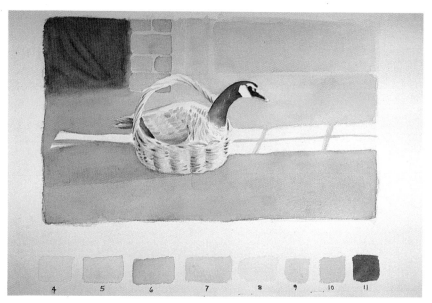

STEP 11 A final wash of dilute Winsor red was applied in order to bring harmony to the overall piece. Note its presence over most of the foreground and around the hearth area.

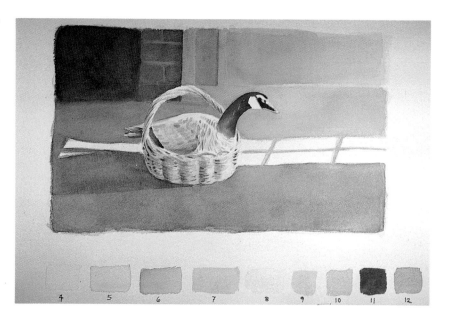

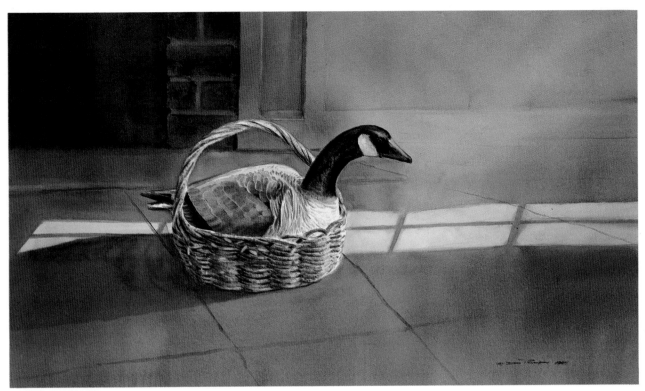

EARLY MORNING
38″ × 21″ (96.50 × 53.34 cm)
Collection of the artist

The finishing touches can be seen in the lines in the floor and the various shadow lines. Some of the highlights on the boards near the fireplace were scraped out with an X-Acto knife.

Keep in mind as you go through these exercises that it is important for you to use them as guidelines only. This is true because you will no doubt find a little variation in your own work. This variation stems from several possible factors. What is important is that you should understand *why* I chose to approach this painting in this particular manner. Once you understand the basic principles involved you will find a better way—your own way.

A word of caution about using a hairdryer to speed up the drying process between washes: don't do it! Although the hairdryer is not a bad alternative for practice work or studies, it has a tendency to create havoc on the surface of quality watercolor paper leaving your washes looking tired and dull. This unfortunate result happens because watercolor paper is made up of fibers that expand and contract as they take on and lose water. In some ways the paper is like a living, breathing thing that is subject to envi-

ronmental factors such as moisture. The paper behaves quite well when it is dampened and then allowed to dry at a normal rate. However, when something artificial and harsh like a hairdryer is introduced, the surface of the paper takes on a fuzzy quality. My personal conclusion is that the fibers become frizzy from the excess heat. While it's possible to use a hairdryer with some prudence, I favor allowing the paper to dry at its own pace. Although this does take up a great deal of time, especially in the beginning stages, I use that time to plan and consider alternatives, while I watch for puddles and examine the wash for any unwanted harsh edges or unpainted sections. While the wash is still quite wet is the only time to make corrections or blend some edges. After it begins to dry, it's too late. Once it is dry you may be able to use a bristle brush to smooth out harsh spots, or an unpainted area may be covered by a new wash or a later darker wash.

INCORPORATING OPAQUE TECHNIQUES

To devote a special section to opaque techniques while discussing glazing technique may seem rather odd. Normally, when you think of glazing, you think of transparent washes of color. After all, that is what glazing is all about—or is it? I would imagine that when the term "opaque" is used, most of you automatically think of gouache, or Chinese white, or "body color" if you are English. However, in this section, I want to explore another aspect of opaque technique. If you recall the transparency/opacity chart found on page 24, you will already know that watercolor paints fall on a continuum. These colors range from very transparent on one side to quite opaque on the other. But if you compare even the most opaque of watercolors with gouache, the watercolor will be much more transparent. So the term opaque is relative; it just depends upon what you are comparing.

In this section, two basic applications of opaque techniques will be discussed. The most common application is the introduction of a truly opaque paint into the watercolor in order to create a special effect or to extend the color range of the work beyond the normal range of transparent watercolor. The second, more subtle approach uses the natural opacity of some watercolor paints compared to others to create opaque effects and opaque/transparent contrast.

To clarify the term opacity I want to give a simple definition. Since transparency can be obtained by painting a darker color over a lighter ground, opacity can be achieved by doing just the opposite—by painting light color over a dark ground. Go back to

the chart for a minute (page 24). Note that every color is painted over the dark black ring. Except for the darkest, most transparent colors, the effect is markedly opaque. When lighter colors are painted over a darker ground, the result is an opaque effect.

Now the degree of opacity varies depending upon the strength of the wash. But in order to be accurate, it's still necessary to correctly label an approach as opaque when lighter color is painted over a darker wash.

In most beginning watercolor classes, diligent instructors point out to students that they should avoid painting lighter washes over darker grounds in order to avoid an opaque, chalky, or muddy look. (When you look at the color chart, you will readily see that some of the colors appear to be quite opaque when they cross the black ring.) While this is often sound advice, there are times when you can use the opaque quality of your paint to definite advantage. I realize that many people have never considered the term opaque in this manner. For many painters, opaque is body color or acrylic paint, but there is a more complete understanding of what this term means. While some artists think that "opaque" paints shouldn't be used in watercolor, others feel quite the opposite. This issue can turn into an endless debate; but that issue is usually based upon a very narrow definition of the term opaque, which doesn't consider the natural opacity of some watercolor paints. Harnessing the natural character of any color commonly found on a watercolor palette and making it work for you is a part of the painting challenge.

No one loves the effect of a good transparent wash upon clean, crisp white paper better than I do. But I also realize that my palette possesses a range of colors that clearly demonstrate a degree of opacity. To allow that natural resource to lie dormant would be a waste. This is especially true since the proper use of the opaque nature can help to create some very interesting naturalistic effects.

The following paintings range from the most obvious use of opaque paint to those that are less apparent.

ACRYLIC EFFECTS

I am absolutely fascinated by snow. I love to watch it as it swirls and blows across the land and covers trees, bushes, and roads. I love to see it early in the morning before the daily traffic destroys the purity of its white expanse. Snow is such an exciting thing; it turns the most ordinary of materials into objects of mystery and absolute beauty. A drab, neutral landscape can be transformed into something beautiful with even a slight snowfall. Several years ago, a brief snowfall in a small town in Pennsylvania inspired *Pennsylvania Storm.* This painting is a classic example of a transparent watercolor sprinkled with an opaque white. The basic palette consists of Winsor blue, cerulean blue, manganese blue, Indian yellow, and Winsor red. The sky and the treeline were handled in a conventional manner using the wet into wet technique.

I began this work by carefully keeping the house completely dry as I flooded the sky with clear water, and only a small portion of the painting received any glazing. Then, while the sky was drying, I dampened the foreground. I kept the two areas from merging by leaving a thin line of the white of the paper dry. You can see the line; it is now the top of the rock wall. In this manner I could work the foreground while the sky was drying without fear of their merging.

The rock wall received a pale wash of manganese blue and was allowed to dry. At the same time, I pulled some of the wash down into the foreground while adding just a small amount of Indian yellow to the wash. As soon as this was dry I laid a wash of pale Indian yellow on the right end of the wall near the tree, being careful not to get any yellow on the trunk of the tree. The remainder of the house was washed in a neutral gray mixed from the primaries; some of this same gray was used in the rock wall as well as the tree. Note that the brushstrokes create the texture of the wall, where I applied varying shades of colors to the wall as though I were laying the stone. In some areas of the wall, I took the point of my red sable round and allowed stronger concentrations of wash to seep into the bottom of some of the damp stones. This helped to create the illusion of shadow without creating a definite line. The tree is composed of a blue-dominated neutral, with some limbs of red-violet-dominated neutral. The shadow area of the main trunk is achieved by increasing the amount of red and blue in the wash.

The opaque acrylic paint used in this work was applied after the paper had thoroughly dried. At this point, I checked to make sure that some of the shadow values were extra strong because the flecks of snow would tend to obscure color in the painting. I sprinkled the white flecks off the end of a wornout toothbrush. I used acrylic for this work because it retains its strength and dries without fading.

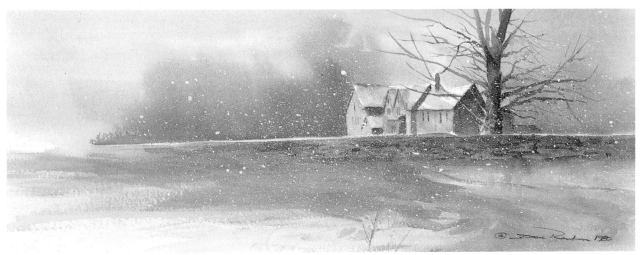

PENNSYLVANIA STORM
16¹⁄₂″ × 7″ (41.91 × 17.78 cm)
Collection of Sonat, Inc.

Incorporating opaque techniques

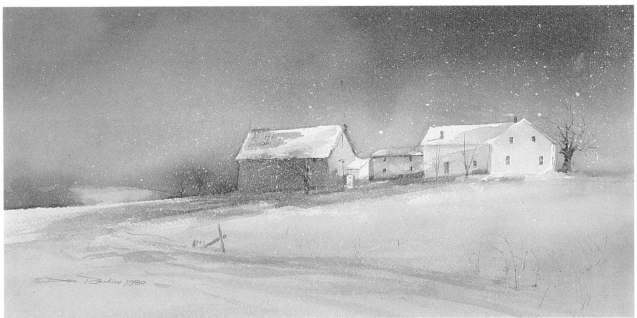

WINTER AT CHADD'S FORD
16″ × 7½″ (40.64 × 19.05 cm)
Collection of the artist

Winter at Chadds Ford is another small watercolor that was developed by using an approach similar to *Pennsylvania Storm*. In this case, the palette is more restricted; this time I used only Winsor blue, Winsor red, and Indian yellow. The washes for the sky and middleground were applied to a dampened sheet. After the sky area was dry, the paper was dampened in the entire sky area again. (I was careful not to wet the barn and house.) While this section was still damp, I introduced a wash, composed of Winsor blue and a little Winsor red, into the middleground to delineate the horizon. The dampened paper accepted the color much like a traditional wet into wet application. The big advantage of glazing is that you can predictably control the results a little more closely than a wet into wet passage.

In order to create the mood I wanted, most of the washes are keyed to the blue side. Even the grays used in the barn are affected by the blue dominance in the painting. However, the red in the barns provides a temperature contrast to the blue shadows between the buildings and the house. Temperature control is one of the advantages that comes from handling neutral color: you are able to create subtle yet effective shifts in color by merely altering the temperature of a wash. For example, if you place two colors next to each other, the warmer color will assert itself more.

The washes of the house create its entire form. There is very little in the way of linear detail to clutter the effect of distant pale sunlight on a white

house. The brightest lights on the house are provided by the pure white of the paper. The snow effect is created with a toothbrush loaded with white acrylic. With a little practice you can learn to flick up a blizzard.

Winter Watch is basically a transparent watercolor, but some opaque color was used in the final stages to give some body to the painting. The white of the window, curtains, toy horse, and the bear on the sled is the white of the paper. I began this painting in a friend's needlework shop. My interest in the scene was in the light as it played upon various pieces of antique furniture and toys. At first, I had a difficult time deciding how to edit out some of the various objects. After thinking about it and sketching a few alternatives, I chose to keep it simple, letting just a few of the many objects remain in the painting. The palette consists of Winsor red, vermilion, cadmium red deep, Indian yellow, Winsor blue, manganese blue, cobalt blue, new gamboge, and some white acrylic.

The shadows and the temperature of the light play an important role in the success of this painting. While the white of the windowsill appears simple enough, it required many washes of new gamboge, Winsor blue, and Winsor red to get just the right balance of color. (There are times when it is necessary to continue applying washes in order to get the right combination.) The curtains were laid in with mixtures of new gamboge and vermilion, and some pale washes of Winsor blue were used for the

96

shadows. The reflected highlight below the window-sill in front of the sled was created with a quick swipe of a bristle brush to scrub out the color. The area was immediately blotted with a tissue in order to remove any color residue that might have created an unsightly ring or discolored spot.

The bear on the sled was first modeled in pale washes of Winsor blue in order to establish its form. The light red areas are a mixture of vermilion and Winsor red; the darker reds are Winsor red and in some cases the darkest portions were mixed with Winsor blue. The gray blues are a mixture of Winsor blue and Winsor red. The blue on the shadow portion of the bear's leg is cerulean blue. The yellows are a mixture of new gamboge and vermilion.

The teddy bear on the floor is a combination of beginning flat washes of new gamboge that were diluted in the highlight areas and later wet into wet washes of Winsor red and Winsor blue. In some of the final washes I took advantage of the texture of the paper to drybrush color on, in imitation of the plush

of the bear. I felt that this area was the most critical section of the painting. If I could achieve the texture, color, and feeling of that bear the rest of the painting would work.

The opaque section of *Winter Watch* is found in the wall. I wanted a certain color and feeling in the wall, but felt I couldn't achieve what I wanted with transparent washes. Finally, my solution was to mix some acrylic white with cerulean blue and vermilion. This mixture was then flooded over the wall with a sweeping motion. I didn't attempt to cover the wall smoothly but rather gave it some texture and some breaks in the color. After these washes dried, I dotted in the wallpaper pattern with white acrylic. The opaque paint mixture helps to give some body to the color on the wall and thus serve to enhance the overall painting. The opaque used in this watercolor is probably not really worth mentioning. Most likely the experienced eye will see the opaque passages without being told where to look. In this case it was used to merely enhance the appearance of the painting.

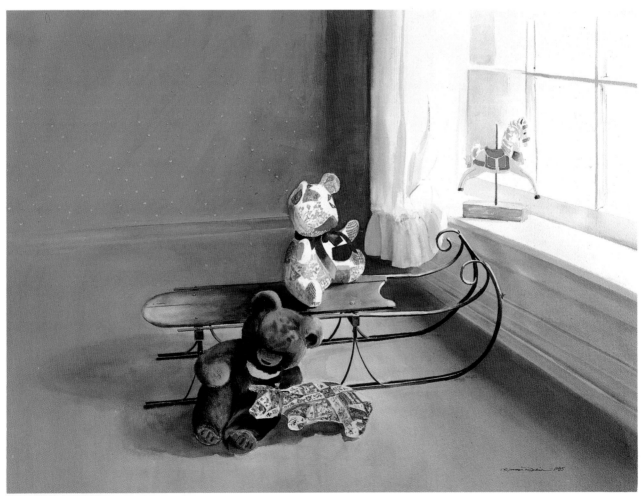

WINTER WATCH
25″ × 20″ (63.50 × 50.80 cm)
Collection of the artist

CHINESE WHITE EFFECTS

With the exception of the fish, *Down in the Stream* is an example of a totally transparent watercolor. I got the idea for this painting by taking the time to look into a quiet little pond where the leaves and twigs had settled out of the current and a small school of darters were swimming by. The fish created a kind of fleeting light show as the strong sunlight flashed off their tiny bodies. Obviously, a work like this requires maintaining a strong mental impression. Such experiences happen so fast that there is no way you can adequately capture them; they must be seared into your memory and then translated into paint.

I felt that the placement of the fish was most important to the success of this piece. If you connect an imaginary line between the fish toward the top and the fish toward the bottom, a triangular shape takes form. This pattern then repeats itself in a triangle formed by the leaves. Thus a smaller triangle inserts into another larger triangle. The rest of the painting is negative space.

There were no preliminary sketches for this work as my feeling for the subject matter was conveyed directly with paint. I began with the leaves and background to set the stage for the little actors who dart across the scene. In creating the fish I took a lesson from Sumi-e tradition which uses the natural shape of the brush to convey convincing forms. If you look carefully, you will see that these fish are nothing more than a simple brushstroke from a small red sable brush. In this case, I used two brushes: one loaded with a neutral, yet strong transparent wash of Winsor red and Winsor blue; the second loaded with Chinese white. First, I used the brush loaded with neutral color; then immediately upon finishing the first stroke, the Chinese white was touched at some point near the head or the side of the first stroke. The moisture draws the opaque white and the two colors merge: the result is a small silver darter. For some of the fish, I used the tip of the opaque brush to make fins. And after the washes were thoroughly dry, I used the fine tip of a brush to dot in their black eyes.

DETAIL *These fish are nothing more than the shape the brush takes as it is laid sidewise on the paper. The fine point of the brush creates the tail area and the blunt end creates the head. To achieve the shimmering illusion of silvery schools of tiny fish, a neutral blue wash was applied first. Then immediately following this initial blue wash, a small amount of Chinese white was touched into the blue with the tip end of the brush. The final step consists of dotting in the eyes with black paint.*

THE SUMI-E TECHNIQUE *While slowly turning the handle of the brush between thumb and index finger, drag the brush sidewise. This technique is easy but requires some practice to get a smooth rhythm going.*

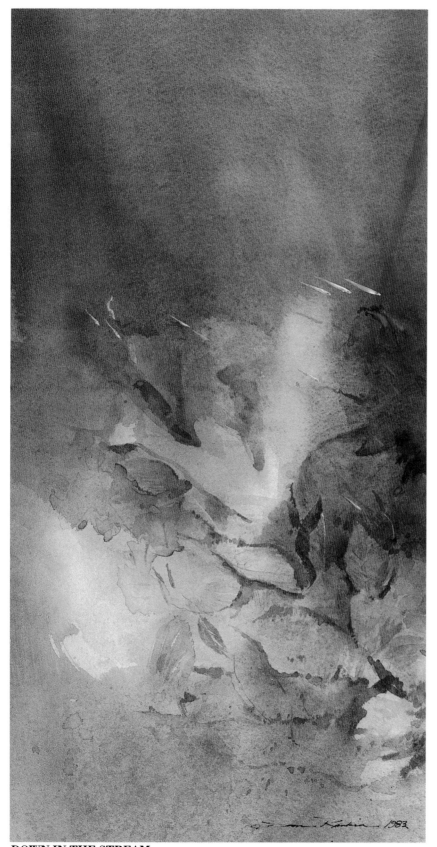

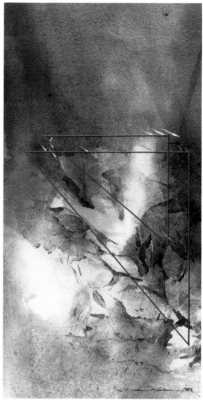

Two interlocking right triangles are formed by the school of fish. This compositional anchor lends a sense of stability to the piece.

DOWN IN THE STREAM
8¾" × 17" (22.23 × 43.18 cm)
Collection of the artist

OPAQUE WATERCOLOR EFFECTS

Pheasant is a good example of making full use of an expanded palette. The day I began this painting there was such a rich array of hues displayed in the early morning light that I just had to capture it with more color than I usually use. The palette consists of Indian yellow, Winsor red, Grumbacher red, Hooker's green, Winsor blue, Thalo yellow green, cerulean blue, and cadmium yellow. The painting began with a series of broad washes. In the sky, layers of dilute Winsor blue and dilute Winsor red were alternated until the color you see was achieved. To suggest the treeline on the horizon, I let the color get stronger as it nears the horizon line. The middleground and foreground were handled as one large wash of color. You can see the initial wash under the pheasant's tail near the water's edge. After the mixture of Indian yellow and Winsor red was applied to the foreground several times, I felt I had a good base to begin applying subsequent glazes. At this stage the paper was predominantly blue and yellow. Note that portions of the tree trunk and the pheasant were left untouched. Since these are large areas, it was easy to paint around them instead of using maskoid.

The first washes were applied to the dampened paper. If you look closely, you will see that these washes are lighter and appear to merge into the blue of the horizon. They also fade out on the far right past the tree trunk. In applying a wash like this there are only two critical areas—the bird and the tree trunk. I used a fine-pointed brush to make sure that the paper was carefully dampened with clear water around the wings and tail feathers. Then when the dark wash was applied, the moisture absorbed the dark wash and caused it to fill in around the outline of the bird. I carefully checked each area before the washes dried in order to take care of any problem spots.

The green of the tree foliage is a combination of washes: the first washes were Winsor blue and Indian yellow; later washes also contained a moderate amount of Hooker's green to help darken the color without making it too cool. The trunk of the tree received Winsor blue and Indian yellow mixtures to get the look of a beech tree. Preliminary washes of cadmium yellow and Indian yellow were washed into various areas of the bird's body. Cadmium yellow was used for the head and Indian yellow for the back. These washes were kept simple, yet bright. Later the feathers were detailed by using appropriate colors on the feathers. For example, the rust color is a mixture of Winsor red and a small amount of Winsor blue washed over an Indian yellow base. When the rust

mixture dried, it kept all of its rich, vibrant color. Cerulean blue was used for the wing patches on the bird's shoulders as well as in some of the striped shadow areas. The sheen of the feathers was created by using a very strong color adjacent to pale washes. The green of the head is Hooker's green deep washed over a cadmium yellow underglaze. Note that the Hooker's green is diluted in the center of the bird's neck, which allows the yellow to create the effect of iridescense. The red patch on the head is a combination of Winsor red in the cooler portion and Grumbacher red for the warmer. Both colors were painted in a strong wash over a layer of cadmium yellow. Although no heavy opaques are used in this painting, some opaque portions can be found in the twigs and grass in the foreground and in the buds in the middleground. In addition, some of the leaves in the dark shadow areas are Thalo yellow green applied in an opaque manner. These opaque areas are achieved not through an opaque medium, but by using watercolor colors such as cadmium yellow, Indian yellow, and Thalo yellow green that when used full strength produce an opaque effect.

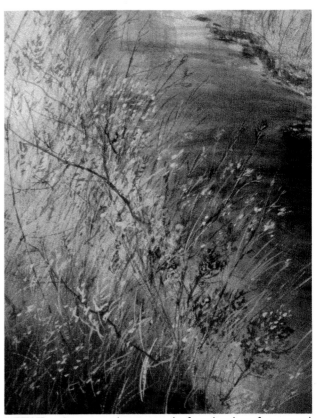

DETAIL *Opaque technique can be found in these foreground grasses. In this area, both drybrush and the fine point of a brush were used. These lighter touches of color—a mix of Thalo yellow green and new gamboge—applied over a darker background creates the opaque effect.*

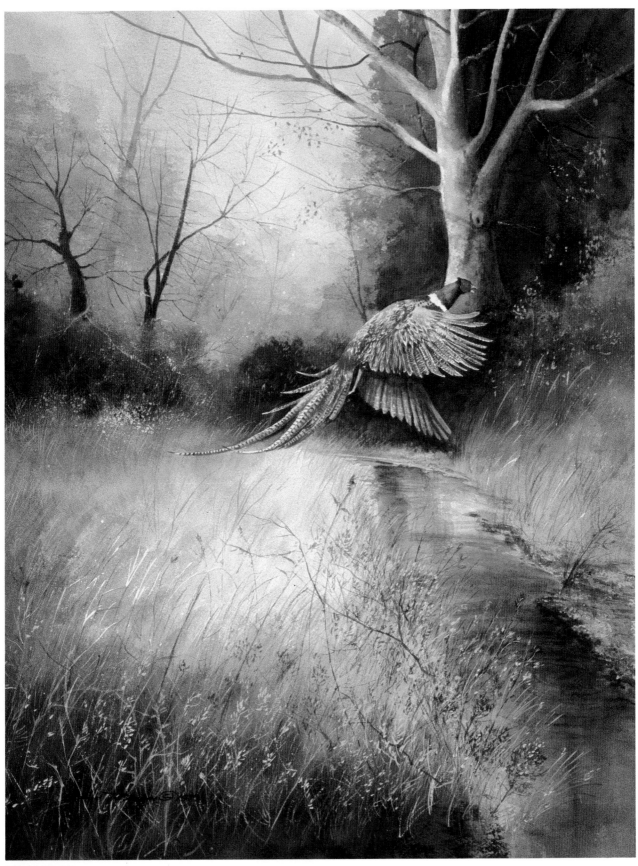

PHEASANT
20″ × 29″ (50.80 × 73.66 cm)
Private collection

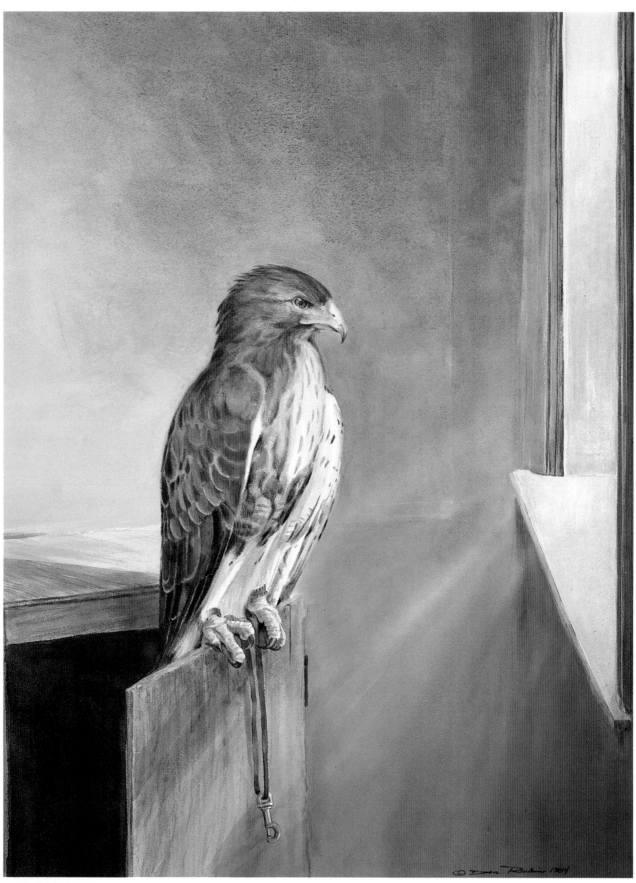

THE PRISONER
22″ × 28″ (55.88 × 71.12 cm)
Collection of Mr. Frank Lewis

The Prisoner evolved from an experience I had in The Great Smoky Mountains National Park. A Red-Tailed Hawk had been wounded and had been brought to a wildlife rescue center for treatment. With its wing healing nicely, the bird was scheduled for release into the wild in the following spring. To me, it seemed as though the bird understood that it would soon be set free and I set out to convey that attitude.

The opaque part of this work is confined to the windowsill and the edge of the distant window facing. Although all of the colors used here are transparent watercolors, I used opaque effects to convey the illusion of a hard surface and the old and textured look of built-up paint. If you look closely, you can see some of the drybrushed strokes used to convey the texture. Some opaque white is also crosshatched in the right-hand corner of the room to help define it. The palette consists of Indian yellow, new gamboge, Winsor red, Winsor blue, cerulean blue, manganese blue, indigo, as well as acrylic white. At no time was any of the white paint mixed with any of the transparent colors on the palette; it was used as white only.

This watercolor is a classic study in the use of neutrals. Except for certain areas of the bird the entire paper was bathed in several layers of new

DETAIL White opaque watercolor was used in this area of the painting to give the windowsill and wall areas the body and definition they need. This was done to set off the soft transparent look found in the bird and in the moody interior.

gamboge. This color was used to establish the light direction and especially the light filtering in at the bottom of the windowsill. After these layers had dried, I set about to create the neutral color that I wanted. In this case, the neutral is yellow-dominant, but very pale washes of Winsor blue caused it to shift to a very slight yellow-green cast. After this was dry I began to shift the color near the window in order to create a shadow area. I wanted to be careful to convey a low-light situation without getting dismal or murky. So the color dominance shifted to a red and red-blue scale. Study the background and the shadow areas. These colors are merely combinations of red, blue, and yellow. Nothing mysterious, just a little practice with neutral color. But the color harmony is solid because all of the colors are related to one another. The cerulean and manganese blues were mixed in combination with Indian yellow and a little Winsor red to create some of the green-grays you see in the shadow side of the windowsill. The light rays filtering into the room are very dilute washes of cerulean blue washed across a darker passage, thus the blue loses its blue character and appears to be white. These areas had been previously staged with the first layers of yellow wash. By that I mean those rays had been indicated with dilute passages of Indian yellow, so that they were lighter than the rest of the wash, much like an underpainting.

The hawk was painted with the same colors that were used to set the stage and mood of the work. However, perhaps I have told the story backward, because this work actually began with a very detailed blue underpainting of the bird. Other areas of the painting were not treated with a blue underwash because I wanted to avoid cold shadows and too much dark. I spent a great deal of time laying in the darkest parts of the bird's wing in order to get the modeling to look the way I wanted. Although tedious, layering is definitely worth the effort.

After the blue underpainting was completed, it's important to know that a yellow wash was applied to the head and beak and then allowed to dry. It was at this point that I began to develop the head. The eye received a very strong yellow wash before a mixture of Winsor red and a small amount of Winsor blue were laid in. The color on the hawk's head is related to the color on the shoulders. The shadows under and to the back of the bird's beak were created by applying Winsor blue. Farther down the back, the color changes character as more blue is introduced into the mix. Remember that from head to tail the color range is achieved by merely altering the ratio of red and blue in relation to the yellow.

Incorporating opaque techniques

In contrast to *The Prisoner, Winter Orchard* was executed much more rapidly. The palette is manganese blue, Winsor blue, Indian yellow, and vermilion. I began with a loose sketch to establish placement of the tree, then I dampened the paper with clear water, being careful to avoid wetting the larger sections of the tree trunk. The sky was washed in first. The first layer was dilute Indian yellow, which covered most of the paper except the brightest highlights on the tree. At the grassy base of the tree I allowed the yellow to become quite strong. The second wash was manganese blue, which was confined to the portion above the horizon line. After this had dried, I wet the paper again. Once more I avoided the larger sections of the tree trunk in order to keep them light. I then laid in a mixture of vermilion and Winsor blue. You can see how strong the first wash was by looking at the lighter section around the base of the trunk. These individual sections were watched for puddle formations until the paper had dried. Any minor corrections, such as irregular or harsh edges, were smoothed out while the wash was still wet. Once the sheet was dried, I dampened it again. This time I increased the strength of the wash and flowed it into the darker areas. Clear water had puddled along the base of the wash, so I allowed it to dilute the wash and create the effect of light or mist you see in the painting. Once this was dry, I brushed in Indian yellow, rather thickly, in a drybrush manner, to suggest grass blowing in the breeze. This was left to dry and then pale washes of Winsor red and blue were washed in to modify the yellow color.

The tree consists of neutral grays, with some of the shadows suggesting reflected light through the use of pale yellow washes in the shadow area. After the texturing work was completed on the tree trunk and darker limbs were painted in to enhance the suggestion of depth, I began to use manganese blue in the shadow areas. Final small limbs were scraped out with the point of an X-Acto knife.

Because light color has been washed over darker passages, *Winter Orchard* demonstrates certain opaque techniques. If you are not careful with this sort of thing you can definitely produce a muddy painting. At the very least, you can wind up with some chalky passages of color. However, there may be times when you want chalky passages. The key to success here is to understand that some approaches can lead to difficulty and attempt to understand why

this happens. Ordinarily the opaque look of a lighter wash laying over a darker wash is not the kind of effect you want. Yet in this case, in late afternoon light, the fungus on this old tree looked blue in the shadows. I could have observed the rules and put the blue down first, but not only would it have been tedious to preserve among darker washes, it wouldn't have given the same effect.

DETAIL The bluish tones found in this tree trunk captures the actual coloring of this kind of tree in late afternoon light. An opaque effect was created by washing a lighter manganese blue over the dark ground of brownish red.

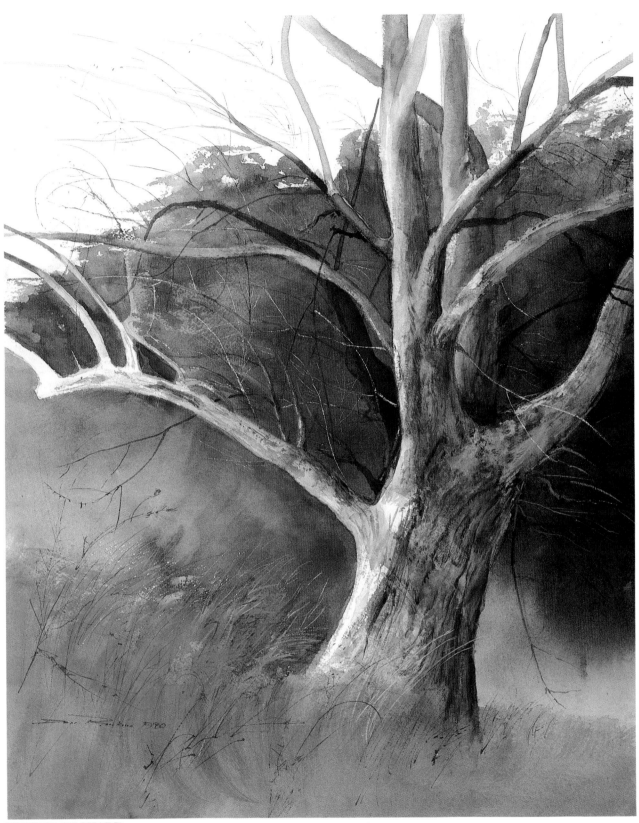

WINTER ORCHARD
13″ × 20″ (33.02 × 50.80 cm)
Collection of Robert Linthout

Incorporating opaque techniques

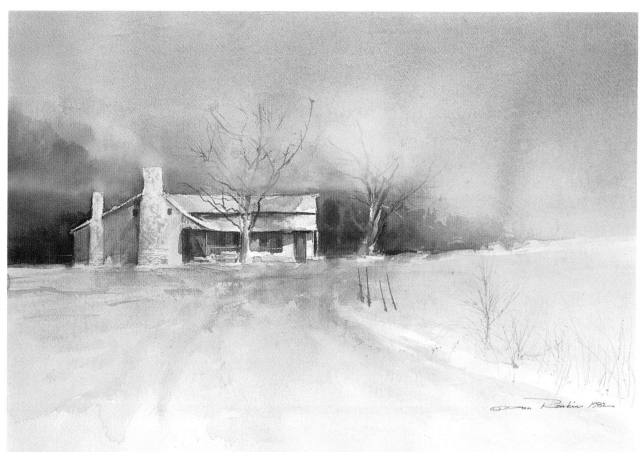

VIRGINIA STORM
15″ × 11″ (38.10 × 27.94 cm)
Collection of the artist

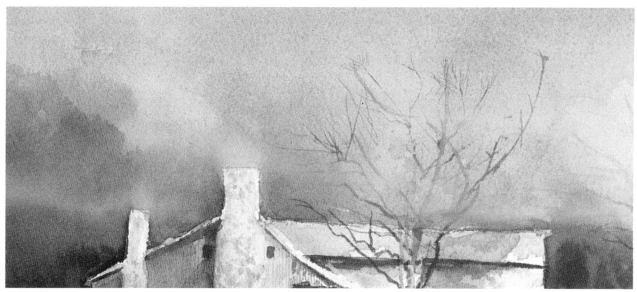

DETAIL *This smokey look was created by initially dampening the background with an evenly distributed wash of clear water. Then, with a ³/₄″ Aquarelle brush, a wash of cerulean blue was pulled across the dampened area and allowed to bleed throughout, creating a natural look of haze filtering through the trees.*

Virginia Storm makes use of the character of certain colors. It is a simple little watercolor with several glazes of color upon it. To my mind the smoke hovering over the house makes the painting work. In fact, it was the smoke that caused me to paint it. The entire work was developed around new gamboge, Winsor red, Winsor blue, manganese blue, and cerulean blue.

In a case like this I like to combine blues in order to achieve a particular sky color. So after a very pale wash of new gamboge had dried, I laid in a layer of manganese blue. You can determine its presence in the upper portion of the sky; it is the base color that has settled into the dimples of the watercolor paper. Some of the manganese blue was allowed to flow in around the front of the house. After everything was dry, a wash of dilute Winsor blue was applied. When this wash crossed the horizon line, a little Winsor red was added to it, which helped to gray out the intensity of the blue.

Several layers of direct wash were applied to the foreground, so that the color harmony between foreground and sky was established. As soon as the paper was dry, I began building up the tones for the dark trees behind the house, a process that was done in three or four stages. At the very top of the treeline, you can see the strength of the first wash. All three washes consist of Winsor blue and Winsor red. Bear in mind that I knew how I was going to achieve the smoky effect. Rather, I should say that I thought that my plan would work. I purposely left a portion of the background weaker than the rest of the section; I merely diluted the wash in this area. I also did this in the tree limbs that are covered by the cerulean blue smoke. This is a part of the illusion. The cerulean blue is just a normal wash, not a heavy opaque passage. It gives the illusion of having a great deal of covering power because many of us assume that the limbs and foliage that are obscured are of the same strength as those elements that are not covered. This is an erroneous assumption. You can achieve similar effects with French ultramarine blue and other fairly opaque colors such as Thalo yellow green, cadmium yellow, and cadmium red light. Once you understand the character of the individual colors you can use your imagination and create some beautiful effects. In this case, the cerulean blue was washed in after all the dark passages had been completed. The area above the roof line of the house, extending across the paper and for several inches above the treeline, was dampened with clear water. The cerulean blue wash was applied in the areas as you see it and then allowed to flow and settle on its own accord. Note that

it is stronger in some places, but in others it appears to disperse and feather away to nothing—just like real smoke. A word of caution: be careful when you dampen an area like this. Be sure that your brush and your water are clean. In some cases it's better to dampen the entire sky in order to prevent an abrupt line from forming across your wash. Most often this won't happen, but in some cases it could.

DEMONSTRATION

All of the colors used in *The Edge of the Cliff* are standard watercolor paints that we call transparent watercolors. It was painted in my old studio near the top of Shades Mountain. On top of this mountain there is a small strip of land that has survived the ravages of progress because of its rough terrain. Most people are unaware of its existence and don't know that with only a small amount of effort it's possible to believe that you are in the deepest wilderness, far from civilization. From season to season there are delights of wild violets, native orchids, jacks-in-the-pulpit, trilliums, a wide variety of ferns, and all manner of growing things.

The Edge of the Cliff was painted in the studio, but it was born out of actual experience. The time was early morning in early spring. There had been an unusually severe winter for our region, and the green of spring seemed to be unusually vibrant and intense, especially in this little pocket of land. I was excited by the light, and some of the colors were incredibly vivid against black shadows. So my immediate response was emotional; but in the studio I had to apply logic.

As you study the progress of this painting, you can readily see the wide range of color value. This was a case where the use of some color in an opaque manner was an ideal solution.

As stated, the light on the flowers caused them to glow against their background. That glow of white was my most important concern here. So instead of using opaque white, I chose to reserve the white of the paper because opaque colors just don't produce the same quality of light that transparent colors do.

The white of the flowers was preserved by two methods: maskoid and careful painting. Personally, I prefer the careful painting approach. By doing so I can flood an area with clean water, but make sure not to wet the area that I wish to reserve as white. Then I just flood the wash in and allow the nature of the wet into wet technique to paint for me. However, in this painting, I used a combination of the two techniques. The maskoid was used in the areas where several flowers touch or overlap one another.

Incorporating opaque techniques

After I had worked my sketch out and was satisfied with the planned design, I got ready to paint. It is my general practice to transfer the sketch directly to the paper before I soak it. To transfer the sketch, I use a lightboard. Years ago, I would use tracing paper and homemade "carbon" paper. With that method the transferred drawing usually lacked the sensitivity of a direct sketch, so I changed my approach in order to preserve the spirit of the drawing. The dull lines that I got from the old tracing method made it difficult for me to translate the feeling that was in the original drawing into a sensitive watercolor.

My studio is equipped with a walk-in shower, which makes it easy to soak large sheets of watercolor paper. I soak my paper in cold water for a short period of time. The objective here is to dampen the sheet enough to insure a uniform surface when it is stapled down. Naturally as the paper dries, it contracts and forms a tight surface. I don't attempt to stretch the paper as I staple it; I just smooth it enough to straighten it and get the bubbles out. Then I leave

the sheet stapled to the board until I finish the painting, when it is removed from the plywood.

Remember that when the paper is damp it is vulnerable to abrasion and pressure, so be careful while you handle it. Once you damage the surface, it will show up in the dried wash. Usually the damaged portion will show up as a spot that will be several degrees darker than the surrounding wash. This damage can happen if anything presses against the paper when it is damp, so be very careful with the surface of the paper. Some readers will discover in this characteristic an opportunity instead of a handicap. You can use this characteristic to your advantage when the paper is still wet. Either before or after a wash is applied you can use your fingernails or other items to inscribe fine lines or various shapes into the damp paper. However, don't confuse this technique with scraping out color when a wash is almost dry. In fact, you might have done this inadvertently while trying to scrape out color in a wash too soon while it was too damp.

STEP 1 As mentioned, the sketch was put on the paper before it was soaked. The small amount of maskoid that is used was placed upon the paper before it was immersed in water. Although I really don't like using a masking agent, I did use it on a few of the flowers that were so closely clustered together that I would not be able to reserve the white of the paper without masking them out.

The first wash was applied wet into wet. When I began to dampen the paper I was careful to paint with the clear water around the individual flowers. Some painters will not want to go to the trouble to do this, but I feel that the result was worth the effort. While I was dampening the paper, I would have to add additional water in order to keep the paper from drying out before I could finish the tedious task of outlining each flower.

The first wash to be laid into the wet paper was new gamboge. Since the paper was stapled flat and contained no ripples, the color oozed into place around most of the flowers without much coaxing. In this wash, I didn't attempt to be deadly accurate, except with the shape and placement of the flowers. After all, the flowers were the reason for the painting. In the rest of the piece I let the wash flow without a great deal of manipulation. My primary objective was to reserve the whites of the flowers; the secondary objective was to develop the middle-tone and shadow values.

STEP 2 Once the sheet was completely dry, I was ready to apply the second wash. In this application I used a mixture of Thalo yellow green and Indian yellow. Note that the Thalo yellow green is predominant. This wash caused the watercolor to look too "hot" in value. The later washes would modify that condition, but at this stage I needed the strength of the color in order to set the stage for the rich, vibrant effect I wanted. This wash was applied to the entire paper. Once again I premoistened the paper, especially around the flowers, in order to make coverage easier. This wash was especially critical for developing the intense, fresh spring greens that I had encountered on the edge of the cliff. As you examine this step, compare it to the final work. Notice how these early washes show through and influence the finished painting. Examine the direction of the washes. It is important to understand that every wash, every stroke is executed with a definite purpose. All of these strokes and washes come together to create a finished statement.

STEP 3 In this step the character of the painting begins to assert itself. Some of the color-value relationships are almost set and others are strongly suggested. The application of Thalo blue begins to bring the color closer to the final statement. If you examine the flowers closely, you will see that they were not completely defined. As the washes continued to develop, greater care was taken with their finished appearance. Each application of wash was utilized in order to refine any mistakes or omissions made in previous layers.

Incorporating opaque techniques

STEP 4 This layer of wash (a mixture of Winsor red and blue) was introduced to help neutralize some of the predominant yellow-green in a few areas. In fact this wash was only applied to the right half of the upper portion of the piece and to the bottom half below the flowers.

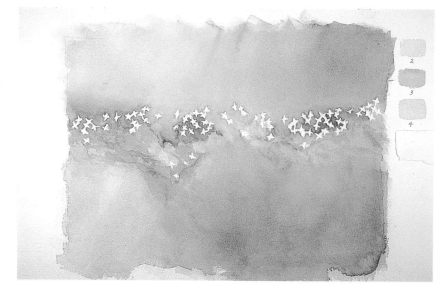

STEP 5 I applied another wash of Winsor blue to further tone down the green. At this point some of the areas around the flowers were rather ill-defined. While the color was being corrected, most of the detail in painting was still very nebulous. I had kept it that way so that I'd be able to take advantage of any abrupt changes in the work. Since no shadows or detail were definitely set, changes wouldn't be as difficult to accomplish.

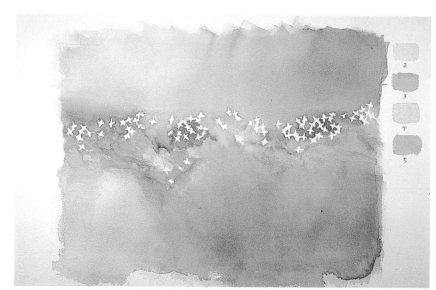

STEP 6 I felt at this point that the painting wasn't very attractive. In fact, a stage like this in the painting process often requires a great deal of faith to continue. But in spite of its appearance at this point, many important things were established with this dark wash. Remember, the color bar indicates the average value of this wash. This dark passage can be achieved by mixing Winsor red in equal proportion to Winsor blue. In some cases, it may be necessary to add indigo in order to get the value dark enough. With this wash I established some of the major shadow values. I also continued to refine the white flowers. Note the value of some of the leaves; you will see that they are quite green. This is a part of the original washes that were applied for the background. I merely reserved some of this color by painting the darker washes around the basic leaf shape.

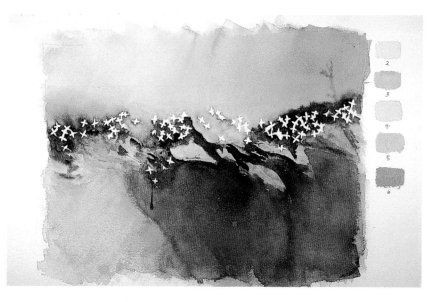

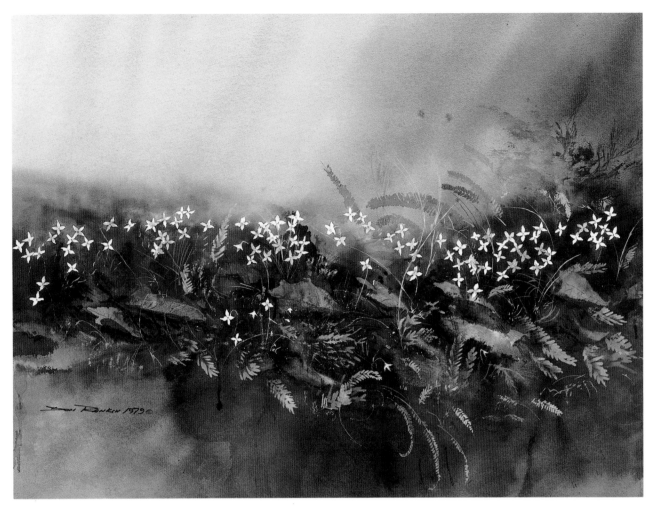

THE EDGE OF THE CLIFF
23¾" x 17" (60.27 x 43.18 cm)
Collection of the artist

FINISHED PAINTING It was during the final stages that I began to use the paint in an opaque manner. Examine the shadows and note how they vary in value. These opaque washes are nothing more than Thalo yellow green which was painted over much of the shadow area at the base of the painting. Even though yellow green is an opaque color, it is still transparent enough to be affected by the variation in shadow values over which it was painted, a fact which caused all of

the fern fronds to automatically fall into proper color relationship with the surrounding color. The same holds true for all of the vines and stems that were painted in with the same color. The ferns were painted in using the edge of a no. 5 round sable brush.

In order to create the effect of dancing light, I varied the strength of the white flowers. Some of the flowers on the right side of the painting were cast into light shadow. This was accomplished with a

mixture of cerulean and Winsor blue. The centers of the flowers were painted with a mixture of vermilion and Indian yellow.

At this stage most of the painting has been completed. However, there were a few finishing touches to be made. Some of the flowers were highlighted with the tip of an X-Acto knife and one or two flowers were scraped out with a knife. Several of the leaves were modeled with vermilion to impart texture and to help regulate their color value.

Incorporating opaque techniques

STEP 1 Creating the illusion of white flowers on a dark background can be easily accomplished without using masking fluid. To begin, carefully dampen the paper, making sure that none of the flowers are dampened. Then wash a layer of new gamboge over the wet sheet of paper. With a little coaxing, the wash will seep into every damp crevice around each flower. Since watercolor is inherently transparent, these flowers will be harder to obscure with each succeeding application of wash.

STEP 2 After the new gamboge has thoroughly dried, dampen the paper again. Once more, make sure to avoid wetting the flowers. Once the paper is damp, apply a wash of Thalo yellow green mixed with new gamboge.

STEP 3 This step is critical; here you must be very careful in your application of a layer of Thalo blue around the flowers. You may even find you need to clean up the edges around each flower as this wash dries. If you want darker shadow areas, add a little Winsor red or indigo to the next wash of Thalo blue.

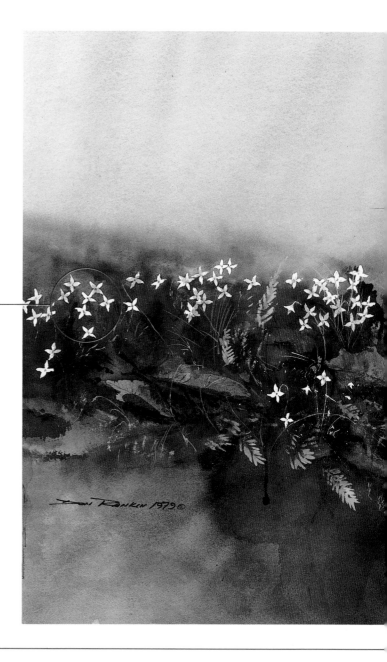

STEP 1 Establish a warm green background, using new gamboge and Thalo yellow green.

STEP 2 Apply a dark mixture composed of Thalo blue and Winsor red.

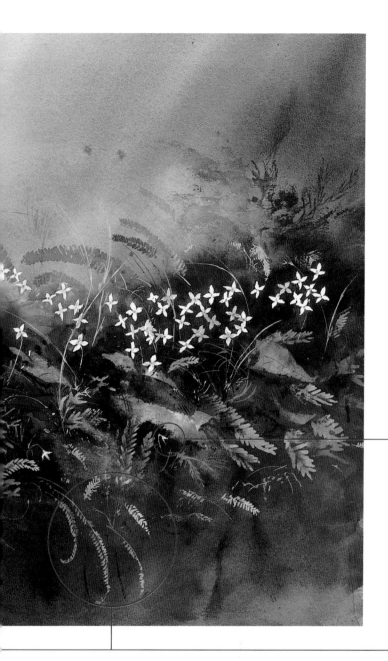

STEP 1 Create a warm green background using new gamboge and Thalo yellow green.

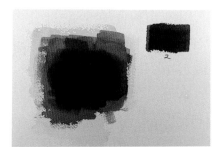

STEP 2 Add a wash composed of Thalo blue and Winsor red to establish the color of the shadow values.

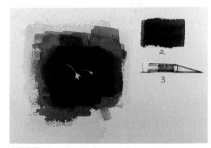

STEP 3 Once this dark area is completely dry, carefully scrape out the white flowers with the point of an X-Acto knife.

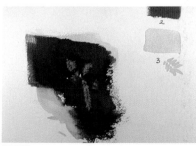

STEP 3 Upon this dark background, allow the brush to create the fern fronds. If you are not familiar with these brushstrokes, closely examine the shape of the fern leaves. They are really nothing more than the shape that a Winsor & Newton Series 7 brush takes as it is laid lengthwise on the paper.

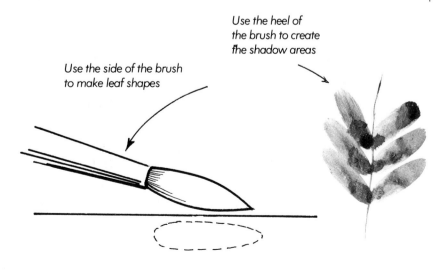

Use the side of the brush to make leaf shapes

Use the heel of the brush to create the shadow areas

SUMMING UP WHAT YOU'VE LEARNED

This section deals with one painting only. While the subject doesn't embody all of the problems that can be faced in composing a landscape, it does present some of the most basic ones. The subject of an old mill has been a challenge for me for over twenty years. Back then a teacher of mine took me to the site and simply told me to draw it. For six months, I wore out many a magic marker trying to capture on paper the old mill. I loved its textures and angles as well as the light, but I hated my miserable attempts at solving the problem. No matter how I tried, no drawing seemed to really convey the mill's elusive quality. Within these first frustrations was born a love-hate relationship that existed for several years. Some time later, I returned to the old mill. While I had learned a great deal, I was still not satisfied with my efforts to really capture the essence of this place. At this point I really felt that I would probably be better off taking a photograph of the scene and forgetting the whole matter.

DEMONSTRATION

As a result of my continuing dissatisfaction with my efforts, I put the old mill out of my mind. From time to time, I would pass by, but I would not allow myself to become absorbed by the place. I would take a glance and leave it at that. I went on to other challenges and time eased the memory of my frustration. Through an interesting chain of events I went back to the old mill two years ago. This time I decided I could take on its challenge. I'm showing you this process here in the hope that it might help you in

solving various technical as well as attitudinal problems in dealing with challenging subject matter.

From the very beginning, I was painfully aware that there was no difficulty in sitting down to do a slick, superficial watercolor of this obvious scene. This was the ideal setting for creating just another "pretty picture." But there is much more here than that. I wanted to go beyond a mere surface statement, but I didn't want to go so far that no one would recognize the subject. These were the restraints that I had voluntarily placed upon myself. Perhaps a part of the difficulty lay in the fact that the old mill was and still is a very popular landmark. Most people in the area are very familiar with the scene. Many artists have captured a likeness of the place in various media. At this point in my life, I see two major obstacles to overcome when trying to successfully paint a well-

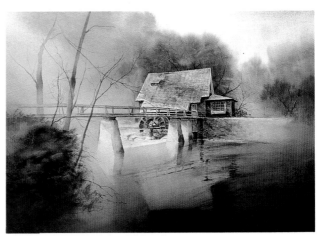

Finished painting of The Old Mill

known landmark. Aside from it being well known, you may be so familiar with the location that you tend to overlook it or take it for granted to such a degree that you never really see it. In this way a casual familiarity may tend to inhibit your full expression of the scene. Also, it can become too easy to accept others' viewpoints without truly seeking or revealing your own. This happens a great deal when you choose to copy someone else's work without thinking and attempting to solve the problem with your own mind. Every artist must remember that his/her viewpoint is all he or she truly has. You will never see anything as your neighbor sees it.

When I returned to the old mill I set about to find a different way, a fresh angle from which to paint. In order to help you understand the challenge I took a series of photos of the site. The valley in which the old mill exists is thick with trees and its dark, foreboding lighting creates some interesting visual effects. In late winter and early spring the afternoon sunlight barrels down through the valley, at times like a searchlight. After the foliage comes out, the light becomes diffused and much of the mill falls into shadow.

As you look at the photographs, you will see that there is no photo that corresponds to the angle I chose to paint. That is because from this angle a photograph would only reveal limbs and undergrowth. So I took artistic license and made some major modifications. If you could get past the undergrowth, you would see the mill as it appears in the painting.

Because of my familiarity with the location, I decided to review a few vantage points. Armed with a camera and a sketchbook, I began to gather material in order to help me decide upon the approach I would take. Most of the decisions were actually made on the spot. Back in the studio, I began to refine the rough drawings I had made on the site. In conjunction with my sketches, I took almost three dozen black-and-white photos. I use black and white almost exclusively. My primary interest is in recording place-

A typical view of the mill

Summing up what you've learned

Most people see the old mill from a very restricted vantage point on the road.

A few hardy souls climb down the bank in order to get a different perspective on things.

The lighting is very tricky down in this valley. At some times of the day it is very dark; at other times, it is strongly illuminated by the afternoon sun.

A detail of the foot bridge that goes to the mill

ment, shape, form, and time of day. I use the shots to help me remember the scene. I do my own photography and compose my own shots. In many cases I compose the shot from the same angle as my sketches. This helps me to recall the situation when I am in the studio. Very rarely do I use color in my sketching shots. I prefer to compose my own color renditions on the spot. In some cases the color is so vivid in my mind that no reference is needed. In fact, years ago I had occasion to use color photography to remind me of a beautiful subject. I had the vision planted in my brain, but I chose to await the development of the color photography. The moment I saw the developed pictures, my vision left. I completely lost a beautiful painting through one look at a mediocre color snapshot. Never again. For many years, I refused to have anything to do with photography in conjunction with my sketching. I firmly believed that it could prove to be a trap that would weaken my ability to draw. I still believe that it can be a trap if you let it happen. However, a camera can be a wonderful tool *if* you use it in a proper way. In short, don't try to trace photographs or copy them blindly. Your work will show it and you'll be the loser.

Now study the progression of sketches and compare them with the photography as they progress toward the steps to begin painting. The amount of time spent on each sketch varied. Some of the sketches were quite involved while others were unrealized and somewhat crude. Regardless, each line served a purpose. That purpose was to communicate to me and to help spark my memory. I think sketches should be like shorthand notes. As long as I know what they say, nothing else really matters.

Preliminary pencil sketches for The Old Mill

Summing up what you've learned

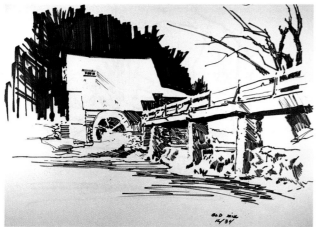

Executed in felt-tip pen, this sketch takes another look at the mill from a different vantage point.

Preliminary for the final reference sketch.

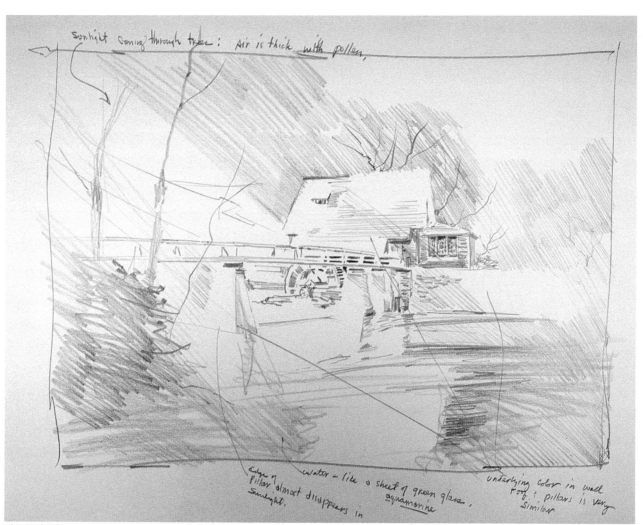

This is the final outdoor reference sketch before studio work was to begin.

After considering alternatives, I chose to develop the old mill as you see it in these sketches. Much of the painting was left to be worked out in the actual painting sequence. My palette consists of new gamboge, Winsor blue, manganese blue, Winsor red, and Thalo yellow green.

STEP 1 The final sketch was transferred to the watercolor paper. Note that certain parts of the sketch are very finished, but other areas have been left vague. In a painting like this where a lot of soft color is going to be established, I don't like to have my senses irritated by a bunch of pencil lines.

As soon as the major elements had been sketched in place, it was time to paint. I began with a Winsor blue underpainting, using three values of blue. Take time to study the underpainting. Make yourself take note of what is painted and of the areas that are not. Much of the character of the finished work will be set with a few pale blue washes. Consider the part of the underpainting that indicates the water. The character of this wash reflects the smooth flowing quality of water. The reflections, some of the ripples, and the shadows were all suggested by this first wash. The major shadow areas, the direction of the light, and the reflections of various items in the water have all been established. Note that some of the major darks are set from the very beginning. These areas grew even darker as the work progressed. But even more important, the placement of these darks helps to suggest the mood of bouncing light.

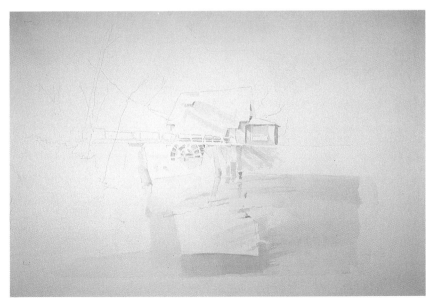

STEP 2 As soon as the blue underpainting was completed and dry, I put the entire sheet of paper into a basin of water and allowed it to soak until thoroughly wet (about five minutes). I then took the wet sheet and stapled it to a wooden board. While the paper was still very wet, I applied a dilute wash of new gamboge, but avoided those areas where the highlights do not contain any yellow. I also avoided the sky. The yellow wash helped to establish a mood of sunny warmth.

Summing up what you've learned

STEP 3 *After the new gamboge wash was dry, I merely brushed in a mixture of Winsor blue and manganese blue, being careful to dampen a large portion of the sky as well as the tree area. In this manner the blue wash could bleed out to a feather edge if necessary, so there would be no harsh, abrupt edge to disturb the flow of the washes that would make up the foliage.*

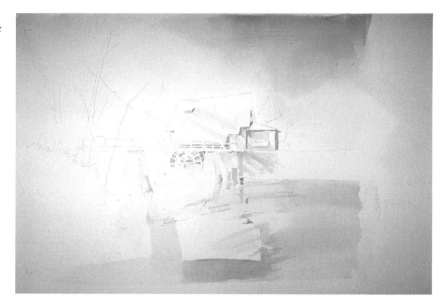

STEP 4 *After the previous wash had dried, I was ready to proceed with another layer of color. Since I was intent on portraying an early spring day, with soft yet direct sunlight filtering through the pollen-laden air, I wanted to keep my washes very soft instead of hard-edged. The best way to accomplish this was to paint wet into wet. The wash applied here was flowed over damp paper. The upper portion of the watercolor was dampened with clear water. Care was taken to avoid the mill area. Also note the indication of light coming in a diagonal sweep from the left corner. In this area the wash was diluted and it may have been necessary to apply more than one layer of this color. It all depends upon how intense your wash is after it dries. Do not hesitate to modify your color if the need arises.*

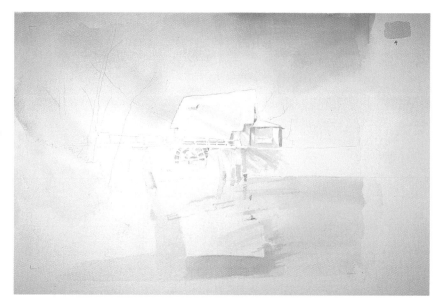

STEP 5 *This wash is a mixture of new gamboge, manganese blue, and Winsor red. As the color dries it separates, creating several shades of orange and yellow. This wash was confined to the upper portion of the painting and was allowed to seep down the rock wall into the water on the right side of the picture plane.*

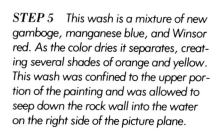

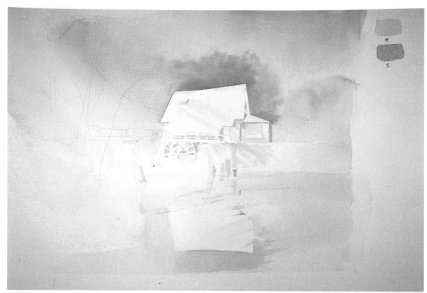

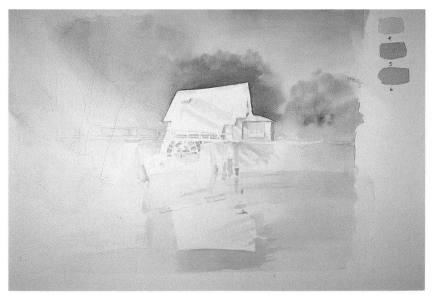

STEP 6 Several washes were applied in a wet into wet sequence. One of the applications was a mixture of Winsor blue and Winsor red. In this step as well as the previous step, all washes were applied to very damp paper. While these washes are difficult to control, I was able to contain them to some degree by wetting only the sky and the upper portion of the painting. I applied the washes with the edge of a square sable brush while imitating the general shape of trees. Naturally, the washes spread out and became feathery soft on the edges, which was advantageous because I was intent upon creating the effect of fresh spring growth upon the trees.

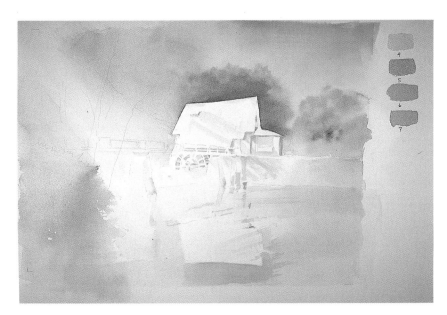

STEP 7 While the upper portion was drying, I decided to apply a mixture of Thalo yellow-green and new gamboge to the underbrush in the lower left corner—a very simple operation. Later, this color would be modified with cooler washes to create shadow in this area.

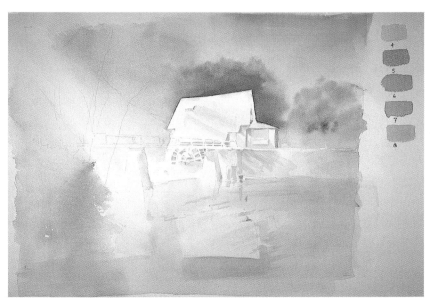

STEP 8 In order to bring the rest of the painting into balance, I applied the first full layer of color to the water and to select portions of the roof and masonry. Capturing the color and the sparkle of the water was a real priority for me in this watercolor. The wash was a combination of manganese blue and new gamboge. On rare occasions, the water flowing down out of the hills in this area will be clear and sparkling like aquamarine. This was one of those days when the water was not cloudy. As a result I took a great deal of care to get the color right. As you study the example you will see that this color was also used as an underwash on the shadows of the rock walls and pillars, as well as the roof. When sketching the scene, I made note that these areas are closely related in color harmony.

Summing up what you've learned

STEP 9 *After the wash had dried, I decided to further strengthen the foreground of the painting. I did this by applying a slightly bluer mixture of the previous color combination. Before applying the wash, I wet the water area with clear water. While it was still damp, I washed the color in with a sweeping diagonal motion. I was extra careful to avoid placing any additional color in the section under the bridge at this time. If a color correction was needed in this area it could be done at a later date. My purpose here was to create a form of graduated wash. The strength of the color was in the foreground; it gradually diminished as it moved toward the horizon.*

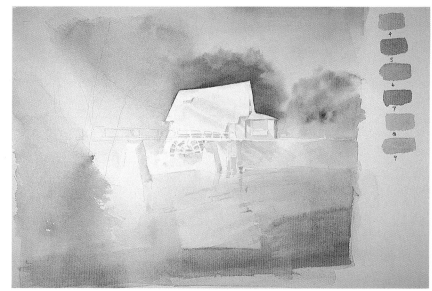

STEP 10 *A neutral wash consisting of manganese blue, new gamboge, and Winsor red was mixed on the palette and washed into several areas. Examine the trees on the left side, the bridge, the waterwheel, the roof, and the rock wall. This wash helps to develop the overall balance. In this step the color on the rock wall was applied as individual brushstrokes, imitating rough-hewn rock. As more color was applied this texture became more prominent.*

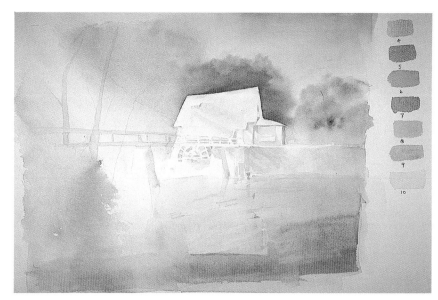

STEP 11 *The neutral wash that was applied next is very close in color and value to the preceding layer. Although it was mixed from the same formulation, it is just a bit darker. This wash was used to begin texture in the roof and to continue building texture on the rock wall to the side of the mill. These are critical steps that will not be readily apparent to the untrained eye when viewing the finished work. These seemingly bland neutrals will help give support to the darker washes that cover them. All in all, they help to contribute to the patina of age that shows through in the finished piece. This neutral wash was also applied to the shadows in the reflections.*

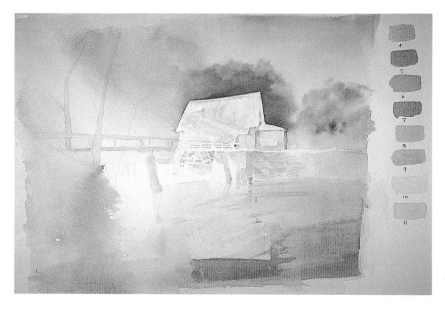

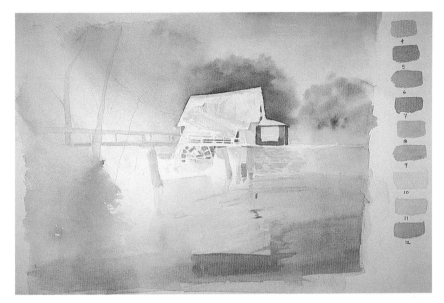

STEP 12 At this point, I was finally reaching the stage where I could concentrate upon strengthening color values and shadows. In many ways this watercolor has been built upon the traditional method of establishing middletone values and then adjusting highlights and shadows to bring the piece together as a working unit. Since this is transparent watercolor, there is one modification to this approach. In this case the highlights have already been established. The rest of the painting fell into a near-middletone value. The only thing left to do was to introduce the shadow passages.

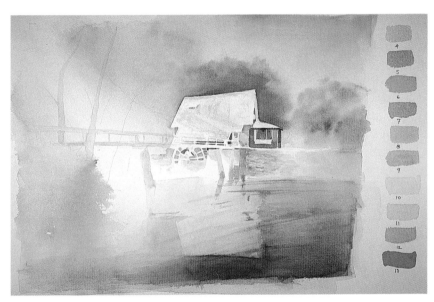

STEP 13 I began to develop the darker tones with a series of washes using Winsor blue mixed with Winsor red. Some of the specific areas include the water in the foreground, some of the areas in the trees directly behind the old mill, and naturally the windows and doors. In some cases, I applied two coats of wash.

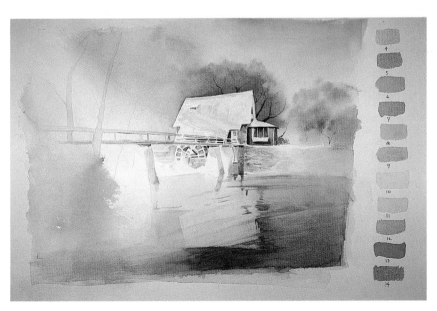

STEP 14 In an effort to continue refining this painting, I applied another mixture of Winsor red and Winsor blue. This time the color is almost blue-violet, a color used to strengthen shadow areas on the mill, the waterwheel, the bridge, and in the foreground around the mill. With this step, all color mixtures used in the painting have been introduced. The remaining work is merely a continuation of the previous steps.

Summing up what you've learned

FINISHING TOUCHES In order to present the most accurate account of the final passages of color, I want to highlight specific sections of the finished piece. Once the foundation of color has been carefully laid, there should be little difficulty following the final applications.

The character of the water has already been established. However, it is not yet dark enough to work in the overall relationship of the painting. At this stage it should not require more than one or possibly two washes to firmly establish the darker value. That value can be established by using a mixture of Winsor blue and a little manganese blue. The area of highlight under the bridge should not require any modification provided your color looks like the sample. Please observe that the color is darkest in the lower right side of the foreground. Also notice that a mixture of Winsor red and Winsor blue has been used in the shadow area around the reflection of the mill. After these washes have dried, examine the ripples and darker shadows in the water. Strengthen them if necessary.

Using a mixture of Winsor blue and Thalo yellow green with Winsor red, begin to darken the value on the underbrush in the left foreground. Test your color on a separate piece of paper to make sure that you are satisfied with the green shade. Continue mixing the proportions until you get a nice, strong, dark green that's not too bright. Compare your color with the finished example. When you are satisfied with the results, paint it in. Be especially careful to blend it into the water to avoid leaving a harsh edge.

Using a no. 5 or no. 6 round red sable, refine the detail in the rock wall underneath the waterwheel and on the other side of the bridge. As you study the stones you will see that a number of previous washes have been diluted and used

on the walls. Some of those colors are nos. 9, 10, 11, and 14. Use this only as a suggestion. If you need to modify color in order to fit your painting, feel free to do so. The final darkest shadows will be a mixture of Winsor red and Winsor blue applied carefully with a sensitive line.

Now is the time to put the finishing touches on the mill. Starting with the roof, use a red sable round to work in the shingle lines. In some cases use the side of the round to create texture on the shingles. The colors used on the roof are combinations of manganese blue, faint amounts of new gamboge, and Winsor red. Regardless of your final mix, note that the roof and the rock walls have a similar color quality. Remember that the roof is critical to the overall success of the painting. In order to convey the effect of weathered cedar shingles, the color and contrast should be in proper relationship to everything else in the watercolor. After you have nearly finished the roof, move down to the waterwheel and darken any passages that should require attention. Aside from sharpening a few shadows and scribing the lines in the window, the mill should be complete.

At this stage there are a few final touches that still need to be made. For example, the trees on the left side need a little extra attention. Carefully dampen the trees individually and allow a little dark neutral wash to create some variation in the color. Also paint in the rest of the trees in the general area. Make any necessary adjustments to the trees on the other side of the creek behind the mill. The highlights were scribed with the sharp point of an X-Acto knife. After these tasks are accomplished, you should carefully examine the painting to make sure that all relationships are pleasing. Make any adjustments necessary to make your painting work as a total unit.

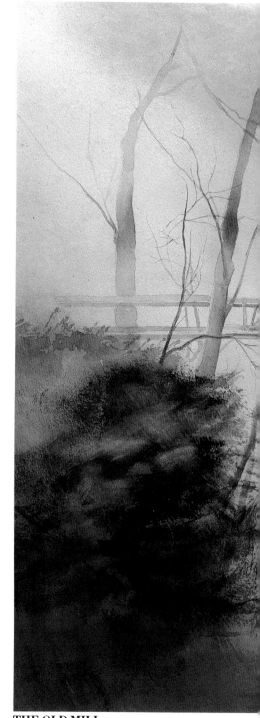

THE OLD MILL
27" × 18" (68.58 × 45.72 cm)
Collection of Mrs. Nancy Lewis

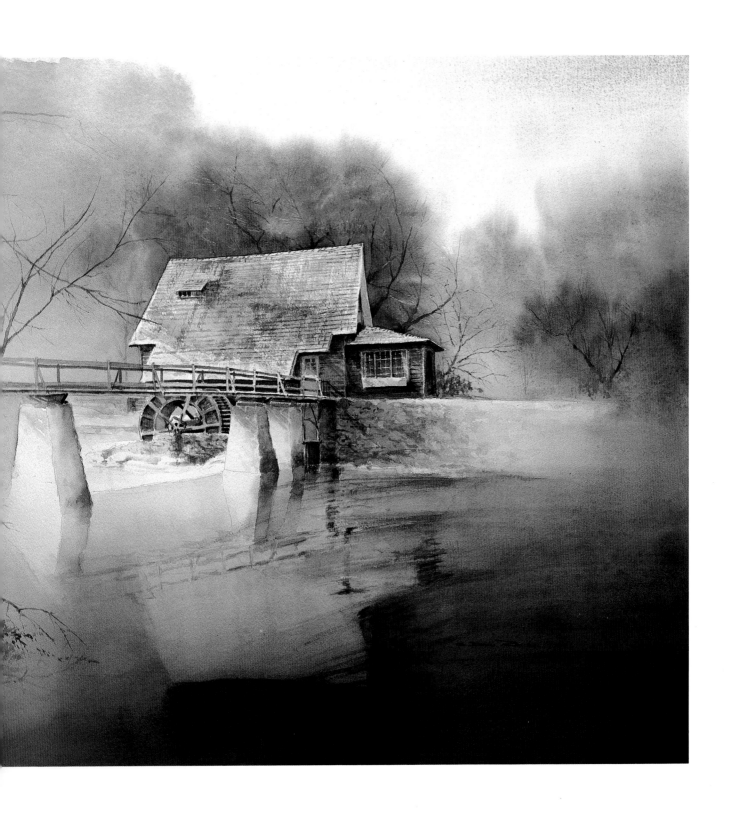

PAINTING OUTDOORS

It would be incorrect to assume that the glazing technique is strictly a studio procedure. Indeed, with a little forethought, you will find it readily adaptable to outdoor work and on-site painting. The degree of glazing you utilize in the field will be in direct proportion to your patience level. In most instances you will find that the washes dry faster outdoors than they do in the studio. I readily confess that much of my work centers around studio procedure. However, much of this was because of earlier habits and necessity. Years ago, career demands required me to spend much of my energies in a studio atmosphere. This left me very little time to spend on outdoor painting. It has been my pleasure to know some excellent painters who rely quite heavily upon outdoor painting experiences. It is my firm belief that every artist should seek to gain outdoor skills.

There is much to be gained from developing this skill. I don't think there is any question that it will help to sharpen your competency as an artist. Painting directly from nature puts you on a keen competitive edge. It does so by forcing you to make some rather quick decisions. Also, it forces you to deal with color and light in their natural realm.

My sketching sessions fall into two categories, planned and totally unexpected. If it is unexpected, a sketch may wind up on any piece of paper available and my drawing instrument will be anything that is handy. When I am on a planned excursion, I go prepared to work in a variety of ways. In the summer and spring, especially in the South, the sun can be very difficult on your eyes. I am thinking specifically

of working on a white sheet of paper in the spring or summer sun. The glare can be very trying. This is one of many reasons that I like to work with Chinese white and India ink on toned paper. The sun is not so harsh on my eyes and I love using the color of the sheet as a middletone value. In that manner, by merely concentrating upon highlight and shadow, I can have a developed drawing in very short order.

When it comes to sketch pads, I keep a variety of them available. A good pad for outdoor work ought to contain a decent sheet of paper that will accommodate a variety of pens, as well as pencils. In some instances, I paint watercolor sketches in my pads. Sketch pads should be made to endure a lot of work and abuse without coming apart. That is one reason I like the type that is loosely bound with a spiral-wire binder.

Although in general I use a good many tools to create my sketches for outdoor work, I probably use ball-point pens and felt-tip markers more than anything else. Years ago, I worked almost exclusively in pencil, but I found there were some problems with that approach, specifically with the pencil's tendency to cause smudging. When I do use pencil, I enjoy working with large carpenter's pencils because they provide a fairly large chisel edge. This enables you to draw with a broad stroke or with just a turn of the point, a very fine line. Today, for my planned trips, I mostly use felt-tip markers as well as my chisel-edged or square brushes. In fact, I shift from markers to watercolor depending upon the subject and my time schedule. For example, if time is short, I will

use a felt-tip marker and work as rapidly as possible in order to gather as much material or information as possible. But if time and circumstance allow, I will use my brushes and cover my sketchbook with quick color sketches and/or value studies. For best results learn to be fluent with a variety of approaches to outdoor sketching. Sometimes the versatility you possess will make the difference between successful sketching and missing that opportunity.

The amount of material you take on location is directly proportional to your strength and stamina, but it's a good idea to refine your selection of equipment. I usually carry a French easel (it folds up into a suitcase) if I'm going to paint as well as watercolor blocks, brushes, water, paints, and other incidentals. Everything except the easel goes into a carrying case. Inside the carrying case, I put my brushes in a brush caddy and clean water is kept in an ammunition can, which makes a very handy water-tight container.

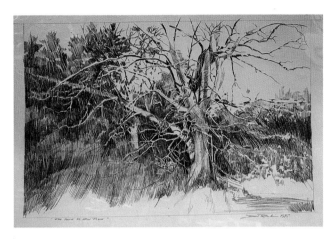

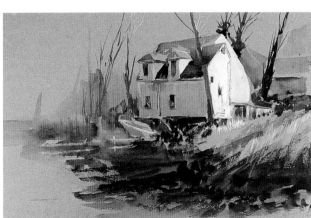

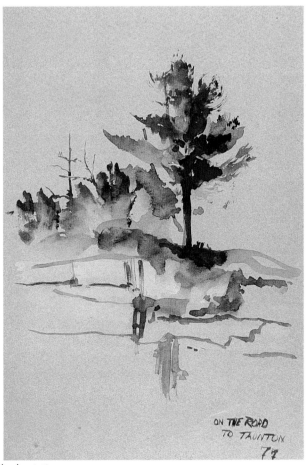

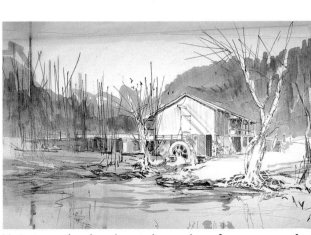

Various pencil and washes studies used as reference sources for finished paintings.

Painting outdoors

The following three pieces are part of a series that grew out of several sketching trips. These three paintings are of the same church at different times of the year. In preparation, several sketches and some photographs were taken. In some instances, some sketches were used in more than one of the paintings.

In *Cades Cove* I wanted to capture the feeling of that clean white church sitting in the midst of all of the early summer green. The angle of the church and the path are basically very accurate renditions of the site. The treeline has been modified in order to provide a strong backdrop behind the church. I wasn't concerned that many of these trees were in fact broadleaf trees, and with a sweep of the brush, they became pines and hemlocks. I did this because I wanted strong color and simplified shapes behind the building. On the left side of the church, I took artistic license and removed a few trees to enhance the illusion of depth on the horizon. This effect tends to draw you into the negative space. As for the building itself, I was particularly interested in the effect of shade and sunlight upon the wooden siding. In some areas the expanse of sunlit white wood was so bright that all detail was obscured; but in other areas the angle of light caused the detail to be rather pronounced.

The underpainting in this piece was confined to a brisk, yet rather intense wash of new gamboge. If you look very carefully, you can see this color just past the church on the horizon; it gives the effect of sunlight filtering into the clearing past the church. A wash of olive green was applied over the new gamboge as soon as it was dry. The darker greens are a mixture of Winsor blue and new gamboge. The darkest values of green were mixed with indigo. The tombstones are Thalo blue and manganese blue as well as a little Winsor red. The neutral grays on the building were mixed from the same arrangement of color. Some Winsor red and new gamboge were mixed into the chimney and rust stains on the roof. This watercolor was executed in a relatively short period of time. The primary objective was to retain the flavor of the initial sketch.

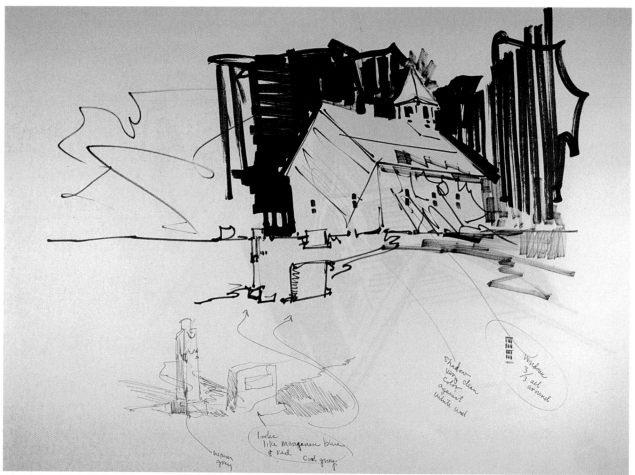

Initial sketch for Cades Cove

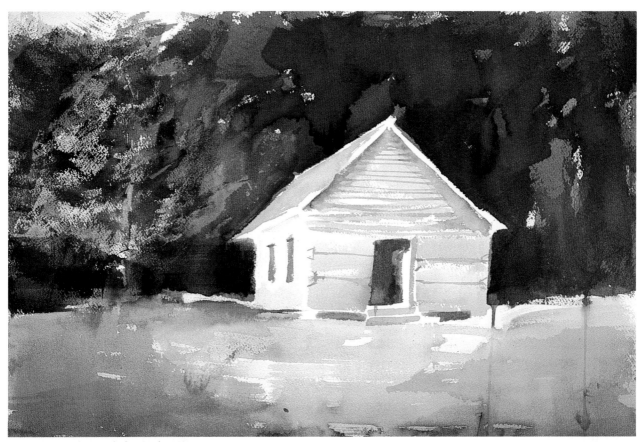

Preliminary value study for Cades Cove

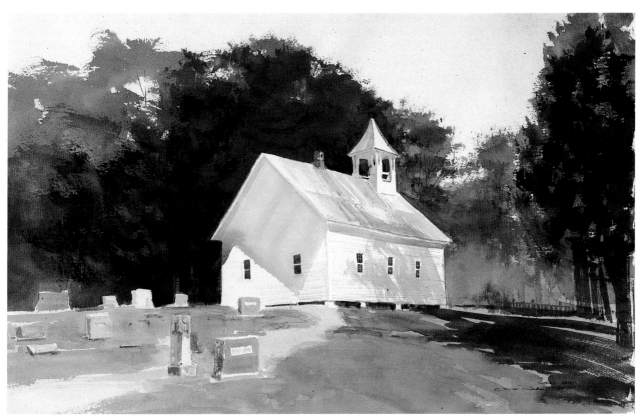

CADES COVE
24″ × 10½″ (60.96 × 26.67)
Collection of the artist

Painting outdoors

Sunday Morning required a little more thought and a little more time to plan. This old church brings back memories of attending services in old country churches. As a child it always seemed like Sunday was sunny and bright. I can remember looking up at the sky past the steeple on those Sunday mornings and seeing the brightest blue sky.

The concept for *Sunday Morning* is very simple, nothing but a steeple piercing a blue sky; and the palette is very limited, at least in obvious color. I began my idea by attempting to incorporate more of the church facade than you see into the painting. But as I continued to consider the matter, I decided to simplify. Because in terms of design, this approach can become very static; I purposely shifted the image slightly off-center to help give the work more interest.

The sky is a series of layered washes. There are at least seven applications of varying strengths of Thalo blue and manganese blue. You can spot the manganese immediately if you will look for the granulation patterns on the paper surrounding the steeple. I continued to let each layer dry and then applied another until I achieved the depth I wanted. The detailing on the tin is a mixture of Thalo blue and Winsor red. The white of the wood is a neutral of new gamboge, Winsor blue, and Winsor red. In the peak of the eave you see two light strips of wash—that is the color that was applied first. I left them for indications of reflected highlights on the ends of the siding. There are a few other examples of bounced or reflected light on the wall. In some areas of the steeple roof and in shadow areas, I used the same neutral color but I cooled it off with Thalo blue. The bell is Winsor red and Thalo blue.

Preliminary sketch for Sunday Morning

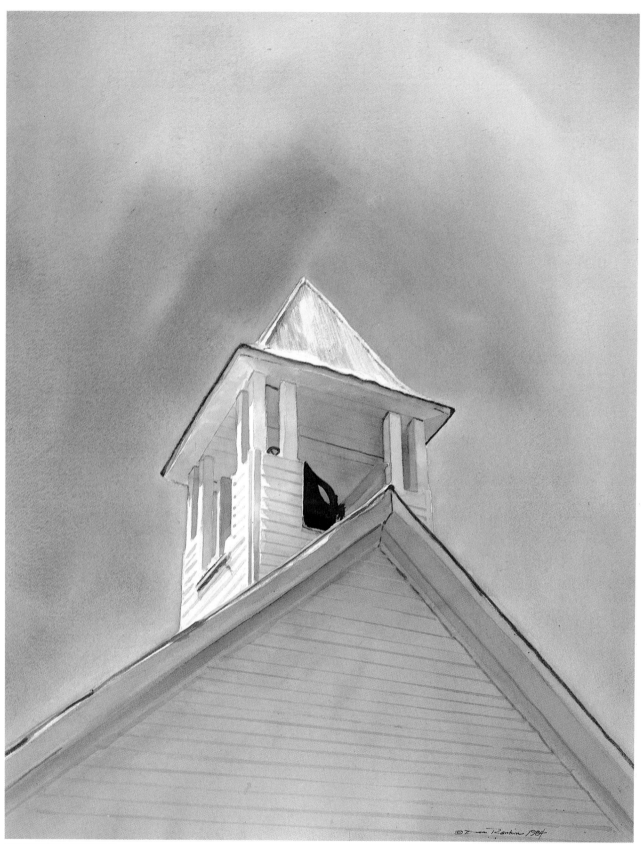

SUNDAY MORNING
19³/₄″ × 25¹/₂″ (50.17 × 64.77 cm)
Collection of the artist

Preliminary sketch for Mountain Mist

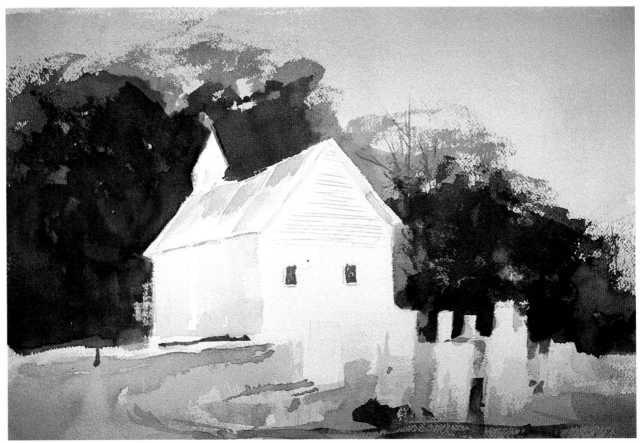

Watercolor sketch for Mountain Mist

Mountain Mist is the most recent of this outdoor series. In this piece I moved some of the elements around in order to strengthen the composition. I also removed a number of trees and changed the type of trees that are present. I was particularly interested in capturing some of the blue haze that often shrouds these mountains. That blue quality can change from a pale haze to one of intense blue; it all depends upon the weather. In order to achieve the blue I wanted, I used multiple washes of Thalo blue and manganese blue with a little cerulean blue thrown in on the last wash. On the right side of the church, the blues are a little cooler because of the introduction of a little Winsor red into the wash. The darkest blue shadows are indigo. The foreground is a primary wash of new gamboge covered by a dilute wash of Thalo blue. The grass texture was indicated by using a bristle brush to scrub it up a little just before the blue wash dried. The tombstones are varying mixtures of Thalo blue, manganese blue, indigo, and Winsor red. The indigo and Winsor red were used mainly for shadow work. While I was interested in the smoky blue quality on the horizon, I was delighted by the expanse of solid white on the end of the church that faced the sun. Except for the two windows and a little shadow work, there is no wash on the paper. While the light was strong enough to burn out the shadow detail, it was still a hazy blue day.

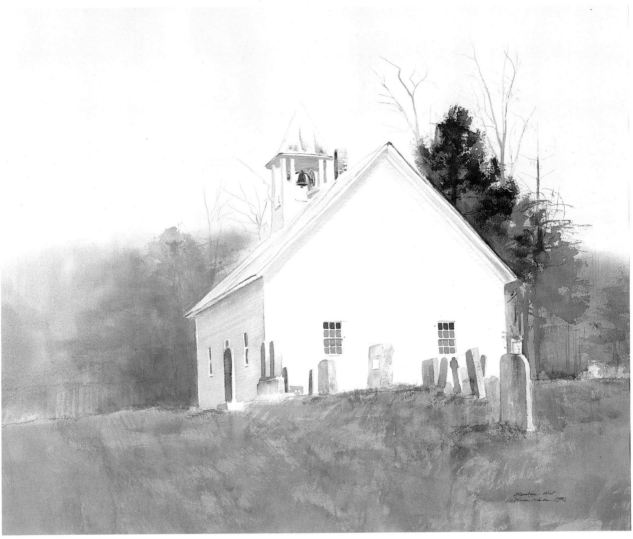

MOUNTAIN MIST
27″ × 23″ (68.58 × 58.42 cm)
Collection of the artist

Painting outdoors

The rest of the paintings in this section were all painted on location. In most cases no sketches exist, except for the few pencil lines underneath the wash. Most of the pieces were executed fairly rapidly. Some of them contain more glazing than others. I think that one of the most important things to be learned in outdoor painting is to focus your attention upon the task at hand. It is so easy to allow yourself to become distracted by all sorts of things. In some cases, however, it is wise to remain aware of your surroundings. I have become so involved in my work that in one painting session I very nearly stepped off the edge of

a cliff. As I recall, after that the painting didn't turn out too well. In each of the pieces shown here I made selective edits of the available subject matter. I focused my attention upon one aspect of the landscape and allowed the other elements to fall away.

Up on Lightning Hill is a typical scene that still exists in the South. In many places in Alabama there are still unspoiled old farm houses such as this, but you have to move quickly to get ahead of the real estate developers or the highway department before they knock them down to make way for something new. Because things can change so rapidly, I try very

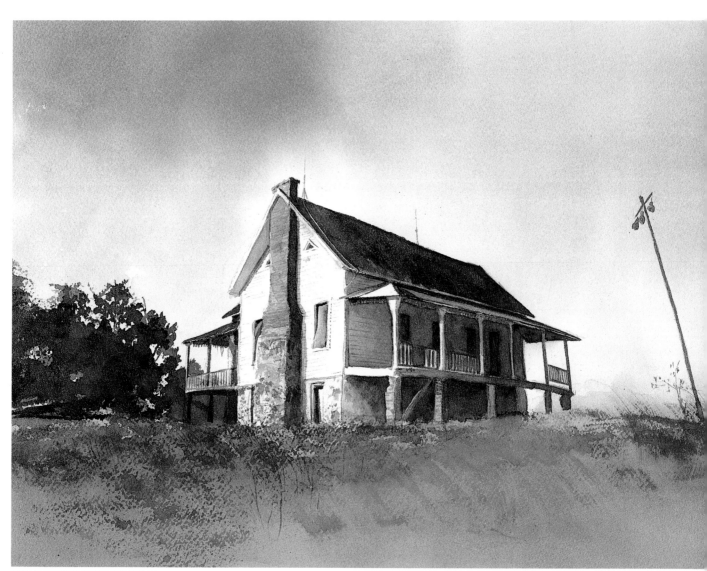

UP ON LIGHTNING HILL
18″ × 10″ (45.72 × 25.40 cm)
Collection of Sonat, Inc.

hard not to delay when I find something that I really want to paint.

This painting was developed with a palette of Thalo blue, new gamboge, and Winsor red. I began the work before the sun had gotten to the angle depicted in the painting. This gave me time to apply several washes of Thalo blue in the porch area. Much of the detail was subdued and cast into silhouette. I find this to be an effective means of communicating.

In sharp contrast to the finely finished *Up on Lightning Hill* is this little piece that was quickly completed in one afternoon. There was very little

time to think about this one. In fact, it really has no name, so for identification I shall call it *Young Deer*. My intention here was to do a value study on the quality of the light coming through the trees in this particular spot. I had washed in several layers of new gamboge, Winsor red, and Winsor blue and was quietly waiting for it to dry when as if on perfect cue, a deer walked into the scene. I did a quick Sumi-e of the deer, which means I let a few quick strokes of the brush define its form. In fact, I didn't do it too well. The deer looks like a young moose. Maybe I should change the title.

YOUNG DEER
Sketch on paper

Painting outdoors

Near the Salt Marsh is a work that was done on location in Ocean County, New Jersey. It consists solely of neutral color built upon neutral color. Most of the colors tend to be yellow-dominant with a wash of Thalo blue used on the building to create contrast. This was one of those bright, somewhat colorless days in early June. The palette was limited to vermilion, new gamboge, and Thalo blue.

Early Winter Morn was painted using the same palette as *Near the Salt Marsh*. However, this piece was painted on a hillside in Alabama in the fall of the same year. While the same palette was used, the strength of the colors was shifted to accommodate the change in the season. With careful observation, you can see that the base color was used in the field as well as the building, except near the left side of the barn where the highlight is indicated. After the washes dried, contrasting color was washed over the field and over the barn. In some areas the blue dominant of the barn merged with the red dominant of the field. The result is a very fluid watercolor that was built upon a neutral warm wash.

Melting Off is a little different departure for me. On delightfully rare occasions I get to paint in the snow. And this watercolor was one of those cases. While there was snow on the ground, it was not so cold that my watercolors froze. On some occasions, I have had that happen and it can produce some delightful effects. Basically, the water freezes into crystals of ice and when it melts, it sometimes leaves crystal-like patterns in the wash. This pattern is usually very interesting and totally unpredictable.

The palette consists of Winsor blue, vermilion, and black India ink. The surface is hot-pressed watercolor board. First, the blue and red mixture was swirled into the sky and foreground and allowed to dry. Then a stronger wash of red and blue was washed into the treeline and allowed to dry. The finishing touch was the use of the ink washes, which run through alternate areas of wet and dry paper. In some places the ink has merged into damp portions of the paper creating some nice effects. Some of the areas in the treeline were created by a slight freezing of some of the last washes. The specific area is in front of and to the left of the house. Applying layers of wash to a hot-pressed board can be a bit of a challenge. Your touch must be exceedingly light and you must be fast. A great deal of hesitation with the brush will tend to pick up the preceding washes. Also you will find your best success will lie with the staining dye colors as opposed to the mineral pigments which tend to float on the surface of the paper.

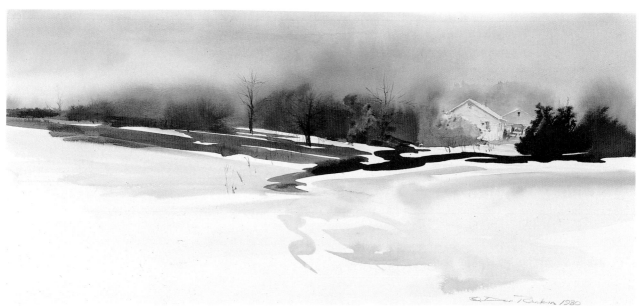

MELTING OFF
16″ × 7″ (40.64 × 17.78 cm)
Collection of Sonat, Inc.

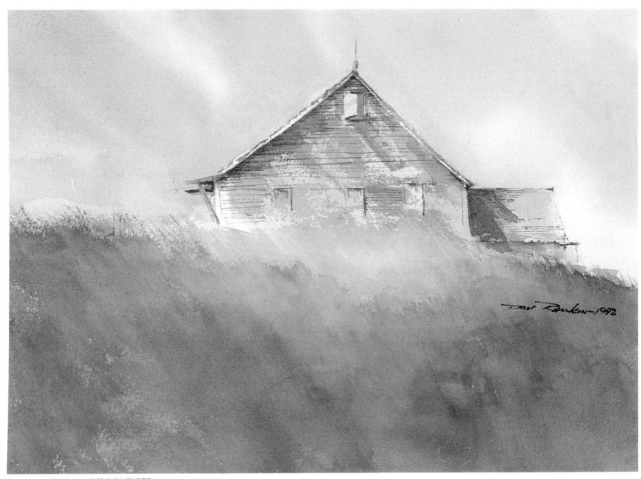

NEAR THE SALT MARSH
12" × 9" (30.48 × 22.86 cm)
Collection of Sonat, Inc.

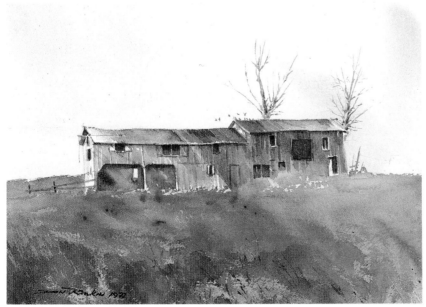

EARLY WINTER MORN
12" × 9" (30.48 × 22.86 cm)
Collection of Sonat, Inc.

Painting outdoors

Both *Mississippi Barns* and *Abandoned Barn* were painted in the hot Mississippi sun in early summer. The palette in *Mississippi Barns* consists of Thalo blue, Indian yellow, vermilion, Hooker's green deep, and indigo. In order to move quickly on this piece I applied two washes one after the other. The first was a mixture of Thalo blue and vermilion to set the sky. While this was still wet, I carefully applied a wash of Indian yellow to the foreground and brought it up to almost touch the sky wash. I could get away with this since I had a very strong, dark treeline that would

cover up a fairly hard edge. In a couple of places the washes merged, forming a yellowish backdrop for some of the trees. After all the washes were dry, I dampened the entire paper except for the barns and their roofs. I then washed in a passage of Thalo blue and a small amount of Indian yellow. Some of this color migrated up into the tree line. After this wash dried, I put in the treeline, using a wash that was predominantly Thalo blue with a little vermilion to kill the intense blue. Part of this was feathered with clear water and part was painted directly on the dry

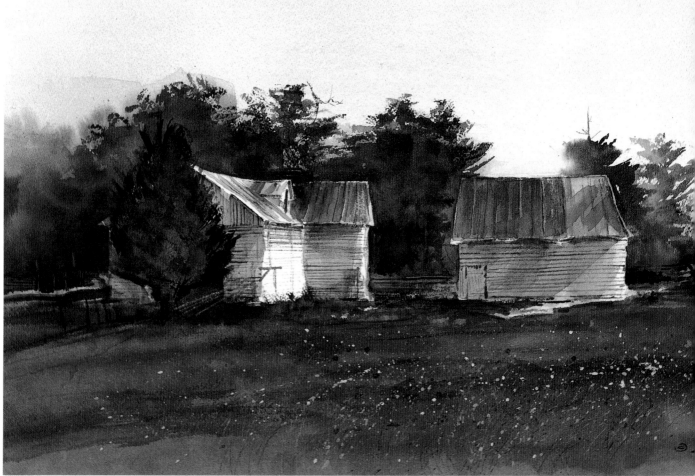

MISSISSIPPI BARNS
16″ × 9″ (40.64 × 22.86 cm)
Collection of Sonat, Inc.

paper in one motion. The darker, cooler values in the trees consisted of mixtures of indigo and Hooker's green deep. The cedar tree in front of the left barn was anticipated. I worked some of the color around it before finishing it with the darkest passages. The barns were painted using Thalo blue, vermilion, and Indian yellow. Since they were whitewashed in the sun, their value was very delicate and high-keyed. I chose to solve the larger portions of the painting before finishing these buildings. The foreground received a few alternating cooler washes to enhance the area. The yellow and Thalo yellow green spatters were added after the painting was brought indoors.

Abandoned Farm was painted on the same day as *Mississippi Barns* but the palette was shifted a bit to convey the color of the place and its more somber mood. A great deal of the color is subdued but the sky and foreground were washed in using a similar approach. Note that the white of the paper was left to suggest the tin roof on the barn. The shadows on the barn, the trees, and the overwash in the foreground consisted of a dilute wash of India ink.

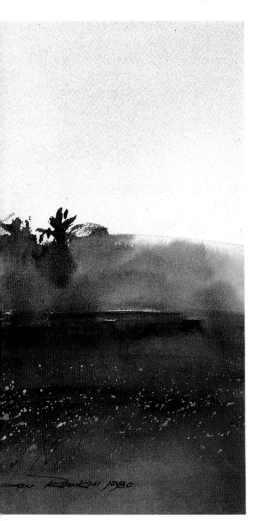

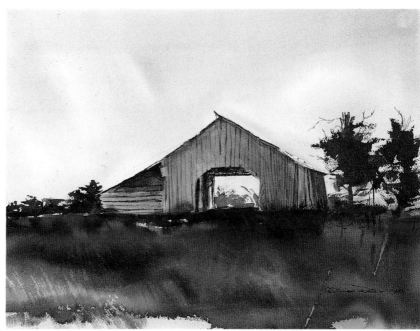

ABANDONED FARM
12″ × 9″ (30.48 × 22.86 cm)
Collection of Sonat, Inc.

Painting outdoors

Bon Ami Mines is a good example of building layers of wash on location. It was an unseasonably hot day in September and the paper dried rapidly. Since I was painting from the mouth of another cave the sun glare was not too severe on my eyes. The palette consists of new gamboge, Thalo yellow green, Winsor red, and Winsor blue. The amount of drawing was minimal on this piece; I just sketched in the opening to the cave and the horizon line.

I began to build the scene using a series of yellow-dominant neutrals. I was extremely careful to avoid getting color into the white areas of the painting because the most important factor in this painting was to get the illusion of the waterfall. Because of the light, the waterfall appeared to be pure white and that was how I left it on the paper. The bright green grass above the cave and just below the treeline was a mixture of Winsor blue and new gamboge. The duller green was a mixture of Thalo yellow green and Winsor red. The water is just another neutral color made from the primaries. The brush was dragged quickly across the paper to suggest sparkle in the water.

Not far from the Bon Ami mines, I painted *Down the Hill*. I was drawn to the scene because of the steep angle of view and the fact that I like old houses in varying degrees of disrepair. Since I was dealing with a bright noon-day sun, I wanted to communicate that in the painting. I chose to leave some areas of the paper white to indicate the heat of the light. The illusion is enhanced by the placement of the shadows.

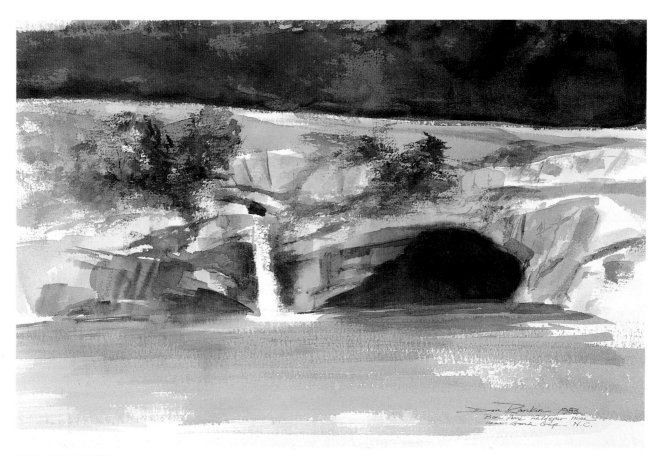

BON AMI MINES
18″ × 12″ (45.72 × 30.48 cm)
Collection of the artist

I washed in the upper portion of the painting with Thalo yellow green and allowed it to dry. While that area was drying, I washed in a pale mixture of new gamboge and Winsor red. This wash was more water than anything else. However, it worked to provide a pale hint of color. As soon as this was dry, I began to work in the darker greens in the middleground that goes behind the house. Several of these washes were executed rapidly. Note how they bounce along the surface of the sheet breaking up into many dots. This effect helps to suggest the texture of the stones and pebbles that were in a dry streambed. Part of the roof was rusting and part was newer and without rust. I worked these alternate mixtures of new gamboge, Winsor red, and Winsor blue with pale and strong

washes of the same mixture. To the stronger I added a few rust streaks (new gamboge and Winsor red) after it was dry. The front porch roof had a much stronger patina of brown. This was accomplished by mixing Winsor red and new gamboge over the earlier wash.

The dark trees on the hillside help create a push-pull effect in the painting. They were painted in two stages. The first stage was the trunks and limbs painted in a mixture of Winsor blue and Winsor red. After that was dry, the foliage was brushed in using Winsor blue, Winsor red, and new gamboge. Note that some of the color varies in intensity depending upon the amount of wash and the ratio of water. For a final touch, I painted the chickens on the roadbed using a dark neutral.

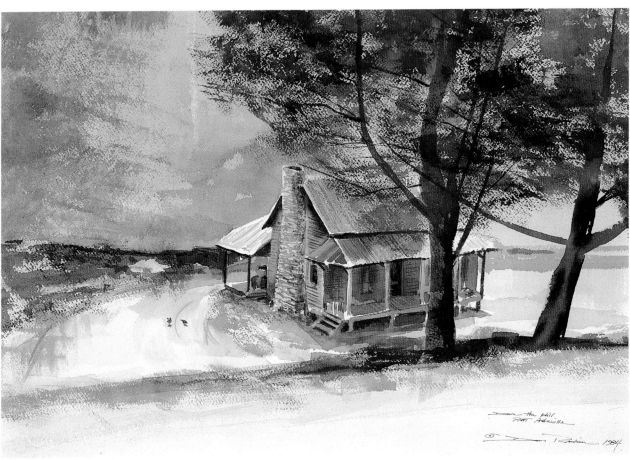

DOWN THE HILL
14″ × 11″ (35.56 × 27.94 cm)
Collection of Sonat, Inc.

INDEX